GREAT MOMENTS IN
HURLING

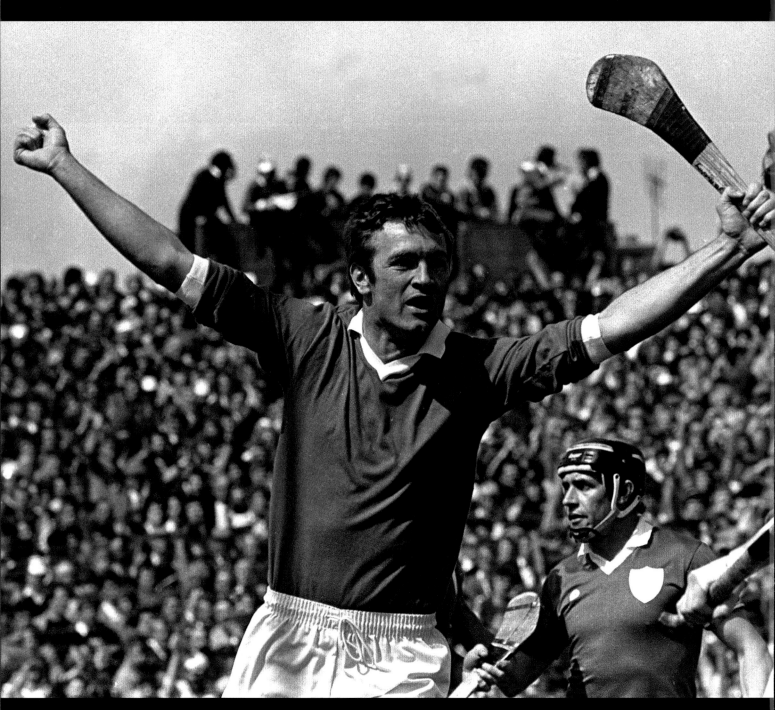

1983

Jimmy Barry Murphy, Cork Hurling.

Ray McManus / SPORTSFILE

GREAT MOMENTS IN
HURLING
from SPORTSFILE

THE O'BRIEN PRESS
DUBLIN

First published 2017 by The O'Brien Press Ltd,
12 Terenure Road East, Rathgar,
Dublin 6, D06 HD27, Ireland.
Tel: +353 1 4923333; Fax: +353 1 4922777
E-mail: books@obrien.ie
Website: www.obrien.ie
The O'Brien Press is a member of Publishing Ireland.

ISBN: 978-1-84717-932-6

10 9 8 7 6 5 4 3 2 1
21 20 19 18 17

Layout and design: The O'Brien Press Ltd.
Printed and bound in Poland by Białostockie Zakłady Graficzne S.A.
The paper in this book is produced using pulp from managed forests.

Published in:

DUBLIN
UNESCO
City of Literature

CONTENTS

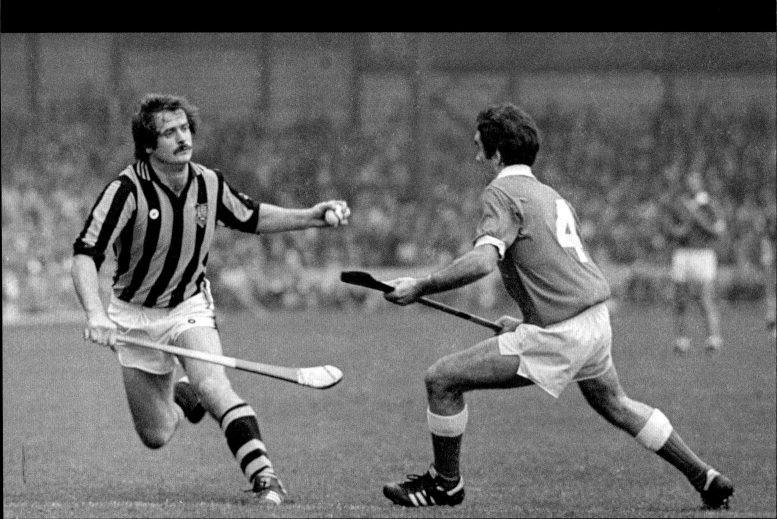

INTRODUCTION

There's nothing to beat an All-Ireland hurling final, and I've been privileged to have seen some truly great battles, like the 2010 final, when Tipperary beat Kilkenny to end their dream of 'five in a row'. Tipp played an intense, hard-hitting game, and had a hero in the hat-trick-scoring Lar Corbett. When the final whistle went, the substitutes and the backroom team raced from the sidelines to greet their teammates. It is days like these that have everything from skillful play to scenes of high emotion that we at Sportsfile take pride in capturing.

I started Sportsfile to combine my love of sport and photography, and since the early days, in the 1980s, my team and I have been pitch side, in every kind of weather, capturing the highs and lows of Gaelic sports – I've been at every All-Ireland final since 1980 and hope to be at many more.

Even after a lifetime of sports photography you still never know for sure when you'll get that great photo – you might have an eye for the game, and develop feel for how it might unfold, but sometimes you don't realise just what you've captured until you see the final photo – and the feeling of capturing the perfect shot is another thing that keeps me coming back, year after year. The excitement never fades, and I'm proud to work with a team of skilled and sports-mad photographers who feel the same way.

Ray McManus 2017

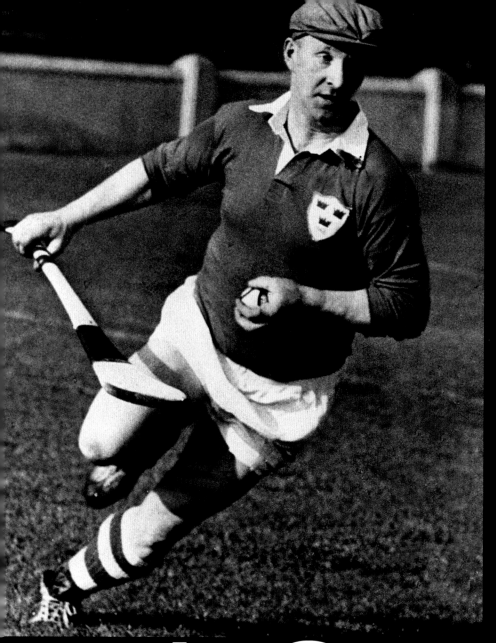

1950s

1950s

The great Christy Ring in action, The legendary Cork hurler and winner of eight All-Ireland medals is widely regarded as one of the greatest hurlers of all time.

-1960s

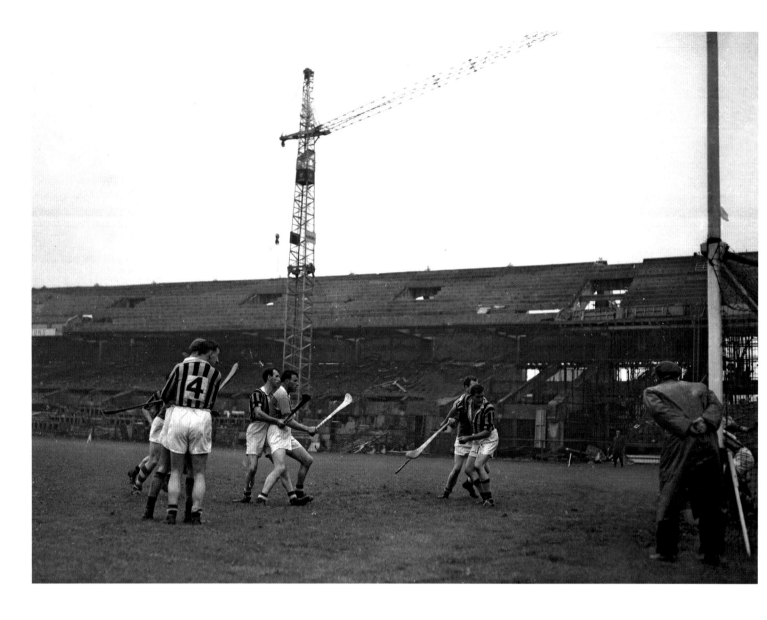

1958

Leinster Senior Hurling Championship Final, Kilkenny v Wexford, Croke Park, Dublin. Throughout the 1950s and 1960s, the Leinster Senior Hurling trophy went back and forth between Wexford and Kilkenny, with only Dublin getting a look-in in 1952 and 1961. On 27 July 1958, Kilkenny were victorious. In the background, we see Croke Park under construction; the then new Hogan Stand would be completed the next summer.

Connolly Collection / SPORTSFILE

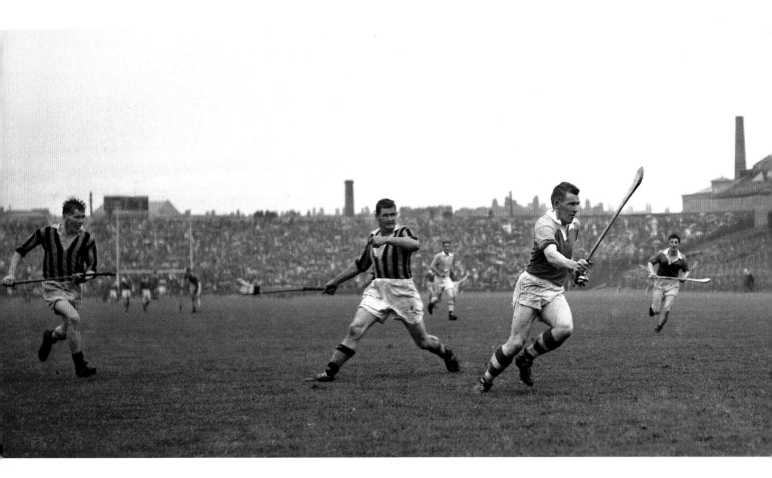

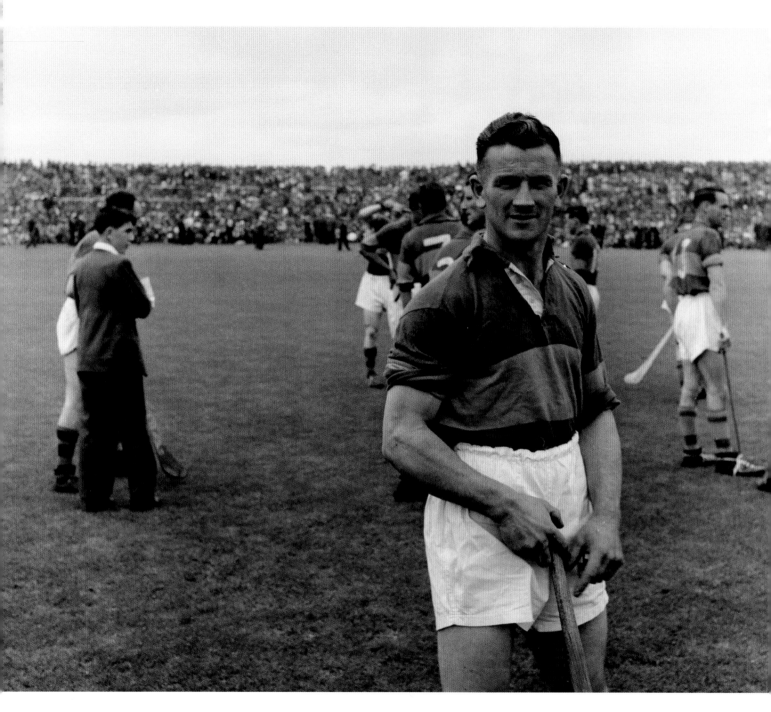

1958

Tipperary's Theo English won his first provincial medal when his team trounced reigning champions Waterford at the Munster Hurling Final in 1958. Tipp would go on to beat Leinster champions Kilkenny in the All-Ireland Semi-Final and Galway in the Final.

Connolly Collection / SPORTSFILE

1960

The legendary 1960 Wexford team, pictured here beating Kilkenny in the Leinster final. The Yellow-bellies would go on to record a famous 2-15 to 0-11 victory over Munster champions Tipperary in the All-Ireland Final.

Connolly Collection / SPORTSFILE

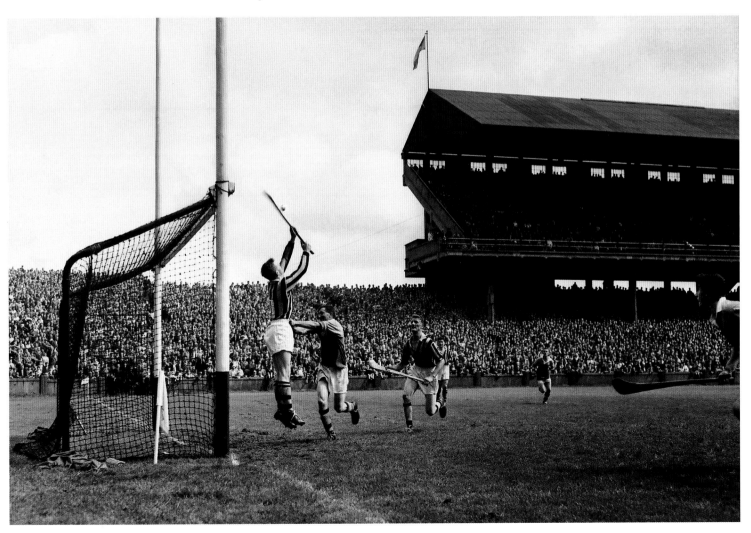

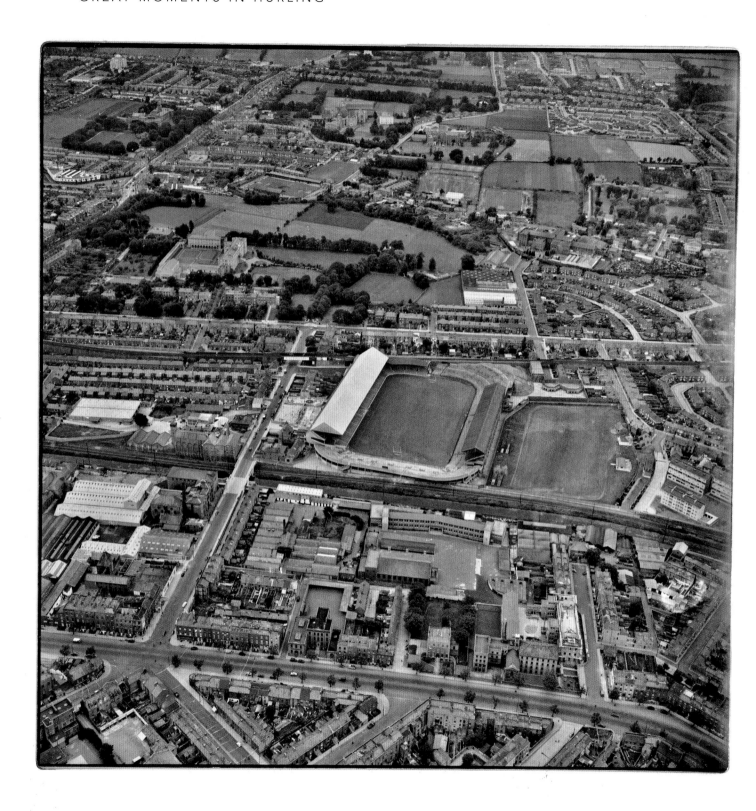

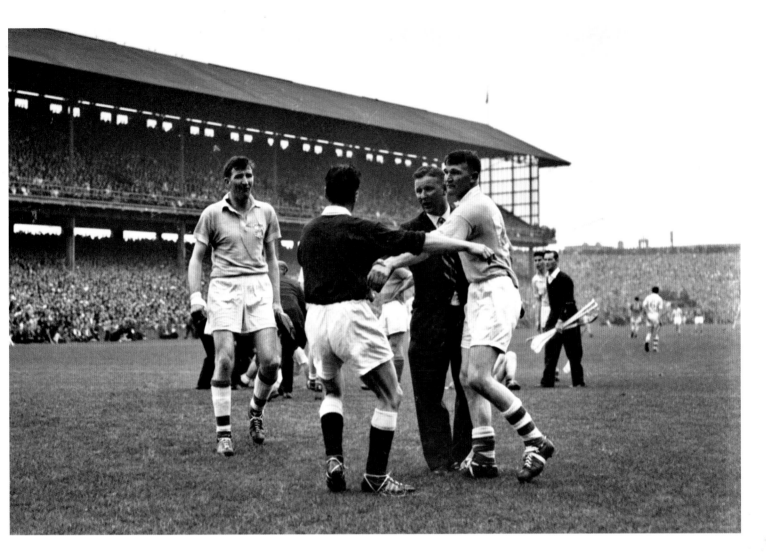

Left: 1961

An aerial view of Croke Park and surrounds. The first All-Ireland Hurling Final to be played on Jones' Road was in 1895 between great rivals Kilkenny and Tipperary. Since 1912, all finals apart from the 1937, which was played in Fitzgerald Stadium in Killarney and 1984, which was played in Semple Stadium in Thurles, have been played on the famous ground. The new Hogan Stand, left in this picture, was named after Tipperary footballer Michael Hogan who was shot on Bloody Sunday 1920, and was completed in 1959.

Connolly Collection / SPORTSFILE

Above: 1961

Dublin's Lar Foley, right, his captain Noel Drumgoole and selector Joe Drumgoole argue with referee Gerry Fitzgerald after Foley was sent off in the 45th minute of the All-Ireland Hurling Final. The Dubs, without their star player, would lose the final to Tipperary by a point.

Connolly Collection / SPORTSFILE

3 September 1961

Dublin and Tipperary clash in the All-Ireland Hurling Final, Croke
Park, Dublin. This final marks the last time that the Dublin hurlers appeared
in an All-Ireland Final, and 1938 was the last time that the Liam MacCarthy
Cup stayed in the capital.

Connolly Collection / SPORTSFILE

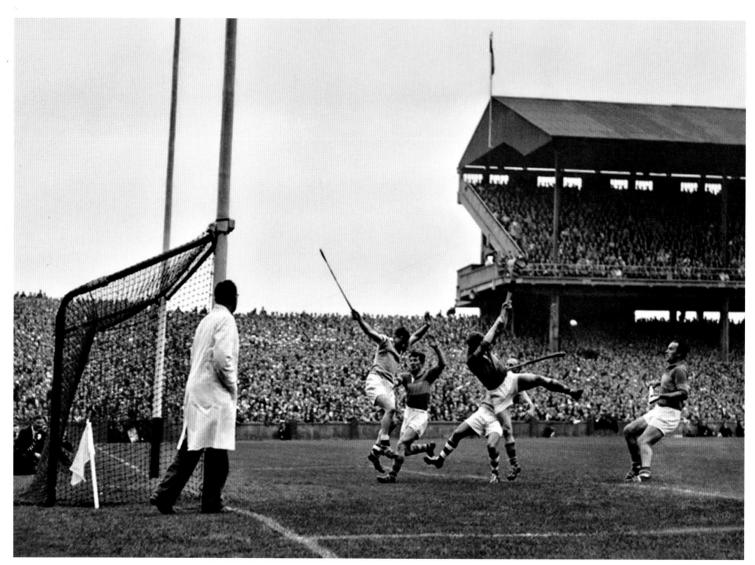

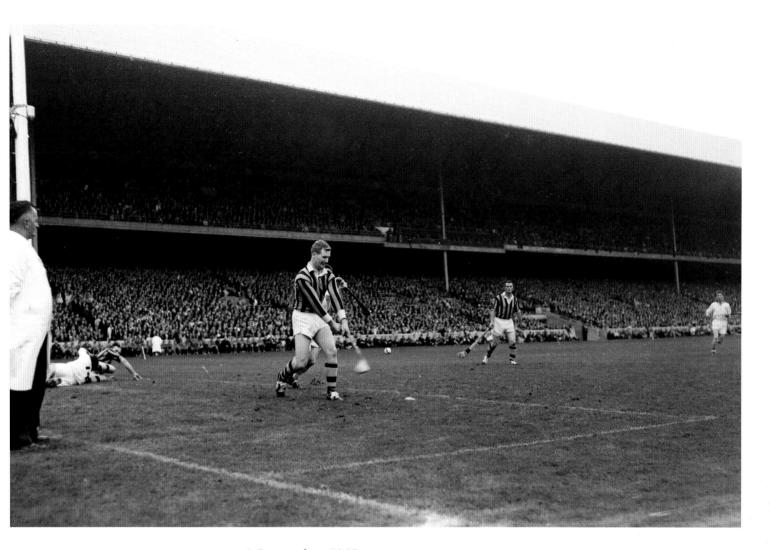

1 September 1963

Kilkenny goalkeeper Ollie Walsh at the All-Ireland Hurling Final, Kilkenny v Waterford, Croke Park, Dublin. The Thomastown net-minder is regarded as one of the best goalkeepers to have ever played the game. Over a sixteen-year career, he won four All-Irelands as Kilkenny's number one.

Connolly Collection / SPORTSFILE

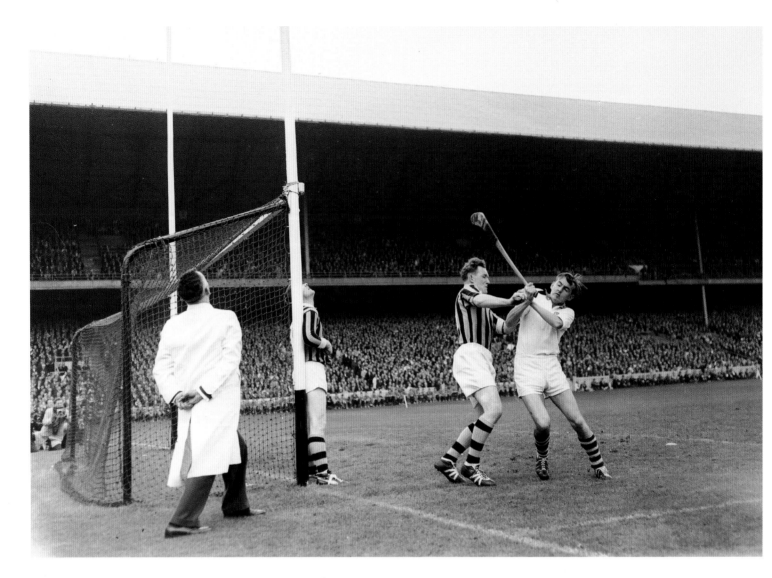

1 September 1963

Leinster champions Kilkenny defeated Munster champions Waterford in a game that saw an incredible ten goals scored. It would be 45 years before Waterford reached another All-Ireland Final in Croke Park, where, once again, they met and were beaten by Kilkenny.

Connolly Collection / SPORTSFILE

5 September 1965

The Wexford and Tipperary teams during the parade before the All-Ireland Senior Hurling Championship Final. Tipperary would win 2-16 to 0-10, giving the Premier County their 21st All-Ireland hurling victory.

Connolly Collection / SPORTSFILE

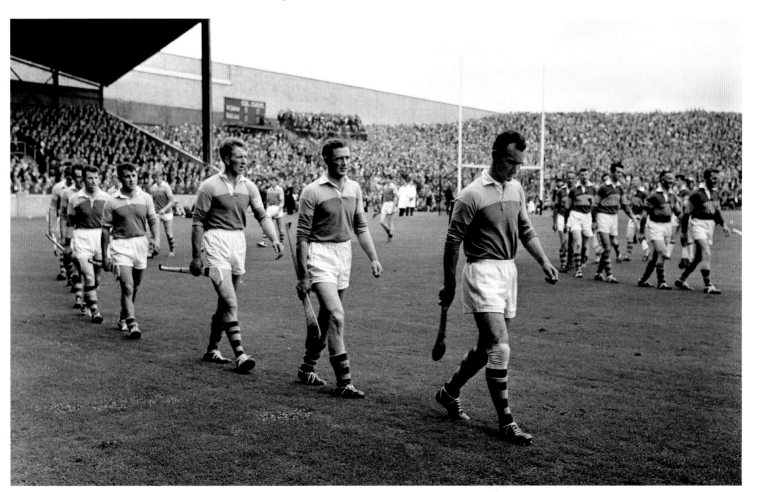

5 September 1965

Wexford captain Tom Neville, left, and Tipperary captain Jimmy Doyle, right, before the All-Ireland Hurling Final.

Connolly Collection / SPORTSFILE

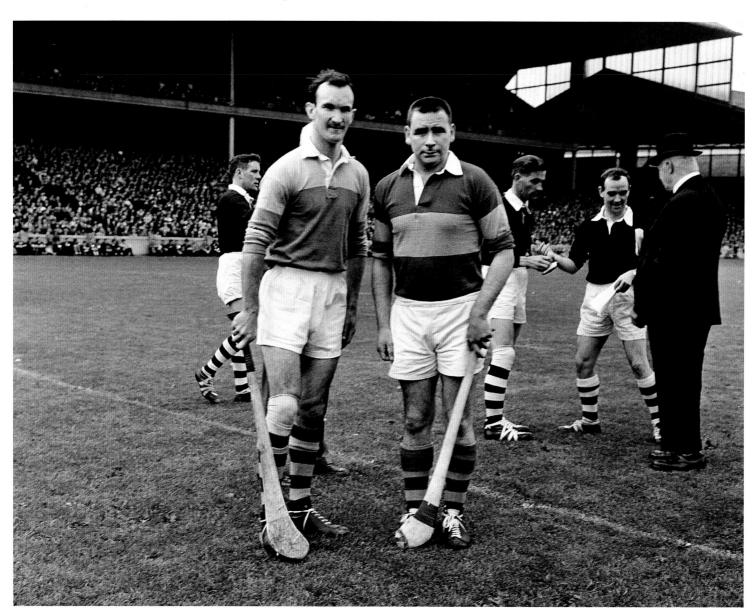

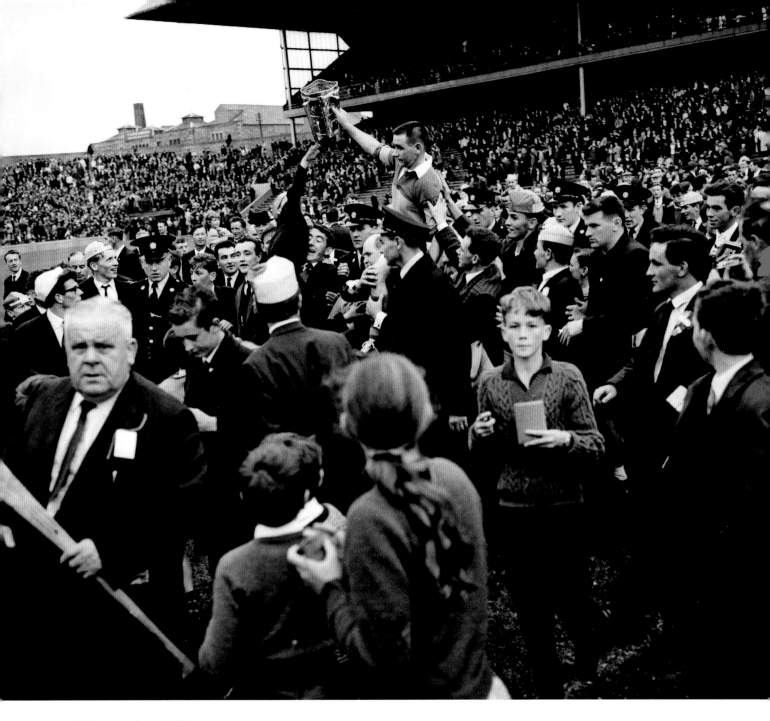

5 September 1965

Legendary Tipperary captain Jimmy Doyle – who, over his career, would win six All-Ireland medals and nine Munster medals – is held aloft by Tipperary supporters after his side's victory over Wexford. The Thurles Sarsfields' man was chosen as left corner forward on both the GAA Team of the Century in 1984 and the GAA Team of the Millenium in 2000.

Connolly Collection / SPORTSFILE

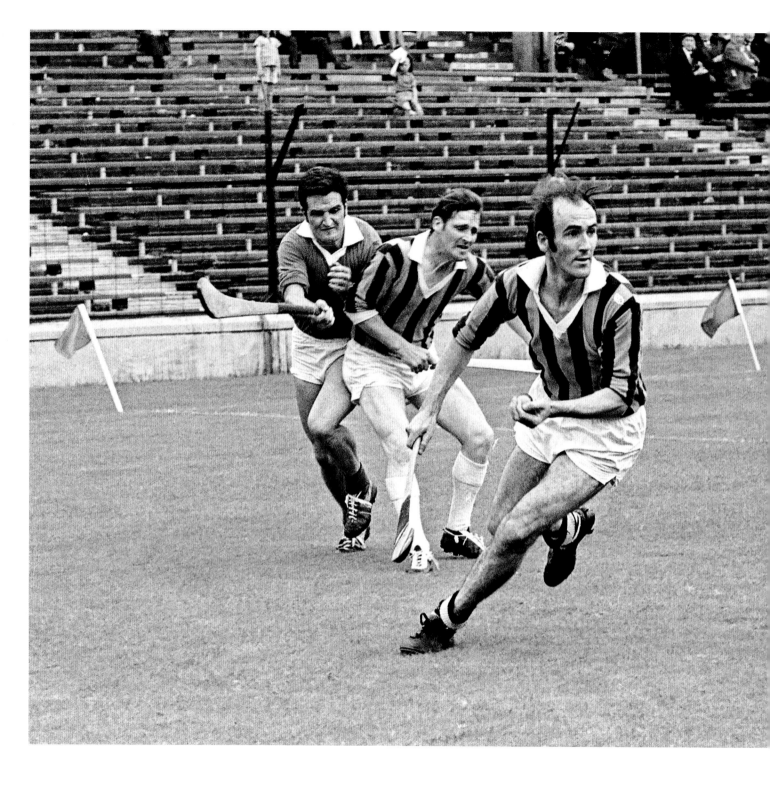

17 August 1969

Eddie Keher is regarded as one the greatest ever players, not only to wear the black and amber, but to have ever played the game. He made his senior debut at the age of 17 in the 1959 All-Ireland Final Replay, and was ever present in the Kilkenny team until his retirement in 1977. An impressive 6 All-Ireland medals, along with numerous individual accolades place the stylish Rower-Instioge man near the top of the list when supporters or journalists debate over who was the greatest ever hurler.

Connolly Collection / SPORTSFILE

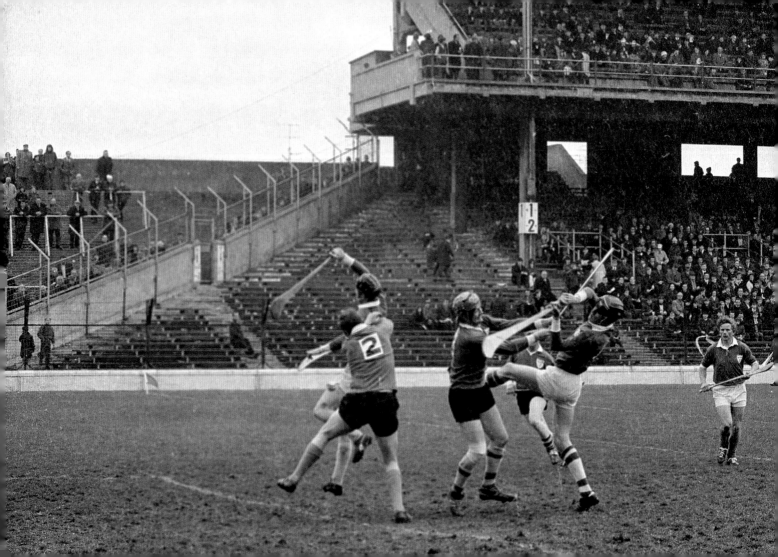

1971

Leinster on their way to breaking Munster's three-year winning streak in the final of the Interprovincial Championship, the Railway Cup.

1970s

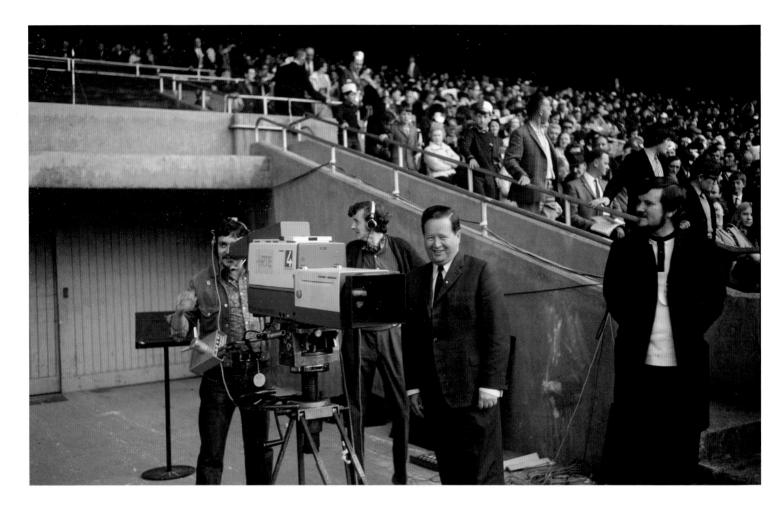

1970s

RTÉ broadcaster Mícheál O'Hehir beside an RTÉ
camera in the entrance to the Hogan Stand, Croke Park,
Dublin. Often regarded as the 'Voice of Gaelic Games',
O'Hehir commentated on 99 All-Ireland Finals between
1938 and 1985. His commentary brought the stories
of the games into homes throughout the country and
the world, first on the radio, and from 1962, on the
television.

Connolly Collection / SPORTSFILE

2 September 1973

Captain Éamonn Grimes squeezes past well-wishers and chief steward Felim Ó Broin on his way to the podium following Limerick's win over defending champions Kilkenny in the All-Ireland Hurling Final. It was Limerick's first victory since 1940; they have yet to bring the cup home since.

Connolly Collection / SPORTSFILE

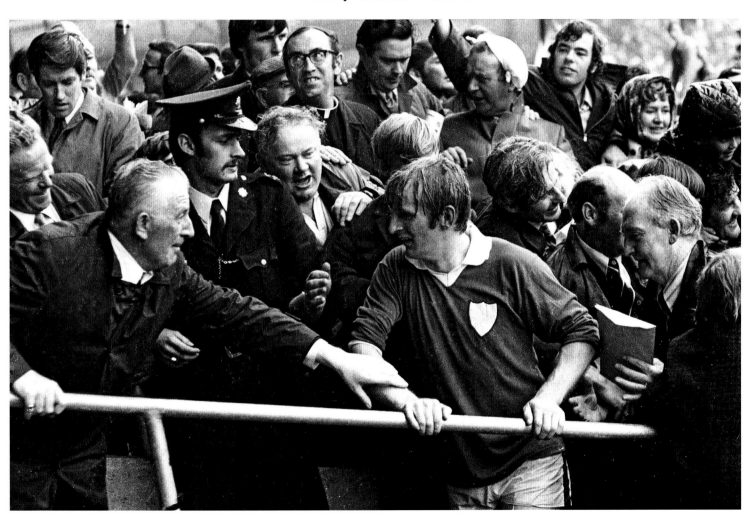

1 September 1974

Limerick captain Seán Foley, left, referee John
Moloney and Kilkenny captain Nicky Orr at the
coin-toss before the 1974 All-Ireland Hurling Final in
Croke Park.

Connolly Collection / SPORTSFILE

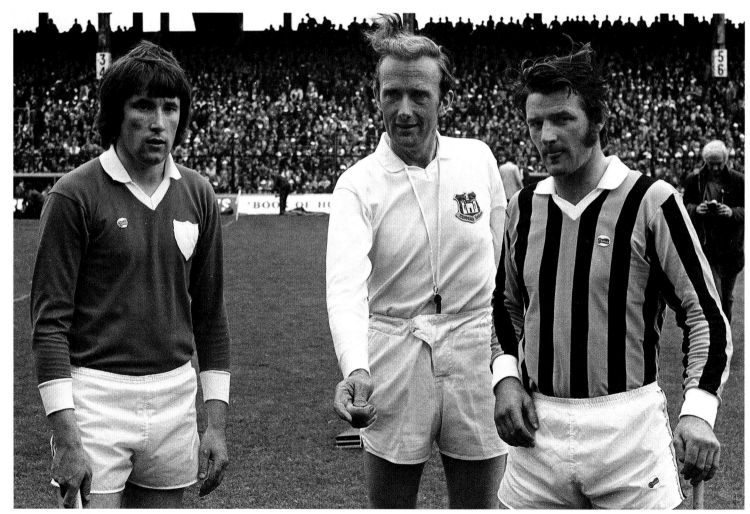

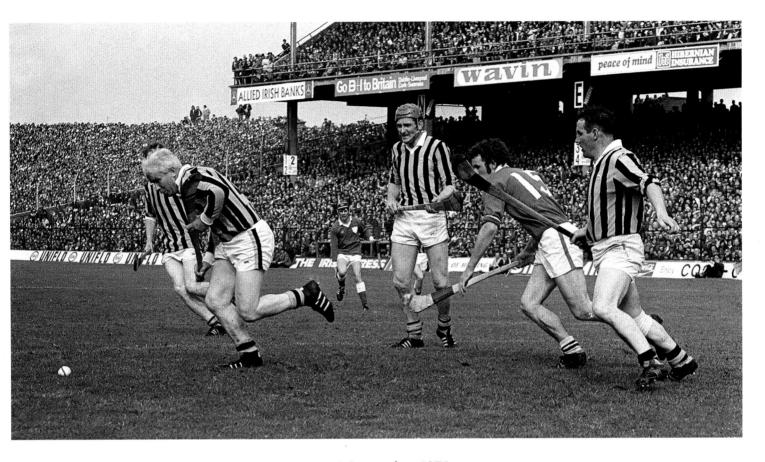

1 September 1974

In 1973, Limerick had an easy win over Kilkenny in the All-Ireland Hurling Final; the following year was a different story. The Cats blistered through the reigning champions to win 3-19 to 1-13. Here, Jim Treacy, Pat Henderson and Fan Larkin of Kilkenny surround Limerick's Frankie Nolan.

Connolly Collection / SPORTSFILE

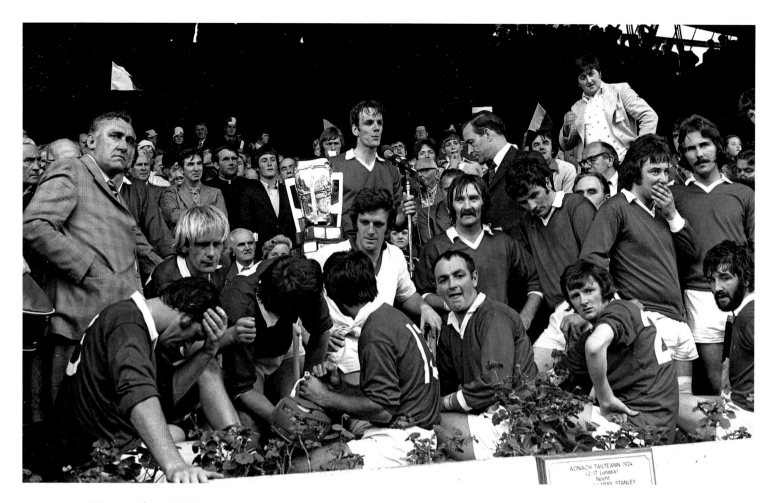

5 September 1976

Cork captain Ray Cummins – one of the few players to have won
All-Ireland medals in both football and hurling, and All-Star awards
in both codes – prepares to make a speech after being presented
with the Liam MacCarthy Cup by GAA president Con Murphy. It was
the start of a three-in-a-row winning streak for Cork: they won over
Wexford in the first two finals, and Kilkenny in the third. Also pictured
are, from left, Cork County Board Chairman Donal O'Sullivan, Pat
McDonnell, John Horgan, Martin O'Doherty, Charlie McCarthy, 13,
Martin Coleman, goalkeeper, Denis Coughlan, Gerald McCarthy, Brian
Murphy, Eamonn O'Donoghue, Sean O'Leary, John Allen and Mick
Malone. All-Ireland Hurling Final, Cork v Wexford, Croke Park, Dublin.

Connolly Collection / SPORTSFILE

3 September 1978

Future Kilkenny manager Brian Cody challenges Cork's John Horgan at the All-Ireland Hurling Final. Cork v Kilkenny, Croke Park, Dublin.

Connolly Collection / SPORTSFILE

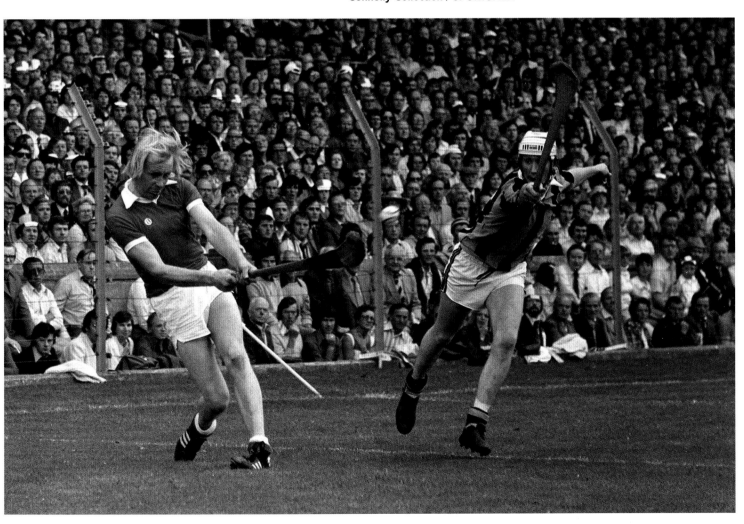

2 September 1979

Cork goalkeeper – and future Dublin hurling manager – Ger Cunningham collects the sliotar in his goal area against Kilkenny in the All-Ireland Minor final. His team would beat the Cats comfortably to collect their second Minor title in a row. All Ireland Minor Hurling Final, Croke Park, Dublin.

Connolly Collection / SPORTSFILE

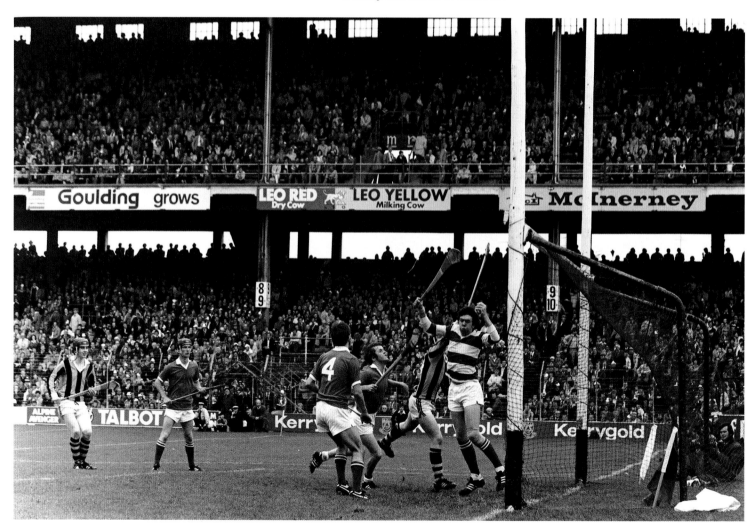

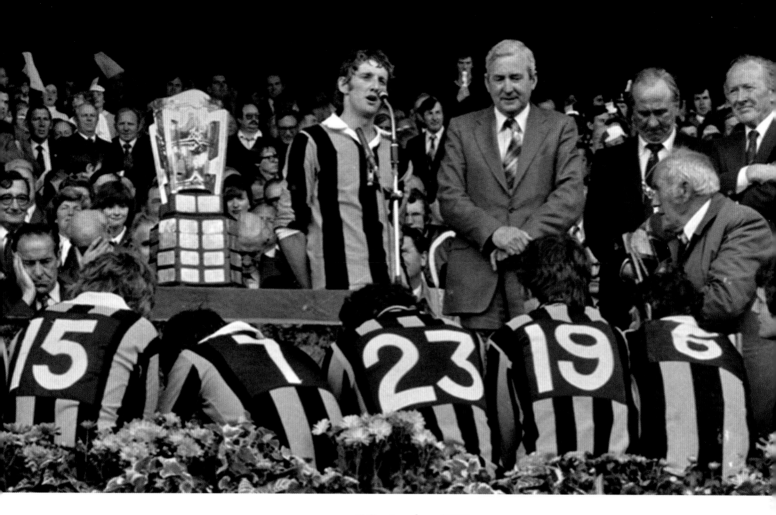

2 September 1979

Kilkenny captain Ger Fennelly makes his side's victory speech after defeating Galway in the All-Ireland Hurling Final. Ger hails from the famous Fennelly family of Ballyhale, where his brothers, Kevin, Brendan, Liam and Séan, and nephews Michael and Colin, have all worn the famous black and amber jerseys with pride. It was the Cats' fourth All-Ireland win in ten years and their 21st overall.

Connolly Collection / SPORTSFILE

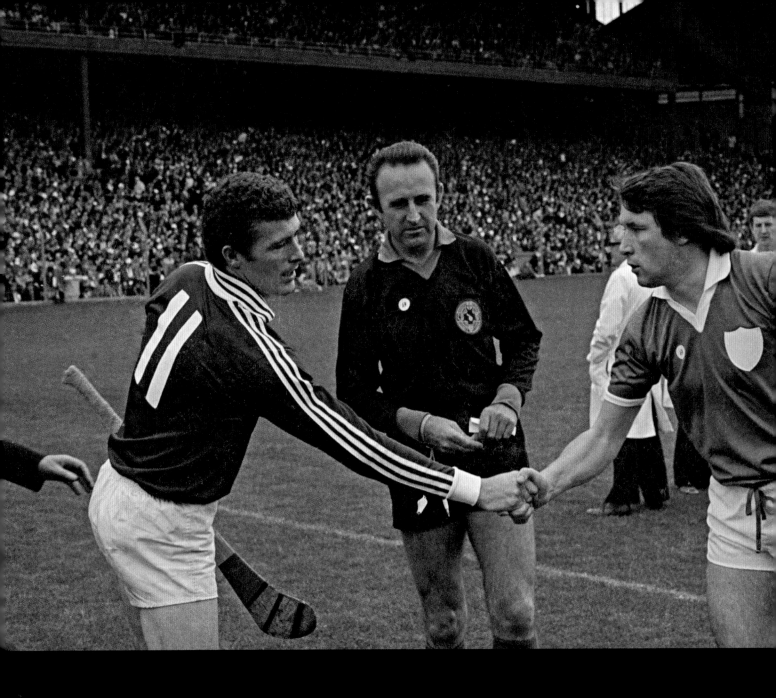

7 September 1980

Galway captain Joe Connolly shakes hands with Limerick captain Seán Foley, as referee Noel O'Donoghue from Dublin looks on, ahead of the All Ireland Hurling Final, Galway v Limerick, Croke Park, Dublin.

Connolly Collection / SPORTSFILE

1980s

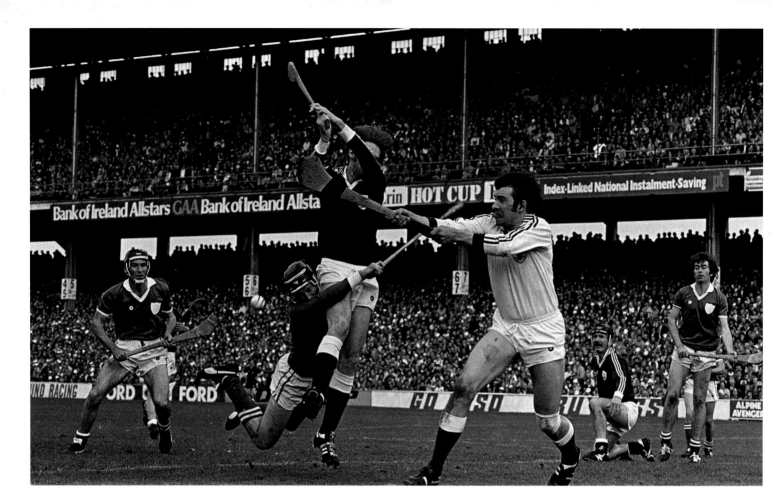

7 September 1980

Above and right: The All-Ireland Hurling Final, Galway
v Limerick, Croke Park, Dublin. Galway goalkeeper
Michael Connelly blocks the ball out to keep the
Limerick attack out.

Ray McManus / SPORTSFILE

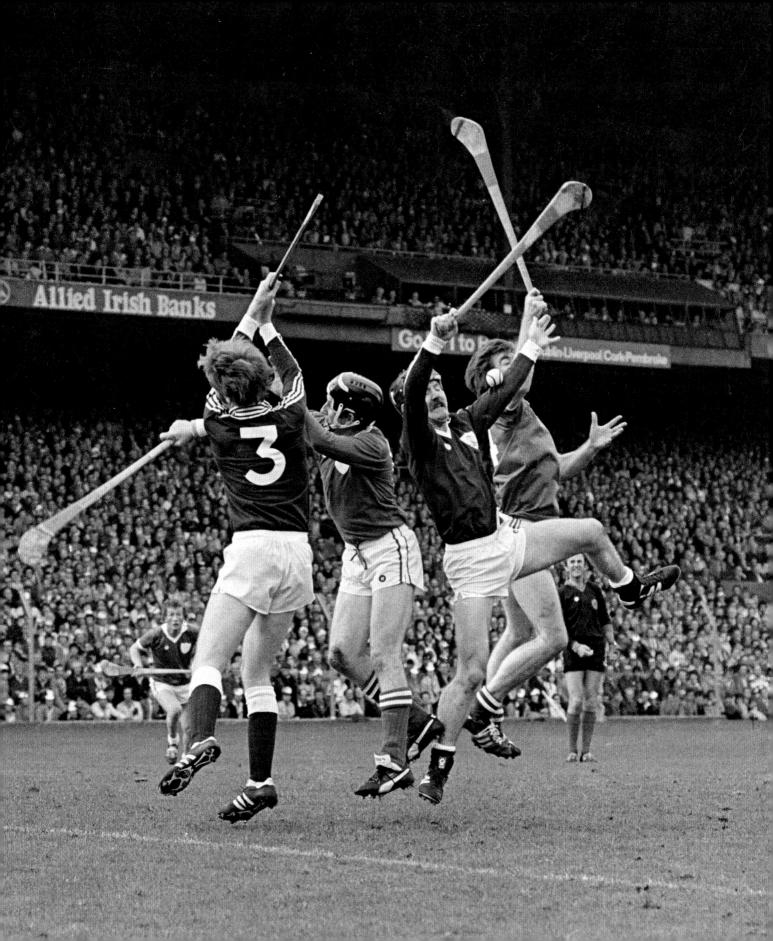

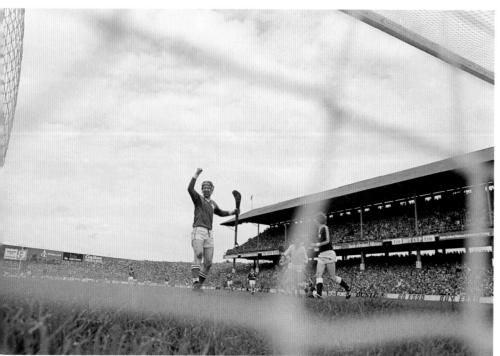

7 September 1980

Left: Mossy Carroll of Limerick during the All-Ireland Hurling Final, Galway v Limerick, Croke Park, Dublin.

Below: Galway players make their way – past enthusiastic supporters – up the steps of the Hogan Stand after their win over Limerick.

Ray McManus / SPORTSFILE

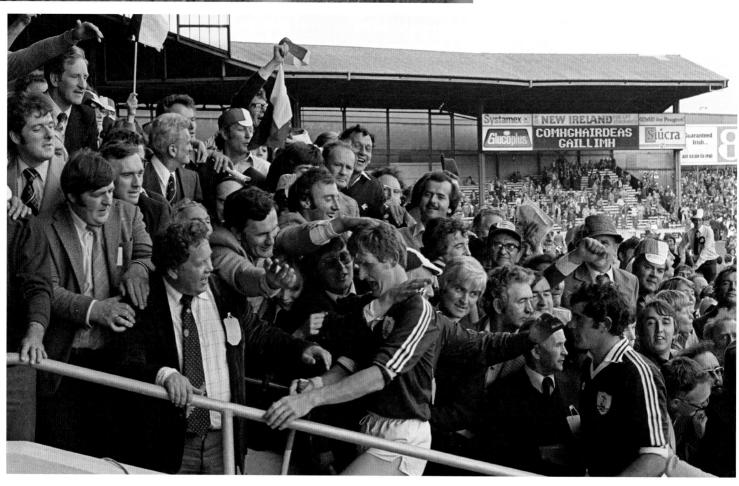

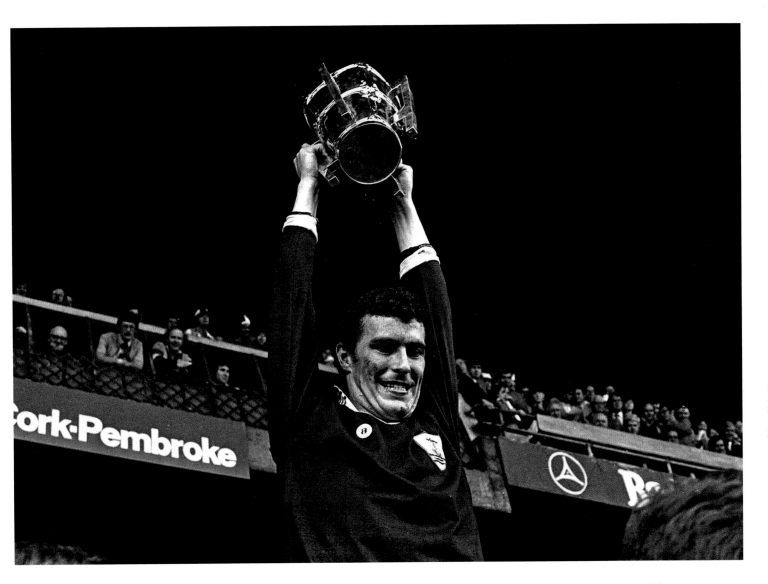

7 September 1980

Galway captain Joe Connolly lifts his team's second ever Liam MacCarthy Cup after victory over Limerick in Croke Park. All-Ireland Hurling Final, Galway v Limerick, Croke Park, Dublin. Galway bridged a 57-year gap to claim the Liam MacCarthy, an event often remembered for captain Joe Connolly's speech after the game.

'Tar éis seacht mblian 's caoga, tá craobh na hÉireann ar ais i nGaillimh … Tá daoine ar ais i nGaillimh agus tá gliondar ina gcroí, ach caithfimid cuimhniú ar dhaoine i Sasana, i Meiriceá, ar fud na tíre, agus b'fhéidir go bhfuil siad ag caoineadh anois le h'áthas … People of Galway, we love you.'

From Joe Connolly's speech

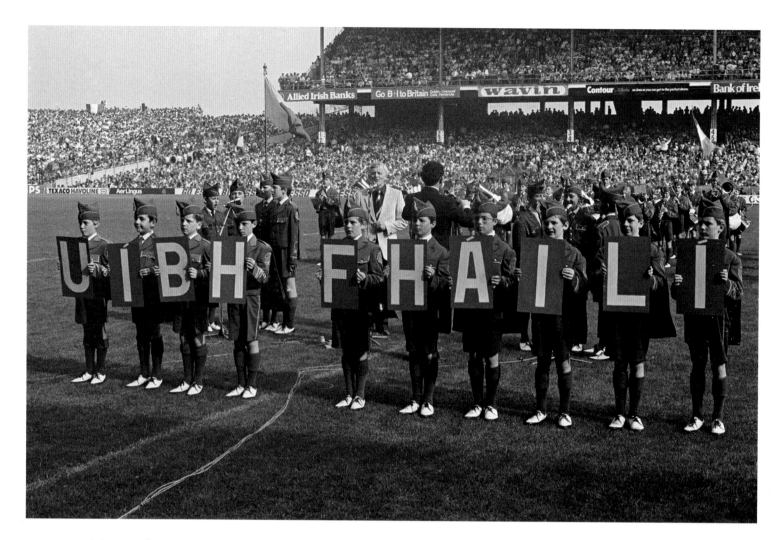

6 September 1981

Members of the Artane Boys' Band display the
Offaly team ahead of the All-Ireland Hurling Final,
Offaly v Galway, Croke Park, Dublin.

Connolly Collection / SPORTSFILE

6 September 1981

Galway's Bernie Forde in action against Offaly's Eugene Coughlan. Offaly v Galway, All-Ireland Hurling Final, Croke Park, Dublin.

Connolly Collection / SPORTSFILE

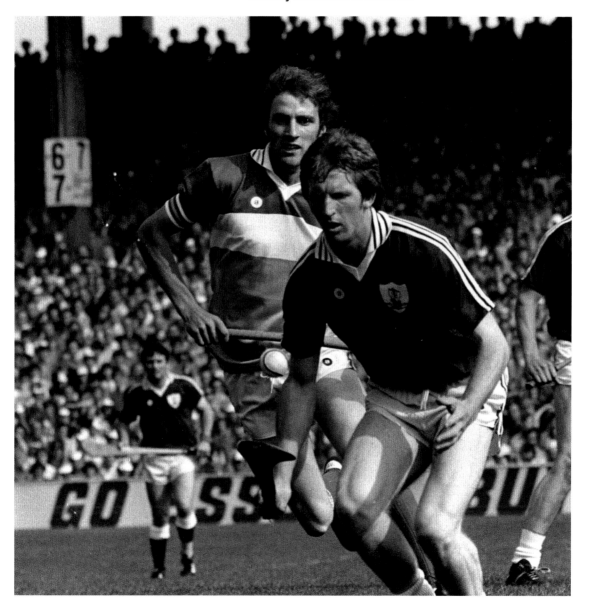

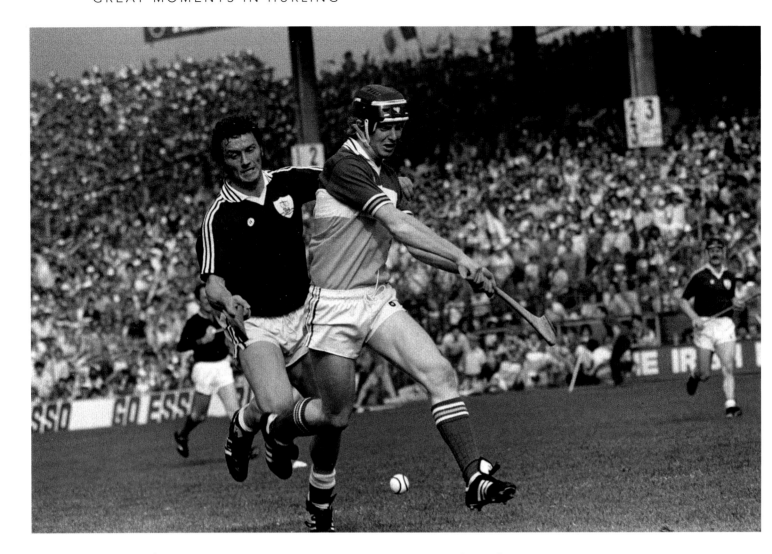

6 September 1981

Action from the Offaly v Galway game, All-Ireland Hurling Final, Croke Park, Dublin.

Connolly Collection / SPORTSFILE.

Opposite page

Offaly players and supporters celebrate their side's first ever All-Ireland title after beating Galway 2–12 to 0–15 in the final at Croke Park, Dublin.

Members of An Garda Síochána were hard pressed to hold back delighted fans in front of the Hogan Stand after Offaly's victory.

Ray McManus / SPORTSFILE

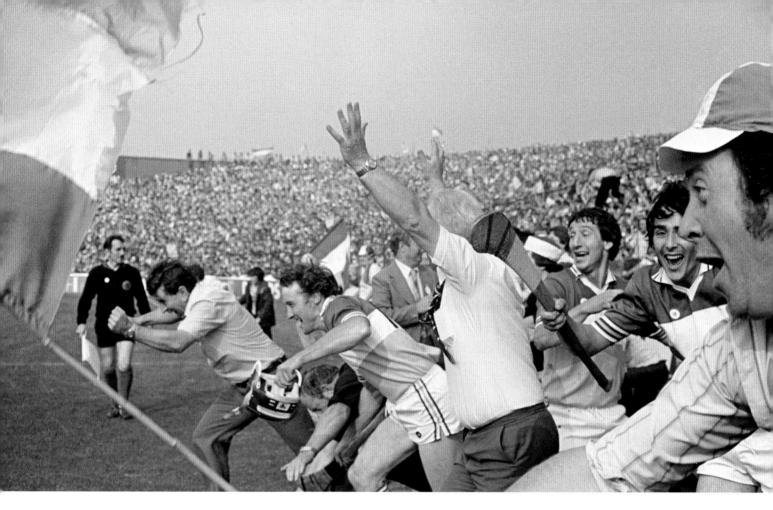

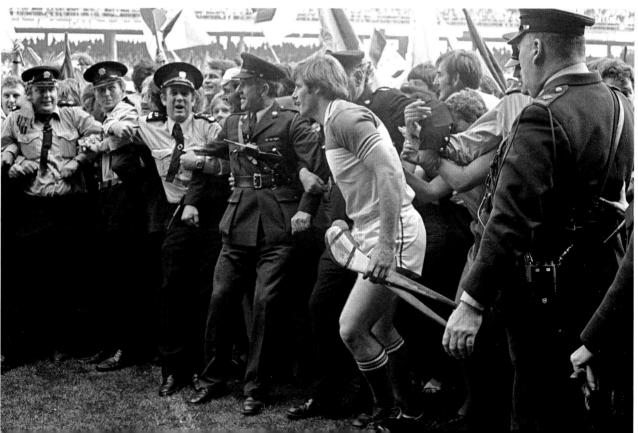

5 September 1982

Opposite:

Frank Cummins, 9, Kilkenny goes up for the ball during the Cork v Kilkenny All-Ireland Hurling Final, Croke Park, Dublin. Cummins is often cited as as one of the greatest ever hurlers; he won four All-Star awards as well as Texaco Hurler of the Year in 1983.

Ray McManus / SPORTSFILE

8 August 1982

Richie Power, Kilkenny, in action against Conor Hayes, Galway. All-Ireland Hurling Semi-final, Croke Park, Dublin. Kilkenny won the match 2–20 – 2–10 and progressed to meet Cork in the final for the second year in a row.

Ray McManus / SPORTSFILE

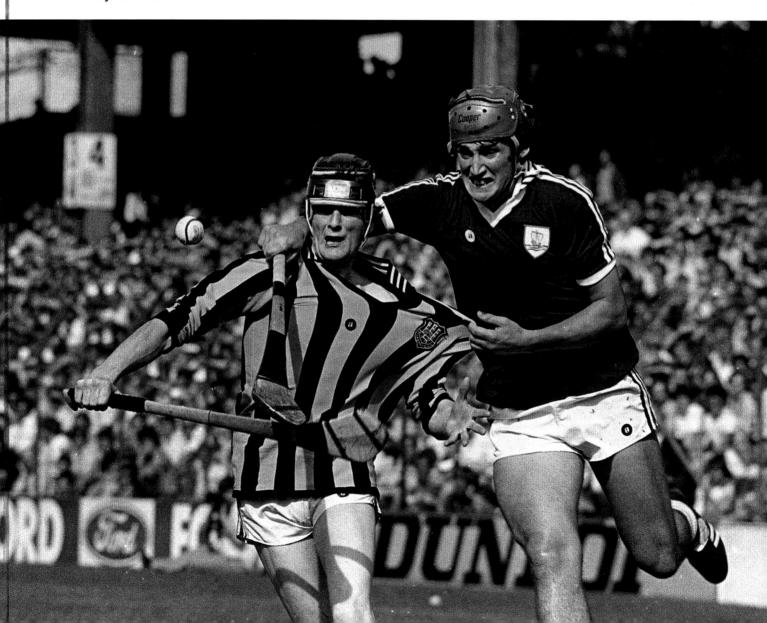

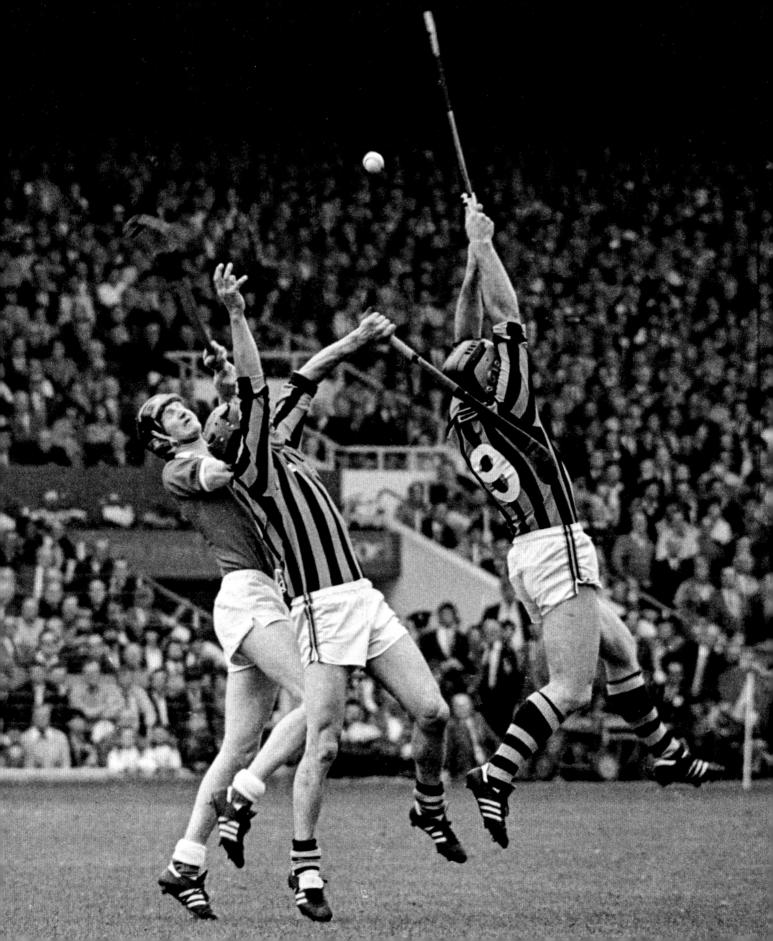

5 September 1982

Above: Supporters watch the game from the Canal End during the Cork v Kilkenny, All Ireland Hurling Final, Croke Park, Dublin.

Right: Dick O'Hara of Kilkenny leaves the field after the his team's victory over Cork, 3-18 to 1-13. All Ireland Hurling Final, Croke Park, Dublin.

Ray McManus / SPORTSFILE

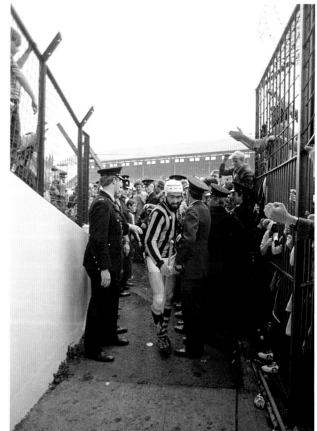

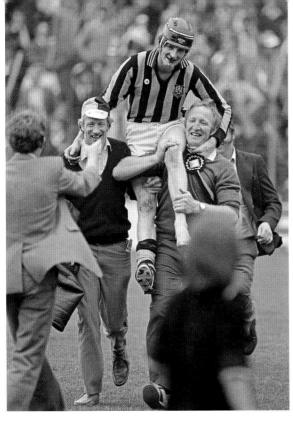

5 September 1982

Left: Richie Power of Kilkenny is carried off the field after the Cork v Kilkenny, All Ireland Hurling Final, Croke Park, Dublin. This was Power's first All-Ireland medal; he went on to win a second – also over Cork – in 1983.

Below: Kilkenny captain – and future Kilkenny manager – Brian Cody brings the Liam MacCarthy cup into the Kilkenny dressing-room after the Cork v Kilkenny, All-Ireland Hurling Final, Croke Park, Dublin.

Ray McManus / SPORTSFILE

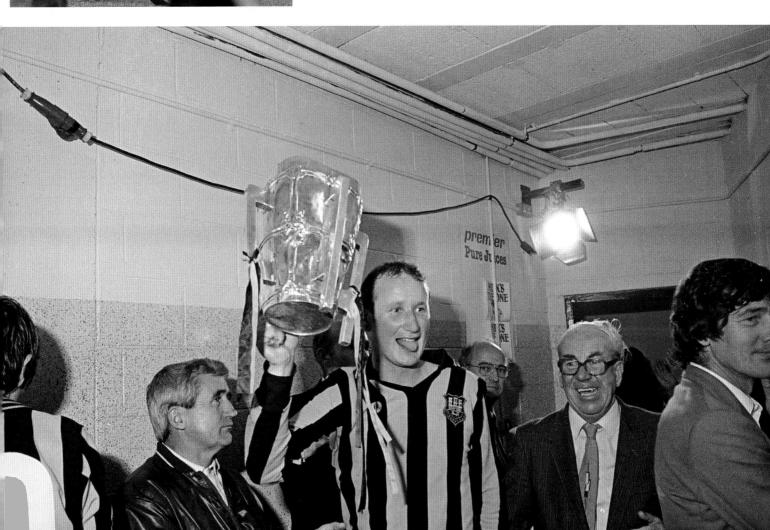

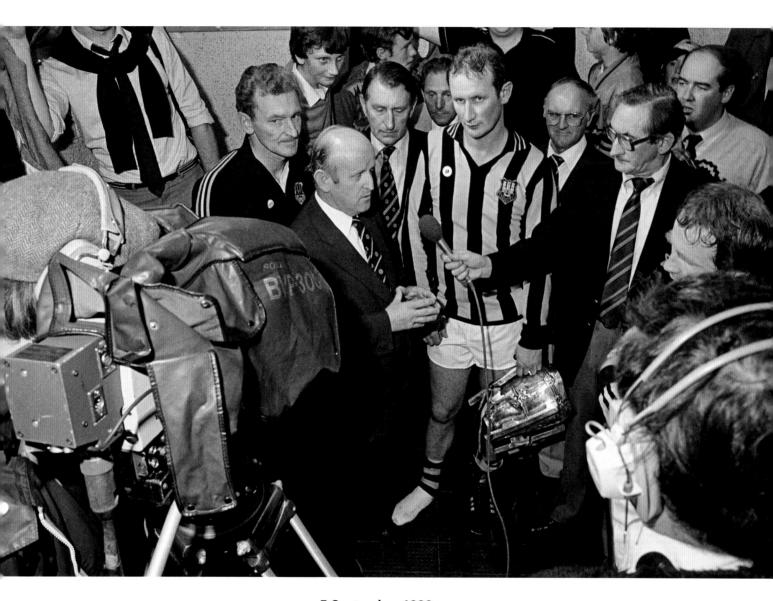

5 September 1982

Kilkenny captain Brian Cody, with Liam MacCarthy in hand, waits
to be interviewed by Mick Dunne of RTÉ as Cork County Board
Chairman Derry Gowen congratulates the Kilkenny players and
officials in the dressing-room after the Cork v Kilkenny, All-Ireland
Hurling Final, Croke Park, Dublin.

Connolly Collection / SPORTSFILE

2 September 1983

Kilkenny's Billy Fitzpatrick in action against Cork's John Crowley, All-Ireland Hurling Final, Croke Park. The Munster champions lost to their Leinster opponents on a score line of 3-18 to 1-13.

Ray McManus / SPORTSFILE

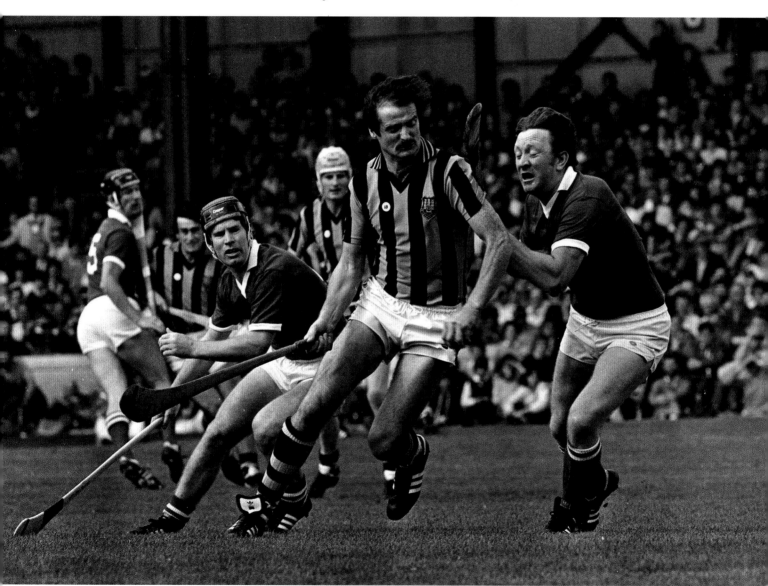

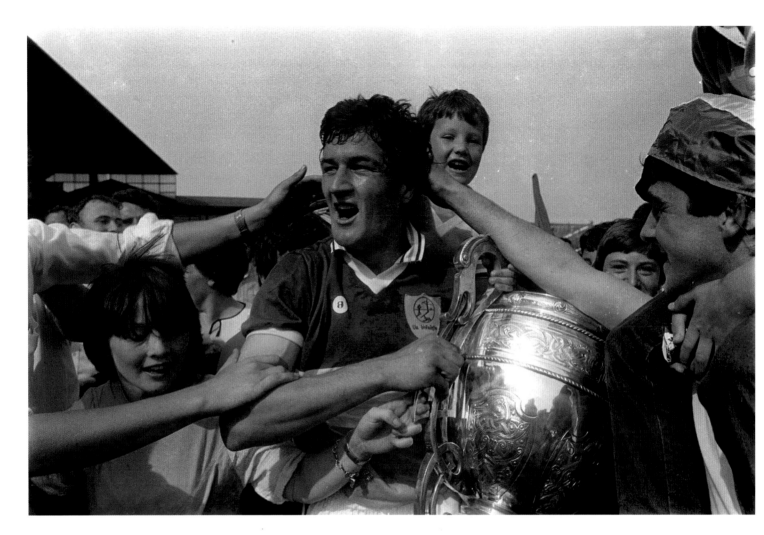

8 July 1984

Offaly captain Pat Fleury is congratulated by fans after lifting the Leinster Cup. Leinster Hurling Final, Offaly v Wexford, Croke Park, Dublin. Instead of heading for Croke Park, Offaly would go on to play Cork in the 'Centenary Final' in Semple Stadium in Thurles.

Ray McManus / SPORTSFILE

2 September 1984

The 1984 Final in Thurles was knows as 'The Centenary All-Ireland' as it marked one hundred years since the foundation of the GAA; as a nod to Thurles as 'the cradle of GAA' the Final was held in Semple Stadium. Before the match, all living former All-Ireland captains (38 captains of 40 teams) were brought out onto the field and cheered by the 60,000-strong crowd.

SPORTSFILE

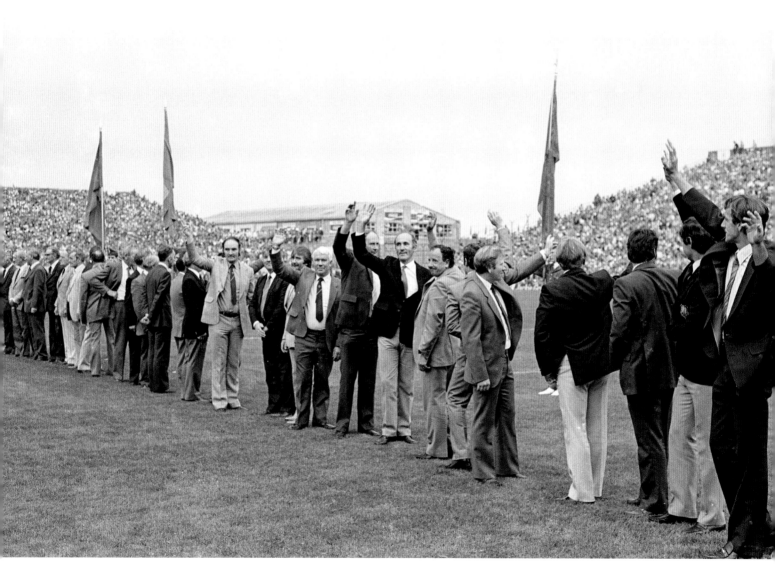

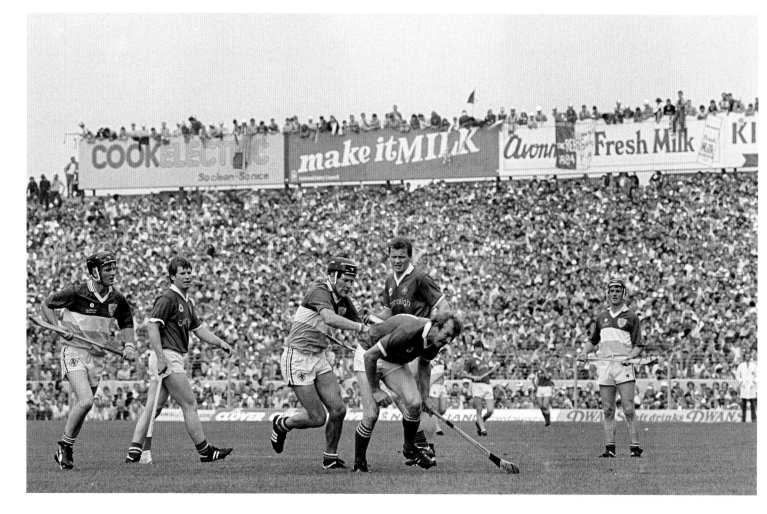

2 September 1984

At the GAA's annual Congress on 28 March 1981, the venue for the 1984 'Centenary' All-Ireland final was announced – Semple Stadium in Thurles. Though GAA president Paddy McFlynn and GAA director-general Liam Mulvihill expressed some concerns about the capacity and facilities at the Tipperary stadium, the decision to award the final to Semple Stadium was passed by a considerable majority.

SPORTSFILE

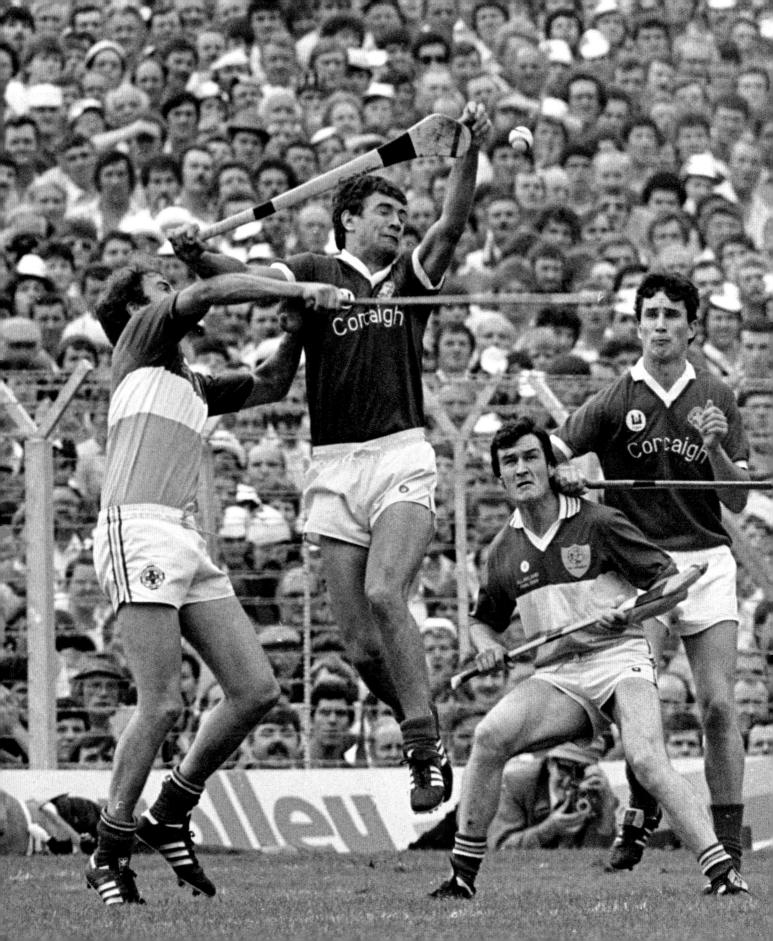

2 September 1984

Cork Captain John Fenton holds the Liam McCarthy Cup also pictured is GAA President Paddy Buggy. All-Ireland Hurling Final, Cork v Offaly, Semple Stadium, Thurles.

Ray McManus / SPORTSFILE

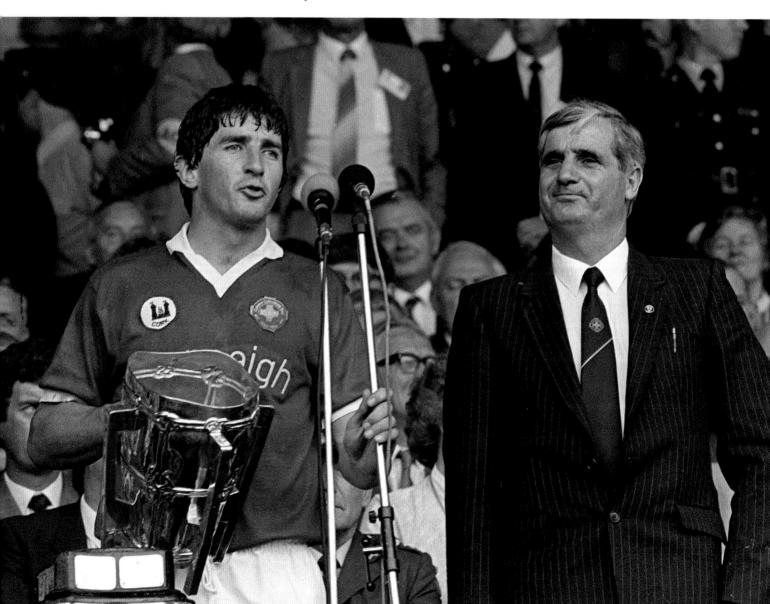

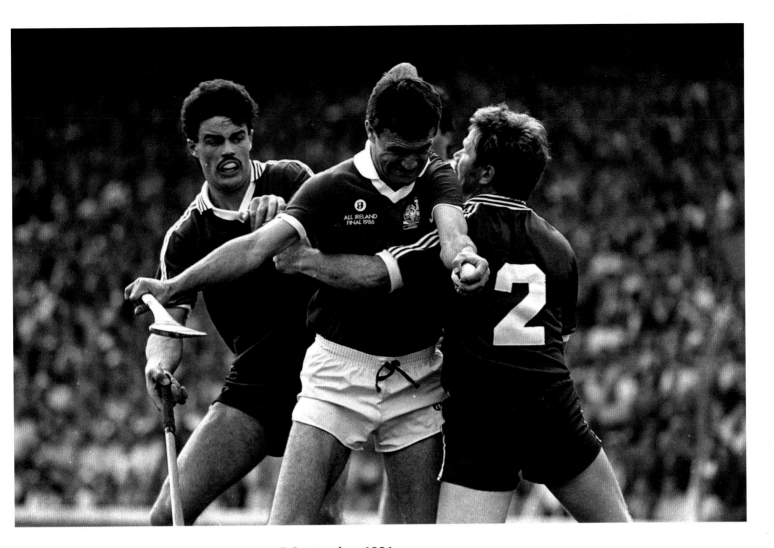

7 September 1986

Cork legend, Jimmy Barry Murphy, centre, is blocked by Sylvie Linnane, 2, and Gerry McInerney, Galway; Cork went on to win by 4-13 to 2-15. All-Ireland Hurling Final, Croke Park, Dublin.

Ray McManus / SPORTSFILE

4 September 1988

Showing their colours: The Tipperary and Galway teams stride out in the pre-match parade. The Munster champions lost to the Connacht men on a score line of 1-15 to 0-14. All-Ireland Hurling Final, Croke Park, Dublin.

Ray McManus / SPORTSFILE

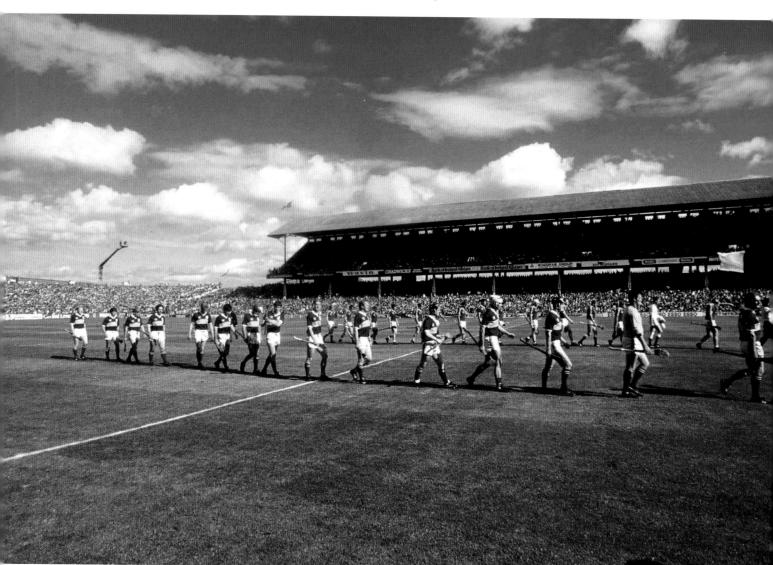

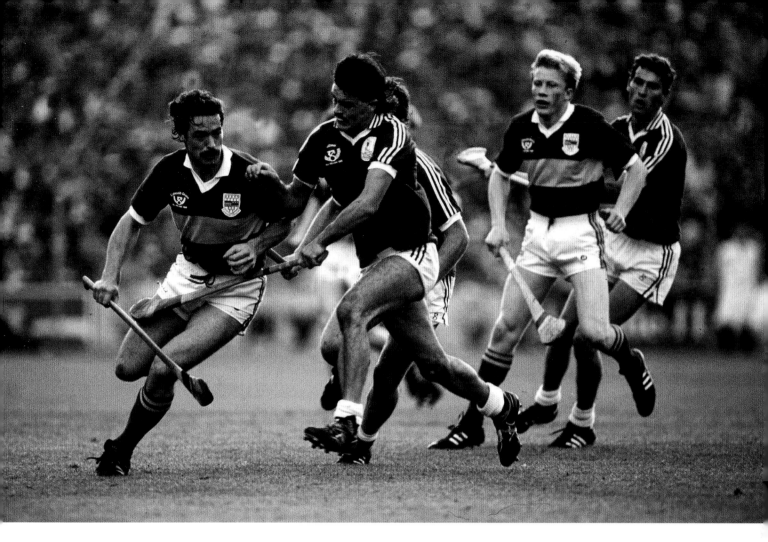

4 September 1988

Close contact! Donie O'Connell, Tipperary, in action against Gerry McInerney, Galway. Also pictured are Aidan Ryan, Tipperary and Michael Coleman, Galway. Galway went on to win the match, 1-15 to 0-14.

Ray McManus / SPORTSFILE

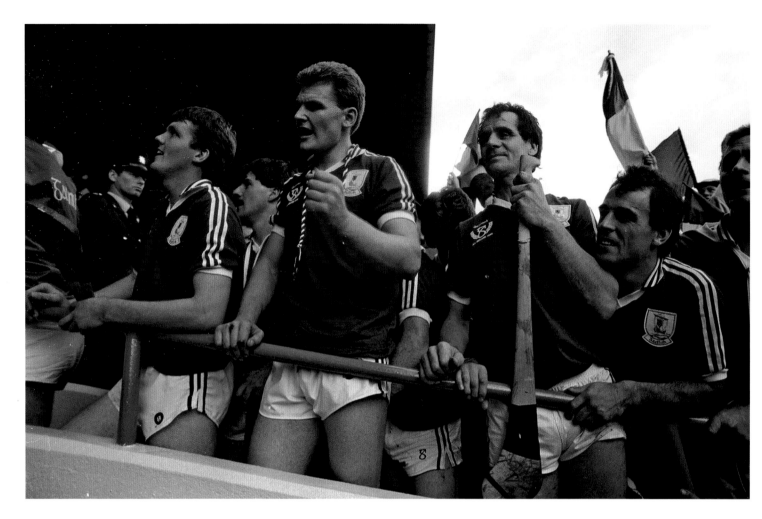

4 September 1988

Galway players, left to right, Martin Naughton, Pete Finnerty, Brendan Lynskey and Pat Malone look on as Galway captain Conor Hayes lifts the Liam MacCarthy Cup, 1988 was the second consecutive victory for the Tribesmen, but their glory days were short-lived; they haven't won an All-Ireland hurling final since. Galway v Tipperary, All-Ireland Hurling Final, Croke Park, Dublin.

Ray McManus / SPORTSFILE

4 September 1988

Galway manager Cyril Farrell is held shoulder high by supporters after Galway's victory over Tipperary. All-Ireland Hurling Final, Croke Park. Farrell is regarded as Galway's greatest manager. He was first appointed to the job in 1979, and over the following 20 years, which included 3 separate stints at the helm, he guided the Tribesmen to 3 All-Ireland titles.

Ray McManus / SPORTSFILE.

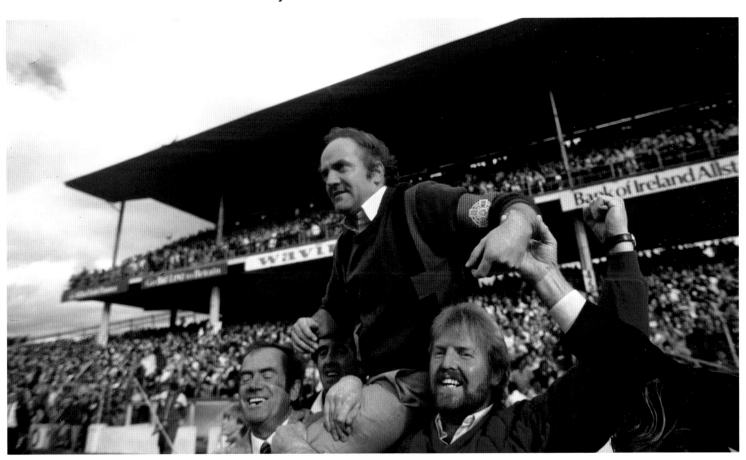

2 July 1989

Cormac Bonner, Tipperary, in action against Damien Byrne, Waterford. Tipperary v Waterford, Munster Hurling Final, Páirc Uí Chaoimh, Cork. Tipperary were the victors, 0-26 to 2-8, and went on to meet Antrim in the final.

Ray McManus / SPORTSFILE

Opposite: 6 August 1989

Antrim manager Jim Nelson celebrates his team's 4-15 to 1-15 victory over Offaly, paving the way for Antrim's second ever All-Ireland Final appearance. All-Ireland Hurling Semi-Final, Croke Park, Dublin.

Ray McManus / SPORTSFILE.

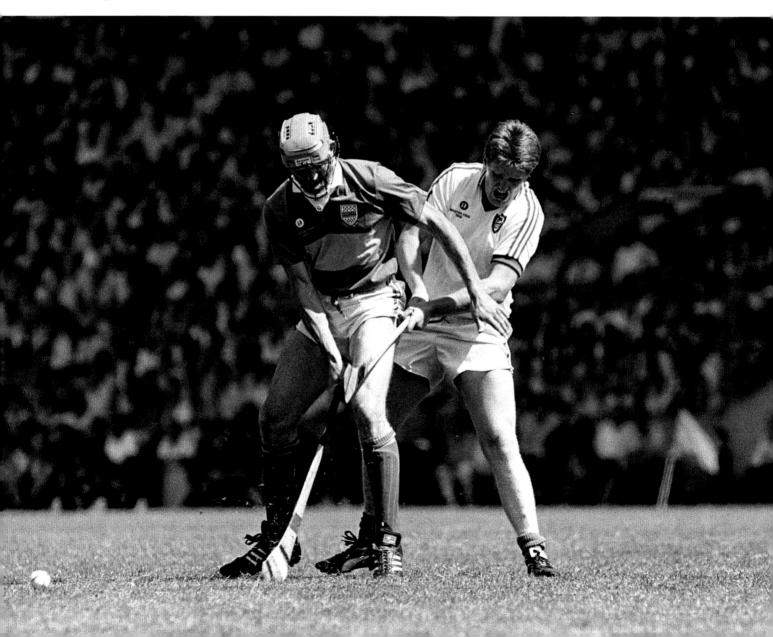

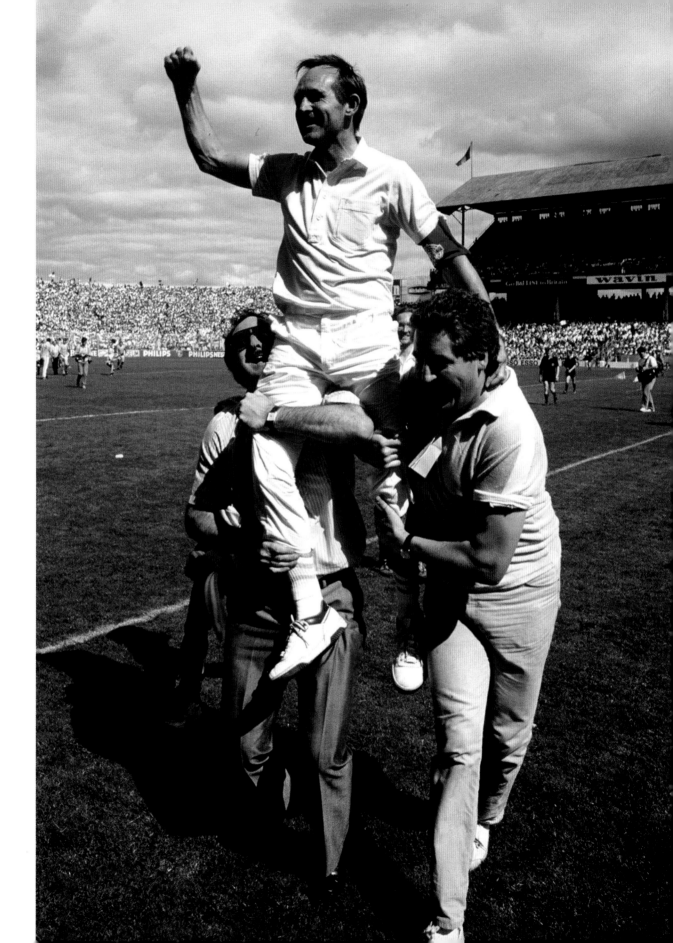

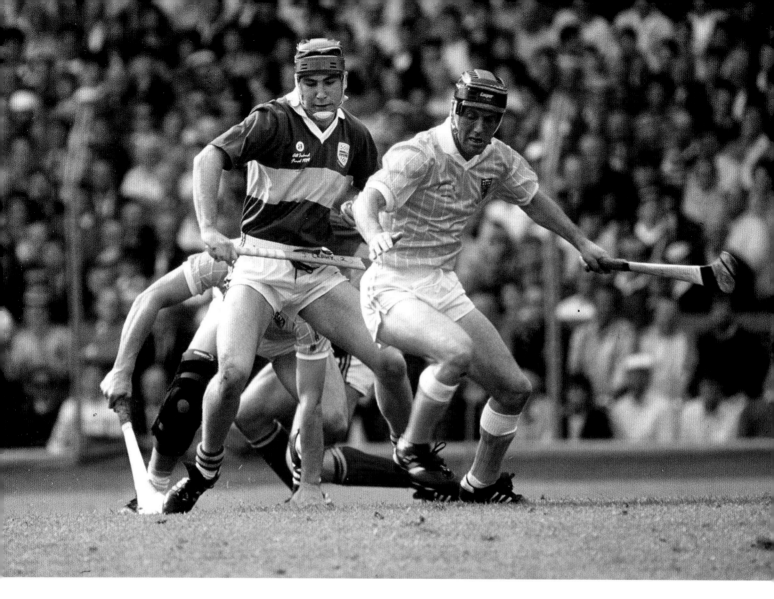

3 September 1989

John Leahy, Tipperary in action against Antrim, All-Ireland Hurling Final, Croke Park, Dublin. The game was broadcast live on Network 2 – the revamped version of RTÉ 2, which had launched in 1988 – with commentary by Ger Canning and Jimmy Magee. This was only Antrim's second ever appearance in an All-Ireland final; they lost 4-24 to 3-9 to Tipperary 46 years after losing to Cork at the same stage of the championship. Tipp's victory also preserved their unique record of winning an All-Ireland title in every decade of the GAA's existence.

Ray McManus / SPORTSFILE

Opposite: 3 September 1989

Tipperary's Nicky English celebrates one of his side's goals with team-mate Cormac Bonnar, left. English set a scoring record for a single player in the modern era – 2-12 – in this match. All-Ireland Hurling Final, Tipperary v Antrim, Croke Park, Dublin.

SPORTSFILE

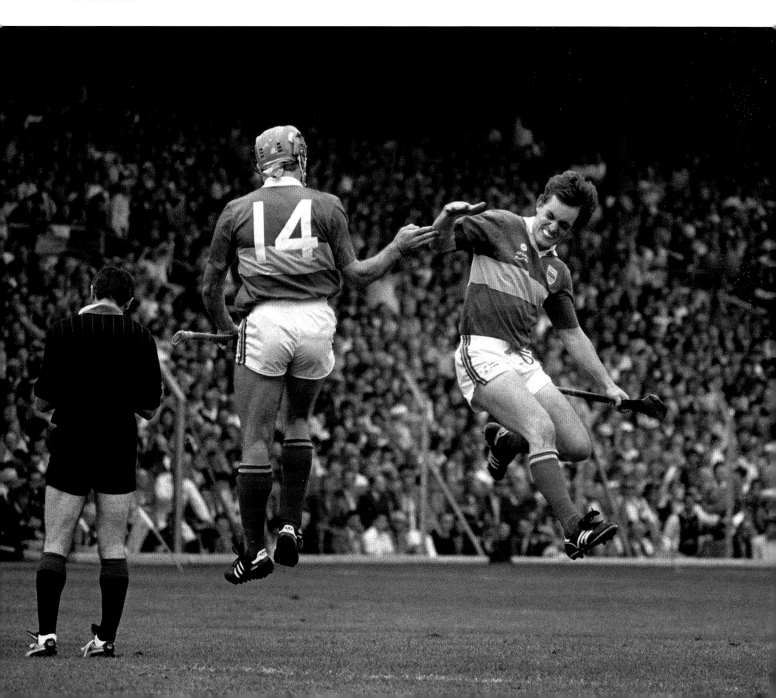

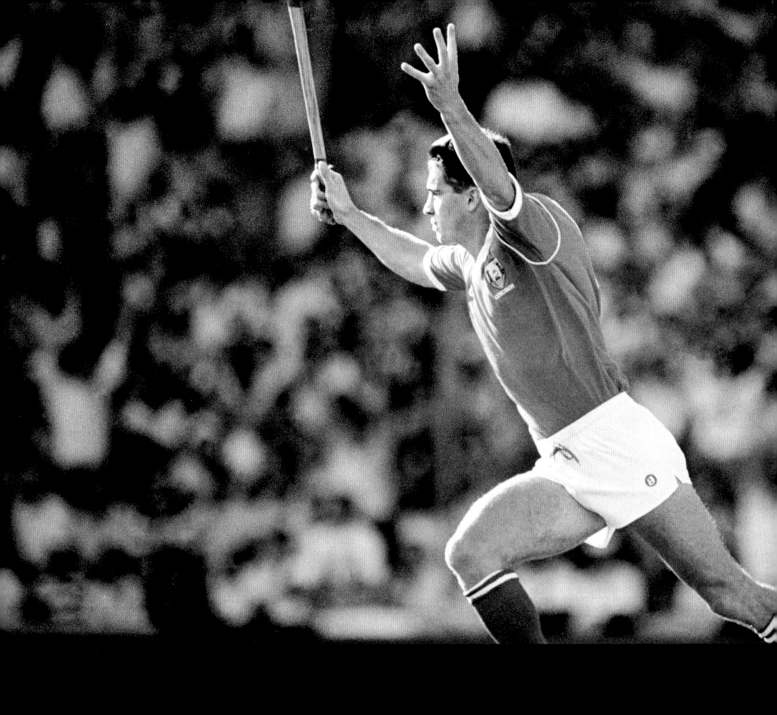

2 September 1990

John Fitzgibbon, Cork, celebrates. Cork, who hadn't made it to an All-Ireland Final since 1986, caused a massive upset to beat Galway, who were appearing in their fifth final in six years. All-Ireland Hurling Final, Croke Park, Dublin.

1990s

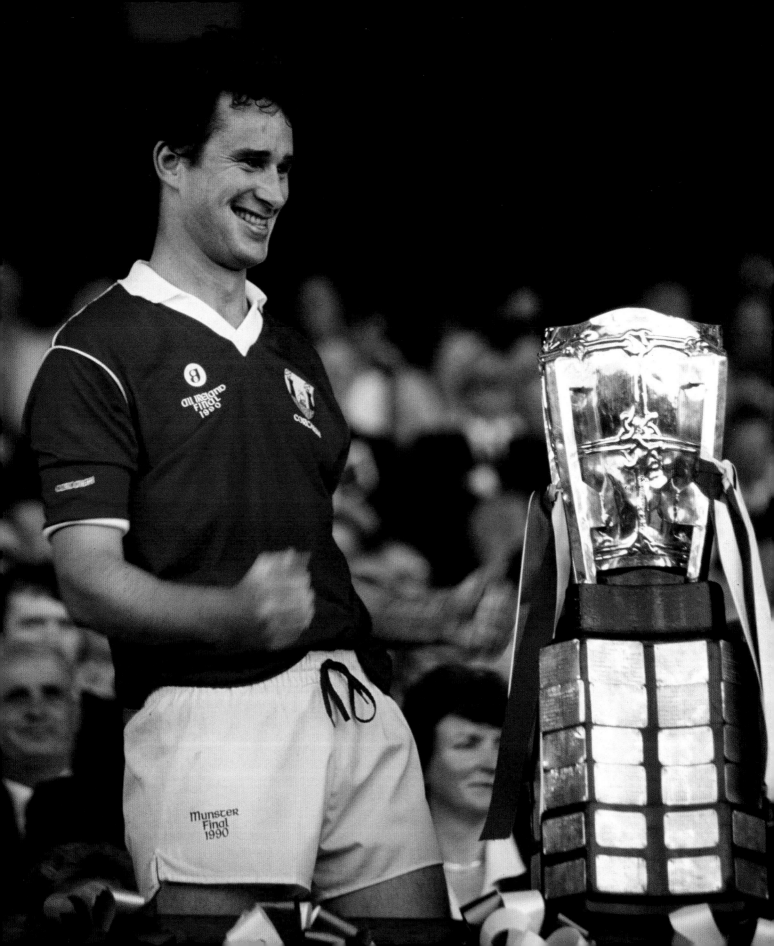

2 September 1990

Left: Cork captain Tomás Mulcahy, who hadn't featured at all in the previous season, prepares to lift the Liam MacCarthy cup. Cork v Galway, All-Ireland Hurling Final, Croke Park, Dublin.

Below: The Cork faithful lift the Liam MacCarthy cup for the first time since 1986, after a match that many regard as the best championship decider of the decade. All-Ireland Hurling Final, Croke Park, Dublin.

Ray McManus / SPORTSFILE

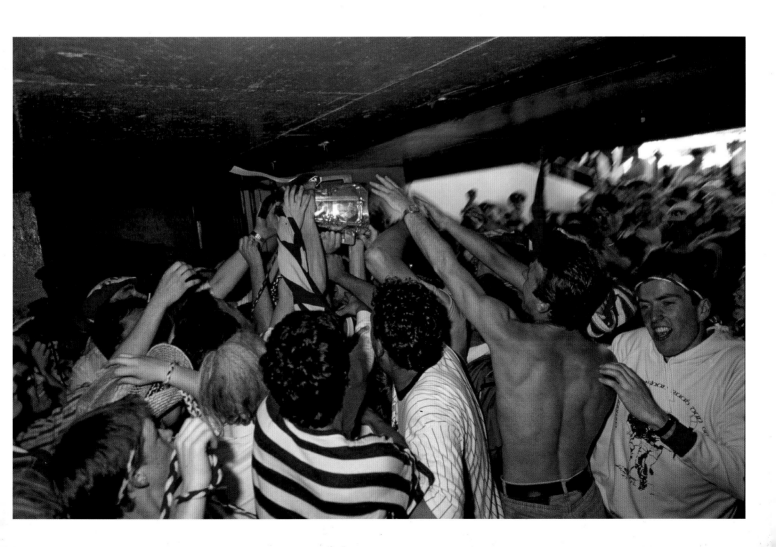

21 July 1991

Kilkenny goalkeeper Michael Walsh, who followed in his father Ollie's footsteps as Kilkenny goalkeeper, supported by team-mate John Henderson, clears under pressure from Brian McMahon, Dublin. The Cats held off the Dubs to win 1-11 – 1-13 Leinster Hurling Final, Croke Park, Dublin.

Connolly Collection / SPORTSFILE

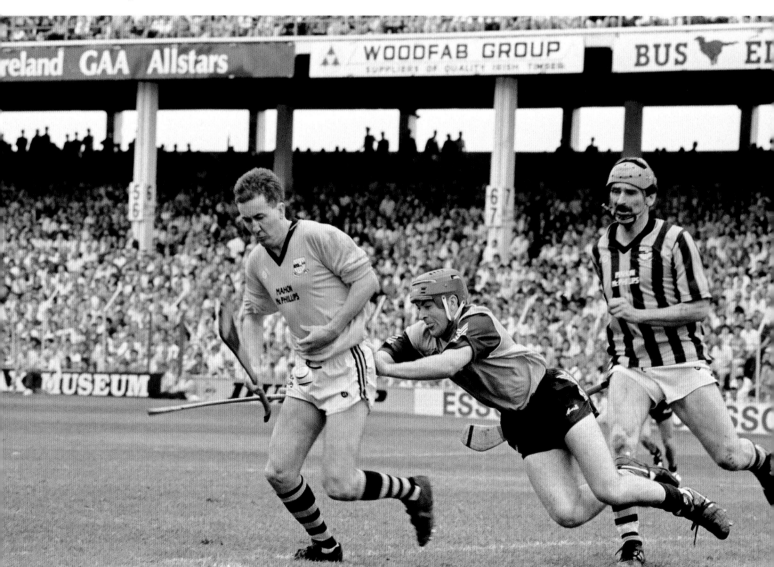

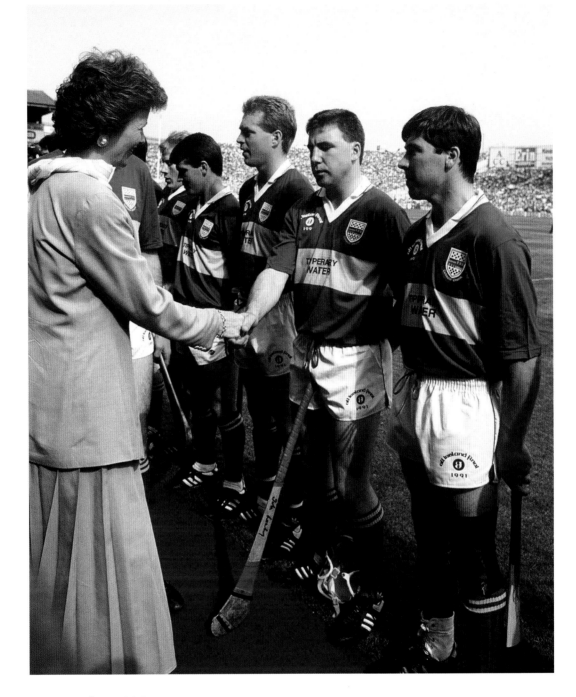

1 September 1991

President Mary Robinson shakes hands with
Tipperary forward John Leahy prior to the game.
All-Ireland Hurling Final, Tipperary v Kilkenny, Croke
Park, Dublin.

Ray McManus / SPORTSFILE

1 September 1991

Former Tipperary hurler and two-time All-Ireland winner Michael 'Babs' Keating guides his side to a second All-Ireland title under his managerial reign.

Ray McManus / SPORTSFILE

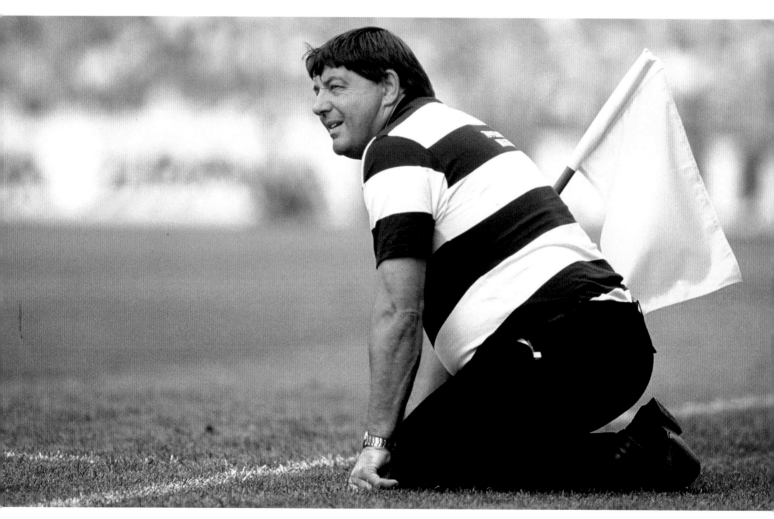

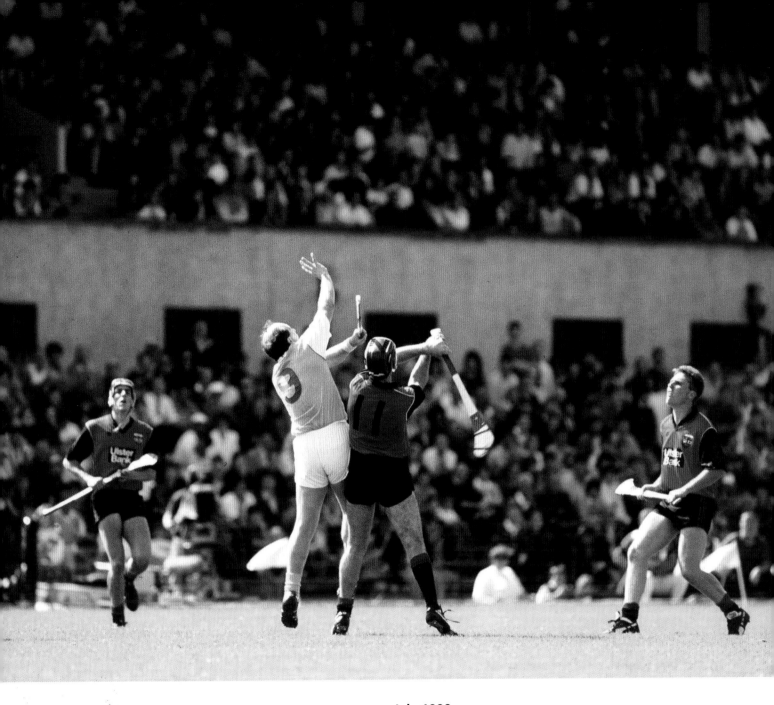

July 1992

At the Ulster Hurling Final, Down run out as comfortable 2-16 to 0-11 winners over Antrim in Casement Park, Belfast.

David Maher / SPORTSFILE.

5 September 1993

Eventual winners Kilkenny march behind the band during the pre-match build-up. The Cats would go on to win the game by an eight-point margin. All-Ireland Hurling Final, Galway v Kilkenny, Croke Park, Dublin.

Ray McManus / SPORTSFILE

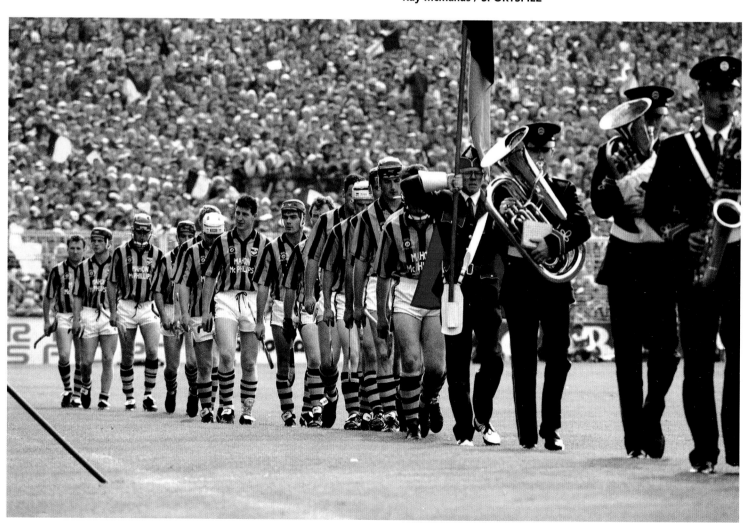

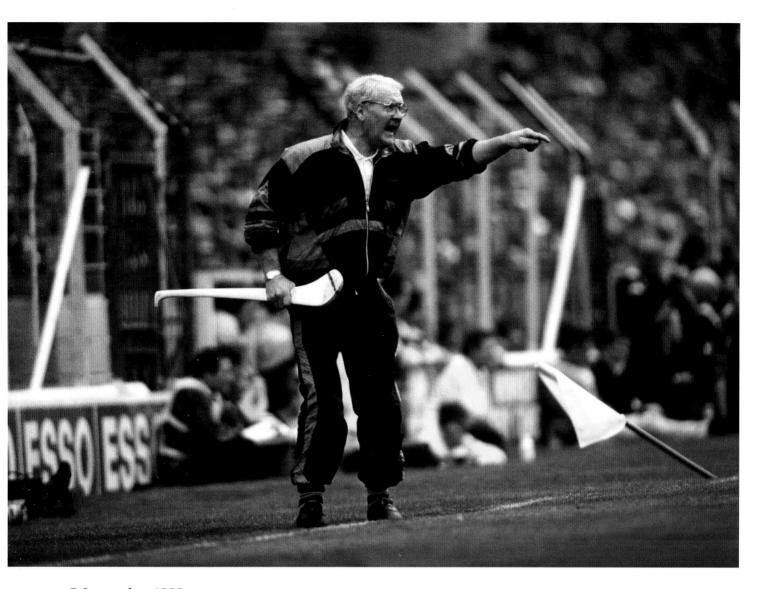

5 September 1993

Kilkenny manager Ollie Walsh keeps his hurl on
hand as he spurs his team on from the sidelines
in the 1993 All-Ireland Hurling Final, Kilkenny v
Galway, Croke Park.

Ray McManus / SPORTSFILE

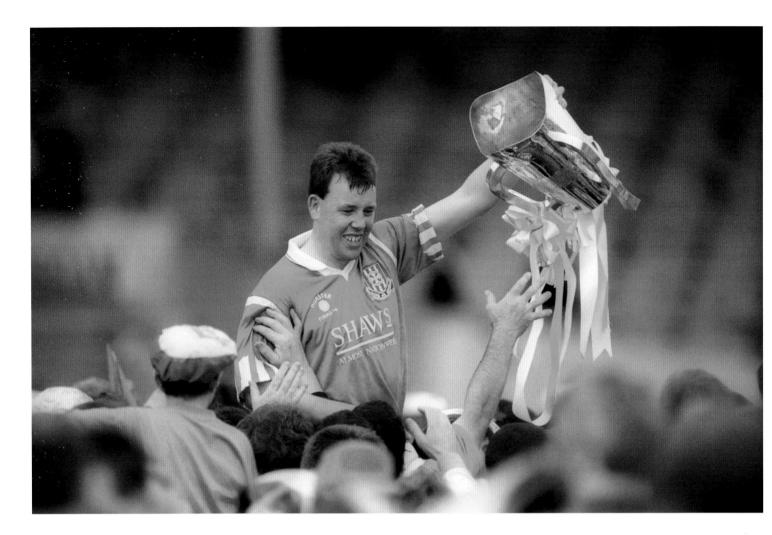

10 July 1994

Limerick captain Gary Kirby, who scored
nine points in this final, is held shoulder high
as he celebrates Limerick's 0-25 – 2-10 win
over Clare. Munster Senior Hurling Final,
Limerick v Clare, Semple Stadium, Thurles,
Co. Tipperary.

Ray McManus / SPORTSFILE

4 September 1994

Johnny Dooley, scorer of 1-4 in the 1994 final, takes the free that would result in a goal for the Offaly men. All-Ireland Hurling Final, Offaly v Limerick, Croke Park, Dublin.

Ray McManus / SPORTSFILE

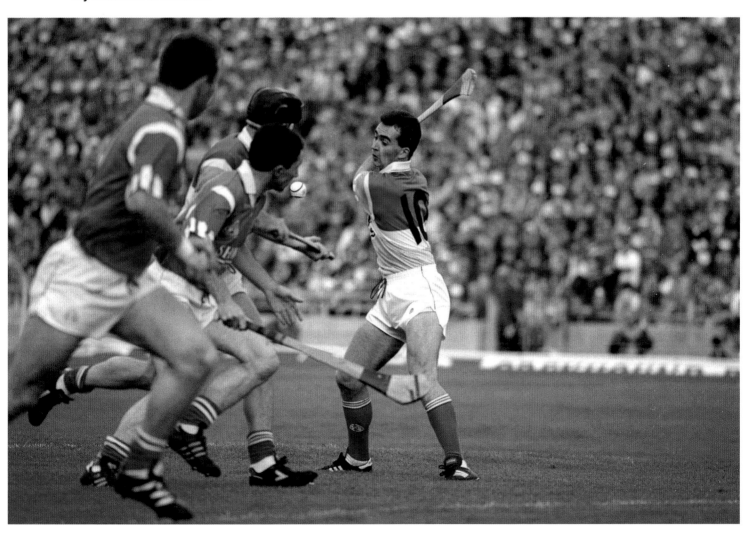

4 September 1994

Offaly men Johnny Pilkington and John Troy celebrate together after their side's impressive 3-16 to 2-13 victory over Munster champions Limerick. The match has been called the 'the five-minute final' because of Offaly's late surge – they scored 2-5 to win the game in the last five minutes. All-Ireland Hurling Final, Croke Park, Dublin.

SPORTSFILE

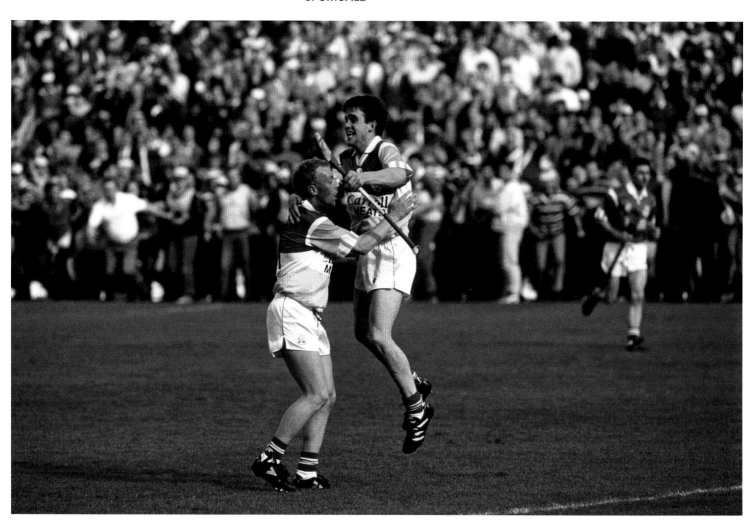

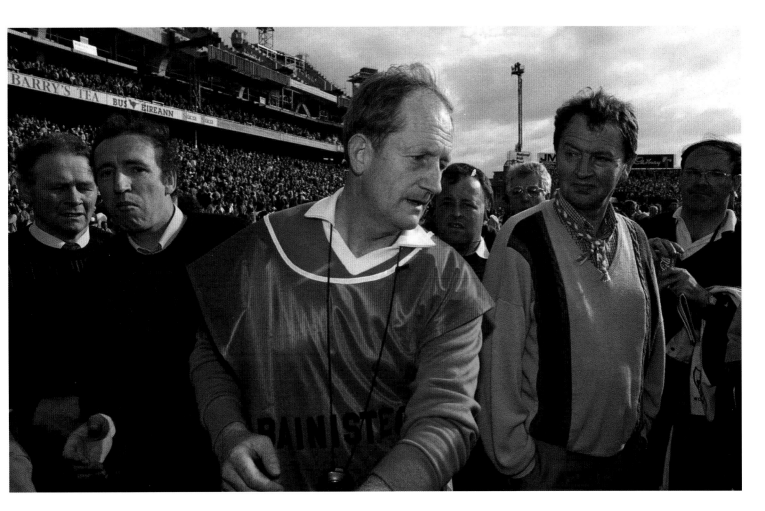

4 September 1994

Offaly Manager Eamonn Cregan, himself a former Limerick star, after the Faithful County had secured victory over Limerick in the 1994 All-Ireland Hurling Final in Croke Park.

Ray McManus / SPORTSFILE

3 September 1995

The Clare hurlers parade behind the Artane Senior Band, to the delight of their supporters in the Canal End, in the pre-match build up to this 1995 All-Ireland Hurling Final, Clare v Offaly, in Croke Park.

David Maher / SPORTSFILE

4 September 1994

Offaly supporters occupy Hill 16. 'Yaba Daba Dooley' (a play on the classic Fred Flintstone catchphrase) was aimed at the heroics of the Dooley brothers – Johnny, Joe and Billy – who formed the backbone of the Offaly hurling team.

Ray McManus / SPORTSFILE

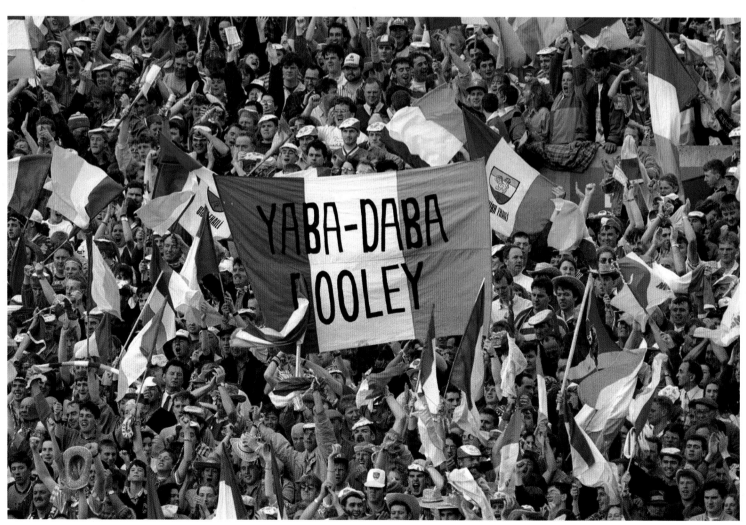

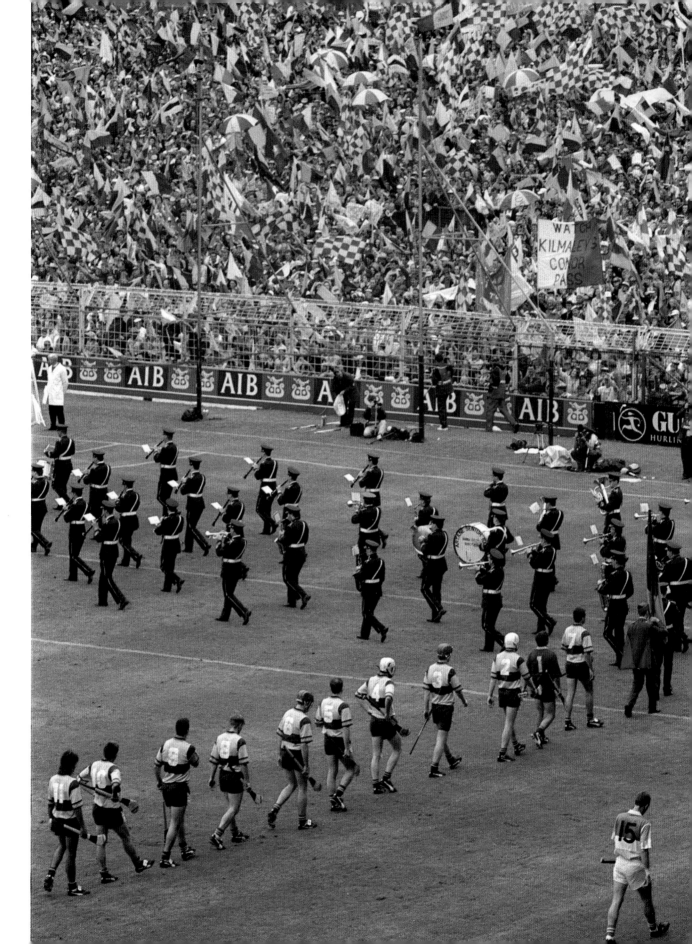

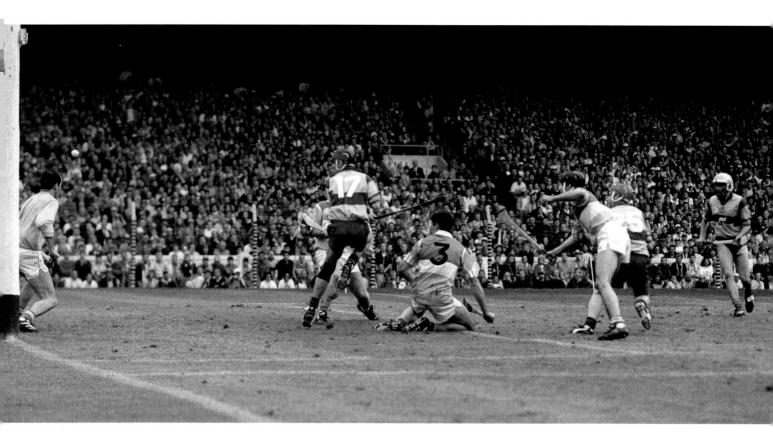

3 September 1995

Clare substitute Éamonn Taaffe makes an impact off the bench by scoring his side's first goal, beating David Hughes in the Offaly net. All-Ireland Hurling Final, Clare v Offaly, Croke Park, Dublin.

Picture Credit: Ray McManus / SPORTSFILE

3 September 1995

Clare goalkeeper Davy Fitzgerald celebrates ecstatically as his side clinch victory over Offaly on a scoreline of 1-13 to 2-8.

Picture Credit: David Maher / SPORTSFILE

3 September 1995.

Clare manager Ger Loughnane holds the Liam MacCarthy Cup. This was the county's first Senior All-Ireland Hurling title in eighty-one years. Clare v Offaly, All-Ireland Hurling Final, Croke Park, Dublin.

Ray McManus / SPORTSFILE

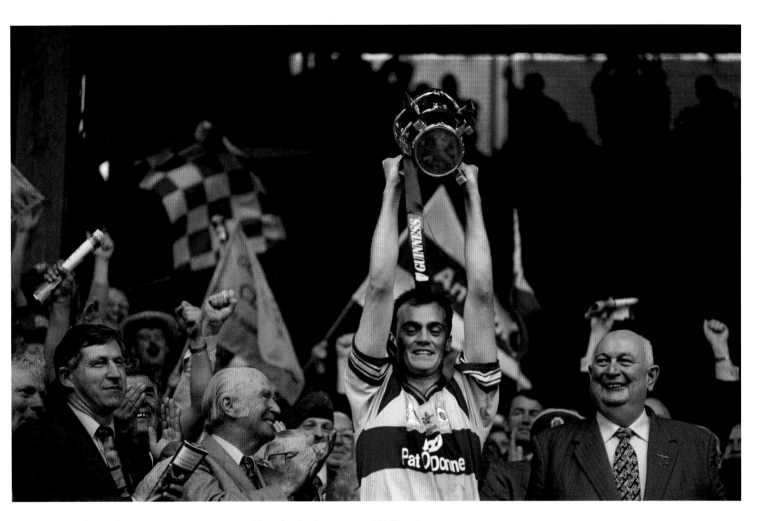

'There's been a missing person in Clare for 81 long years. Well today, that person has been found alive and well, and that person's name in Liam MacCarthy. We have listened to many, many jibes down through the years. We were told to stick to our traditional music, well in Clare, we love our traditional music, but we love our hurling as well. Many people are due many thanks ... first and foremost ... the many great teams down through the years ... many of those teams were better than this Clare team, but they were never as fortunate as we were. Now we accept this Liam MacCarthy Cup on behalf of all those teams who ever wore the Clare jersey ... And finally ... a man who gave every last drop of sweat and blood he had, the great Ger Loughnane ... It's going to be one hell of a week, and we look forward to seeing you all in Ennis tomorrow night.'

Anthony Daly's acceptance speech

3 September 1995
Clare captain Anthony Daly lifts the Liam MacCarthy Cup alongside, from left, Liam Mulvihill, Director General of the GAA, The former President of Ireland and Clare native, Dr Patrick Hillery, and GAA President Jack Boothman.
SPORTSFILE

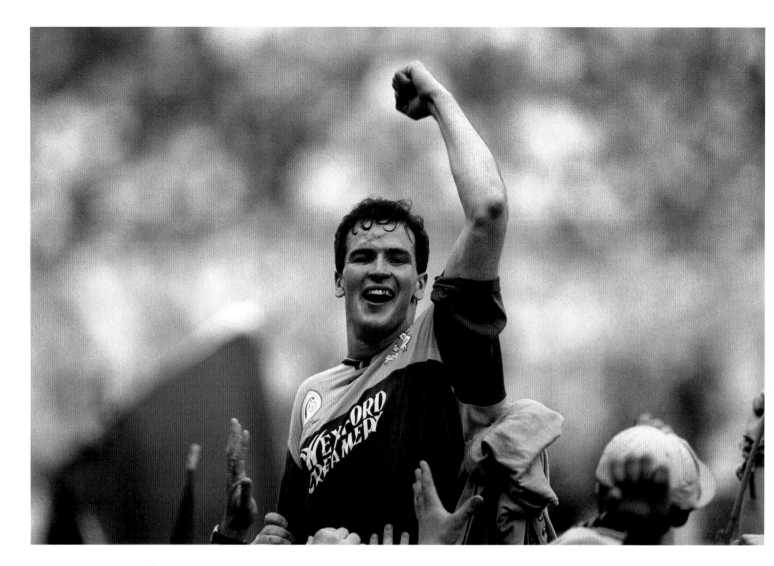

1 September 1996

Adrian Fenlon celebrates as the fourteen
men of Wexford withstand their Munster
opposition to claim All-Ireland glory.
Wexford supporters were 'Dancing at the
Crossroads' in 1996, as the county won
their first All-Ireland title since 1968, by
beating Limerick, 1-13 to 0-14. All-Ireland
Hurling Final, Wexford v Limerick.

Ray McManus / SPORTSFILE.

1 September 1996

Wexford boss Liam Griffin, who would step
down as manager at the beginning of the 1997
campaign, celebrates a historic All-Ireland title
win for the Leinster side.

David Maher / SPORTSFILE

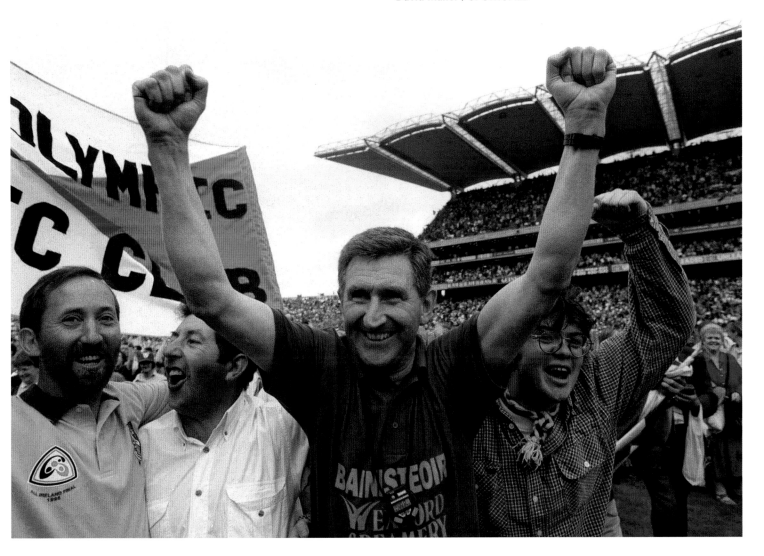

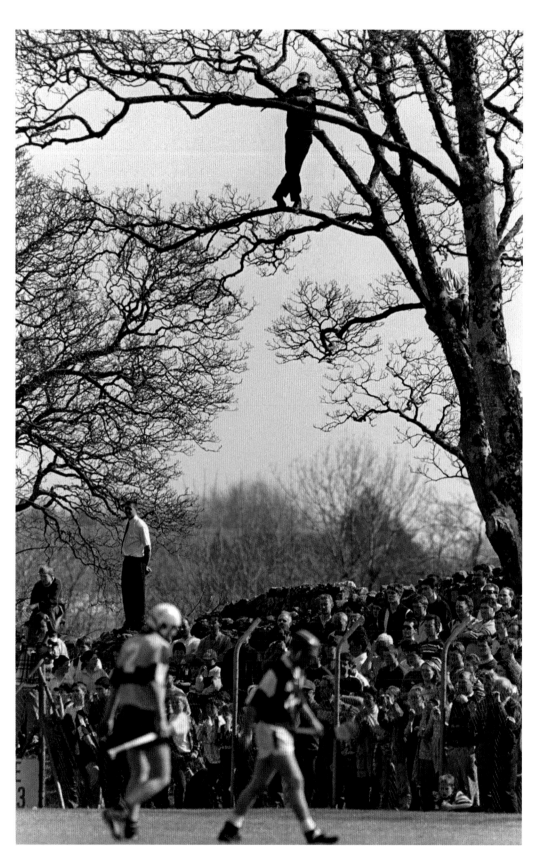

13 April 1997

A truly dedicated supporter watches from afar in this National Hurling League tie between Clare and Galway. Church and General National Hurling League, Athenry, Co. Galway.

David Maher / SPORTSFILE

8 June 1997

Steven McDonagh of Clare drills the ball past Ger Cunningham in the Cork net to grab the decisive goal and send Clare into the Munster Championship Final. Munster Hurling Semi-Final, Gaelic Grounds, Limerick.

Ray McManus / SPORTSFILE

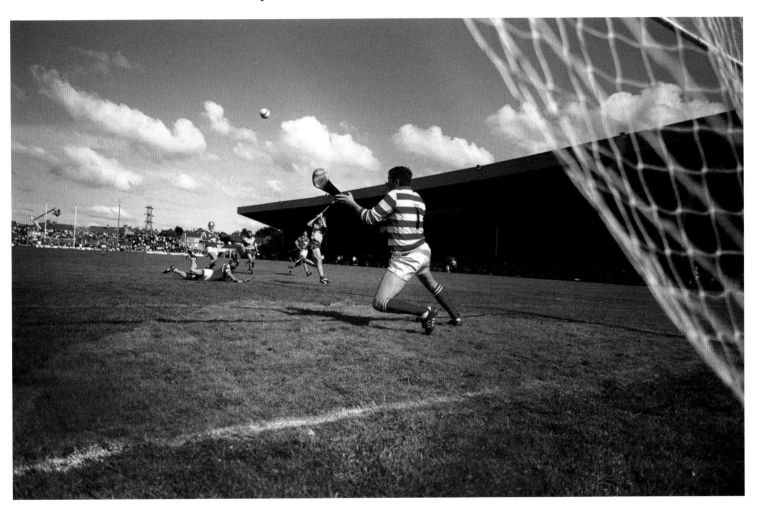

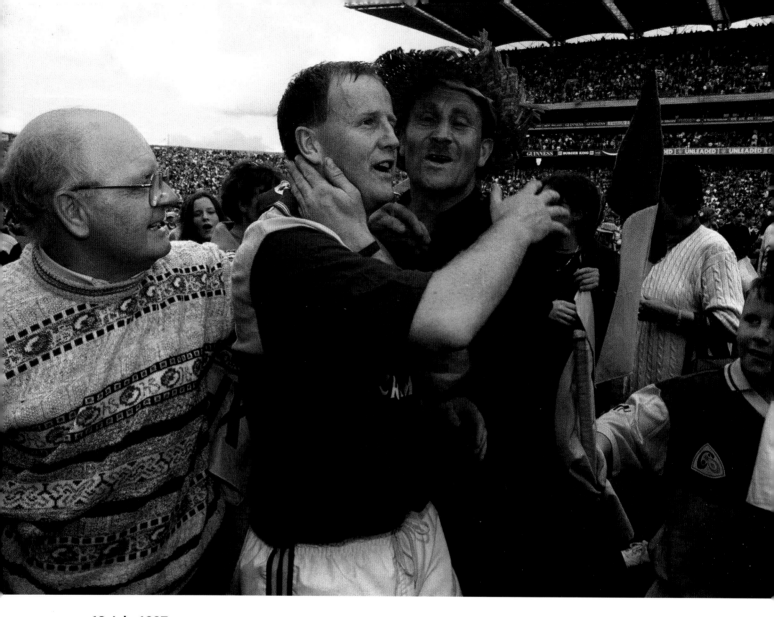

13 July 1997

Wexford's Tom Dempsey is congratulated by fans after their victory

over Kilkenny, Leinster Hurling Final.

Brendan Moran / SPORTSFILE.

17 August 1997

Opposite: The Wexford hurlers march in front of Hill 16,

which their supporters have transformed into a sea of

purple and gold. Tipperary v Wexford, All-Ireland Hurling

semi-final, Croke Park, Dublin.

Matt Browne / SPORTSFILE

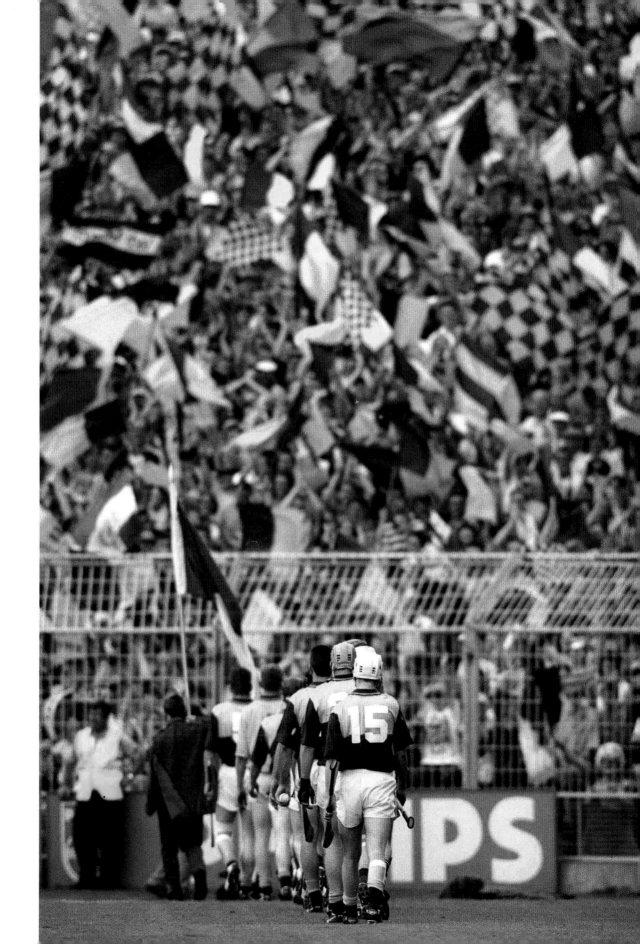

17 August 1997

Wexford's John O'Connor stays strong despite the best efforts of Liam Cahill and Brian O'Meara of Tipperary. All-Ireland Hurling semi-final, Croke Park, Dublin.

David Maher / SPORTSFILE

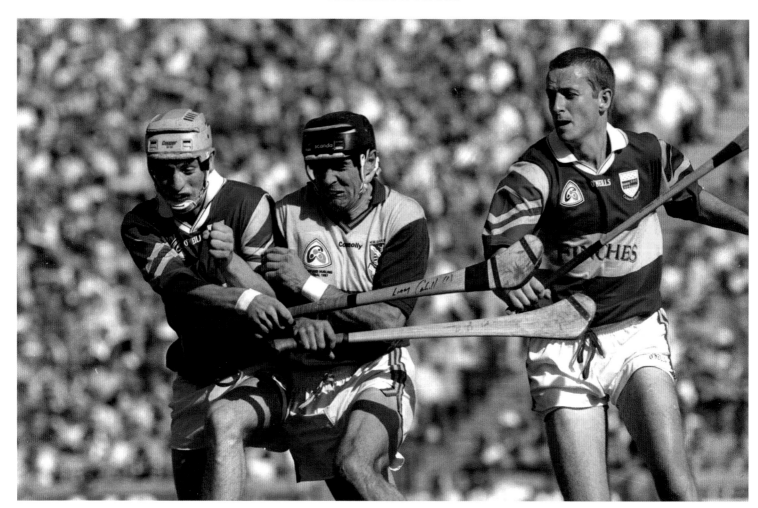

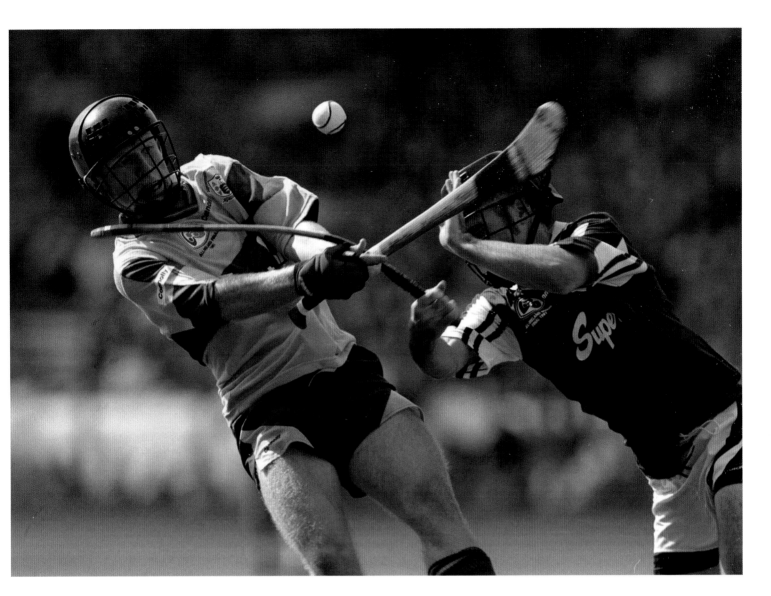

14 September 1997

Galway's Joe Hession shows he's willing to risk breaking his hurl in an attempt to win possession from Donal Madden of Clare in the 1997 All-Ireland Minor Hurling Final.

Matt Browne / SPORTSFILE.

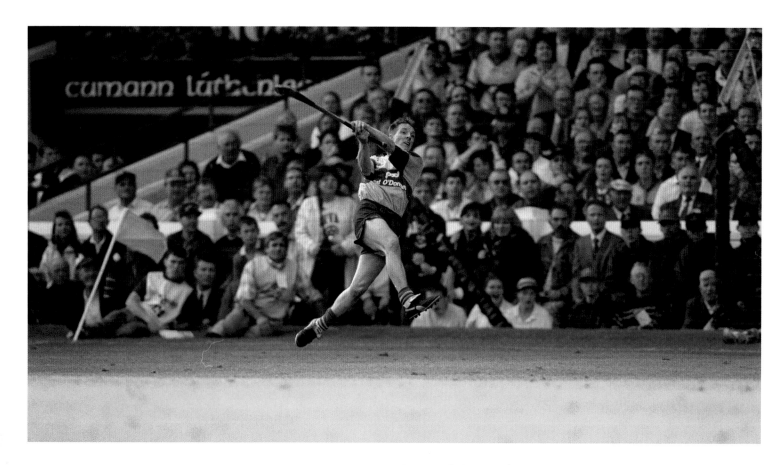

14 September 1997

Jamesie O'Connor, along with the Clare faithful, watches as his shot sails over the bar for the winning point in the 1997 All-Ireland Hurling Final, Croke Park, Dublin.

Ray McManus / SPORTSFILE.

Jamesie O'Connor's late point secured Clare's second All-Ireland in three years. A couple of minutes earlier, Tipperary had scored a goal which put them a point head going into the closing minutes of the game. Ollie Baker levelled the game, before O'Connor found himself in space 50 metres out in front of the Hogan Stand. I was sitting in my usual spot at the corner of the Cusack Stand and Hill16. This picture breaks one of our most important rules, 'No ball, no picture', but it was such an important score, where you see one of the greats along with supporters in the Hogan Stand watch an All-Ireland winning point sail between the posts, I was happy to make an exception.

Ray McManus, photographer

14 September 1997

Anthony Daly's wife, Eilís, watches as her side beats Tipperary 0-20 to 2-13 in the All-Ireland Hurling Final, Clare v Tipperary, Croke Park, Dublin.

Matt Browne / SPORTSFILE

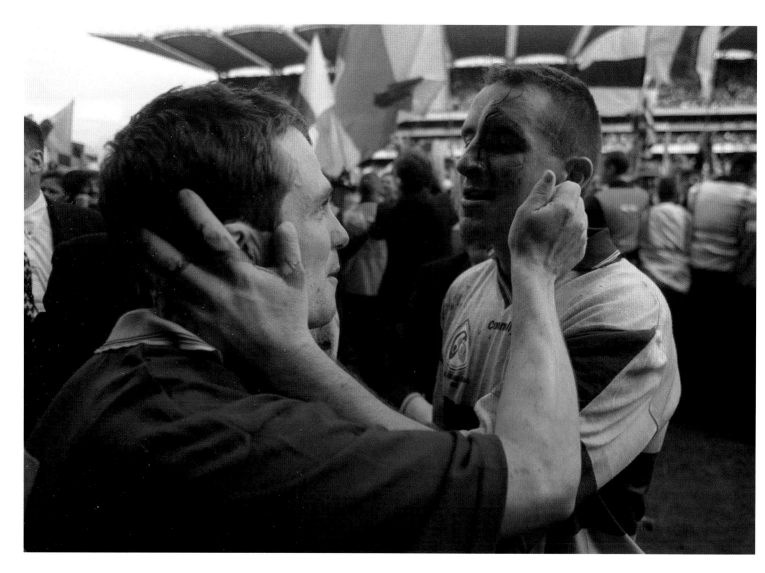

14 September 1997

Goalkeeper Davy Fitzgerald celebrates with a bruised
and beaten Colin Lynch after their All-Ireland Final victory.
Fitzgerald pulled off a heroic last-gasp save to secure the
win for the Banner County. All-Ireland Hurling Final, Clare v
Tipperary, Croke Park, Dublin.

David Maher / SPORTSFILE

7 June 1998

Waterford players Stephen Frampton, left, and Billy O'Sullivan try to catch their breath after a Munster Hurling championship win over Tipperary, on a scoreline of 0-21 to 2-12 at Páirc Uí Chaoímh.

Ray McManus / SPORTSFILE

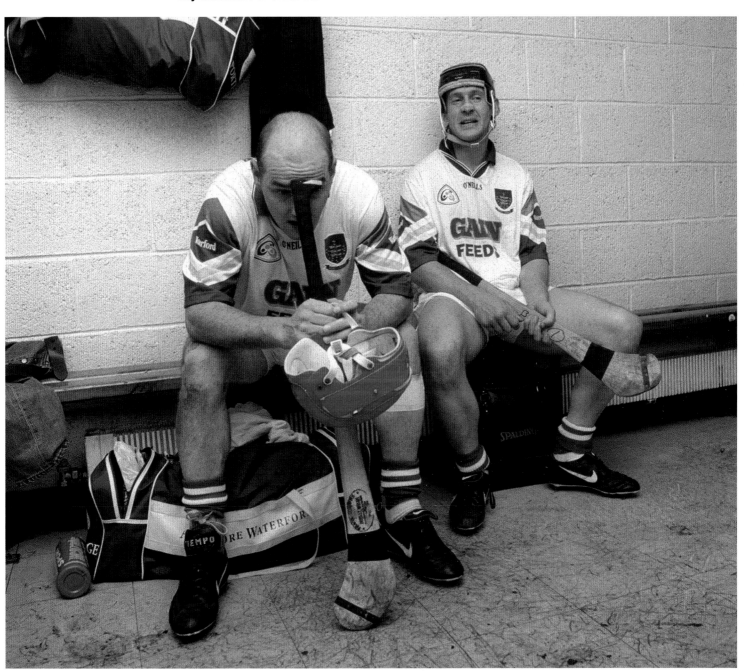

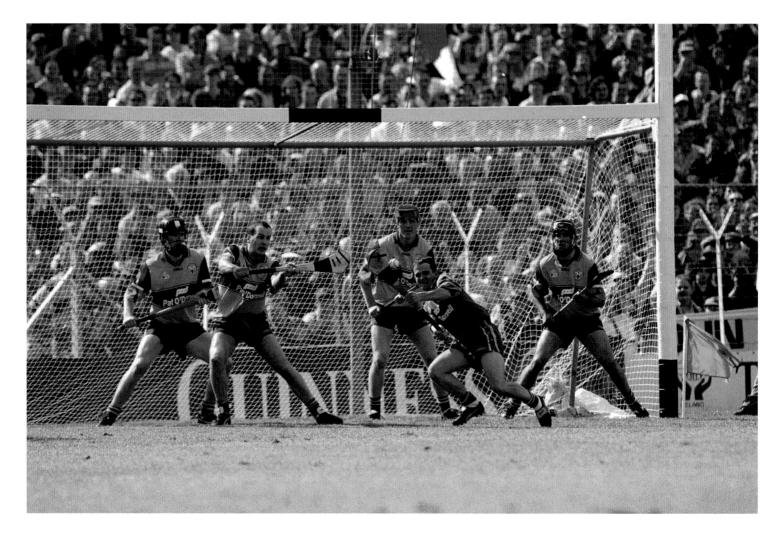

21 June 1998

Clare goalkeeper Davy Fitzgerald makes
a great save in the dying minutes of the
match to secure a spot in the Munster
Hurling Championship Final, Thurles.

Ray McManus / SPORTSFILE

5 July 1998

A dejected Darren Hannify of Offaly collapses to the floor after his side's defeat at the hands of Kilkenny in the Leinster Final. Offaly would gain their revenge in September, by coming through the 'back-door' and defeating The Cats. Croke Park, Dublin.

Ray Lohan / SPORTSFILE

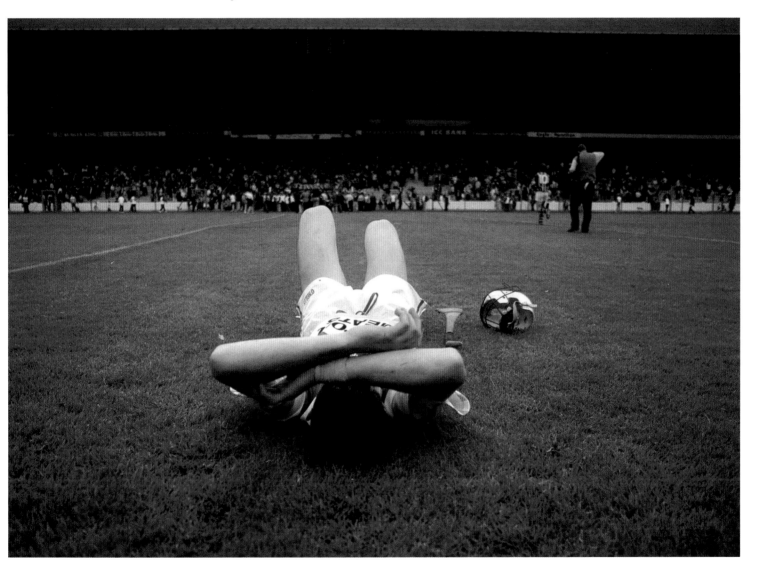

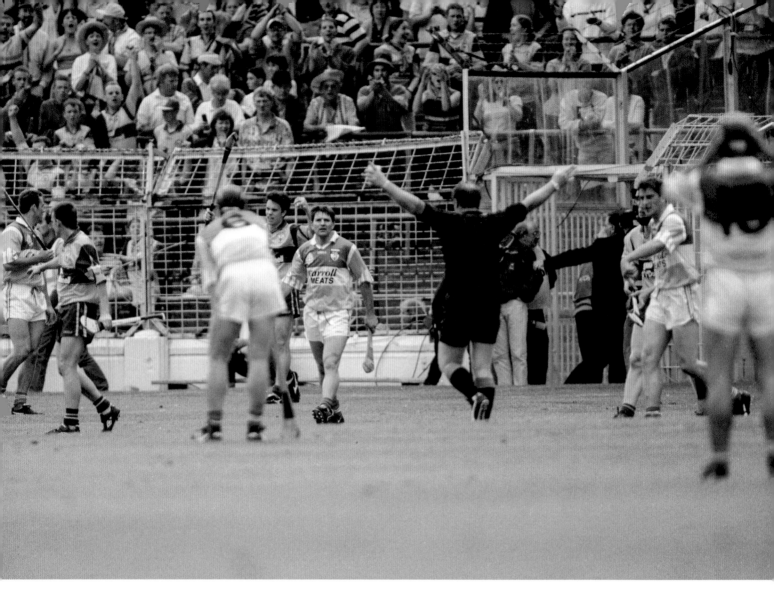

22 August 1998

Referee Jimmy Cooney blows the full-time whistle near the end of the match at the All-Ireland Hurling Semi-final. With 2 minutes to play, Clare led by 3 points, when Cooney blew the whistle. After protests from the Offaly supporters, a replay was arranged for Thurles, which Offaly went on to win.

Ray McManus/SPORTSFILE

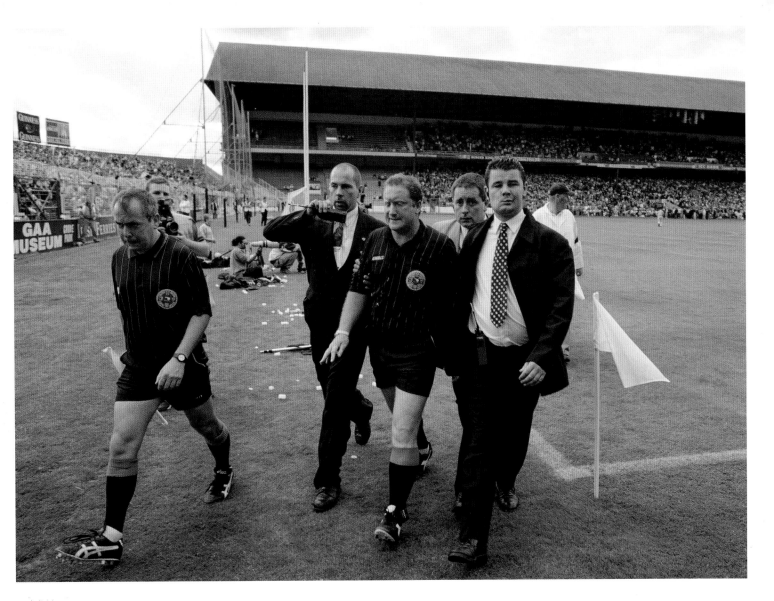

22 August 1998

Referee Jimmy Cooney and one of his linesmen, Aodán Mac Suibhne, left, are escorted off the pitch by Croke Park security after the game.

David Maher / SPORTSFILE

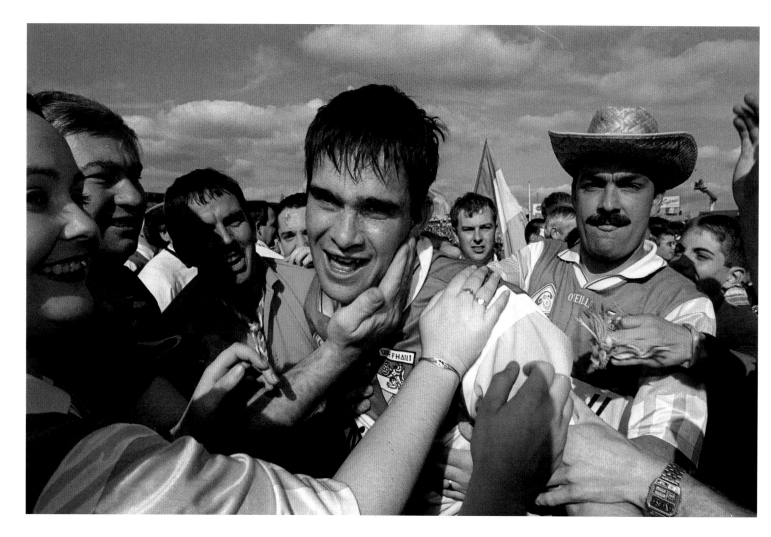

29 August 1998

Offaly's Johnny Pilkington is is congratulated by fans after his team's victory over Clare. All-Ireland Hurling Semi-final, Semple Stadium, Thurles.

Brendan Moran / SPORTSFILE

13 September 1998

Offaly player Brian Whelahan celebrates his goal – which set his side on its way to eventual All-Ireland victory – with teammate Joe Errity. Whelahan played most of his career at wing-back; he was selected in this position on the GAA Team of the Millenium, but suffering from the flu for this game, the management moved him up to the forwards, he scored the goal, got Man of the Match and Offaly would record a famous victory. Offaly v Kilkenny, All-Ireland Hurling Final, Croke Park.

Ray McManus / SPORTSFILE

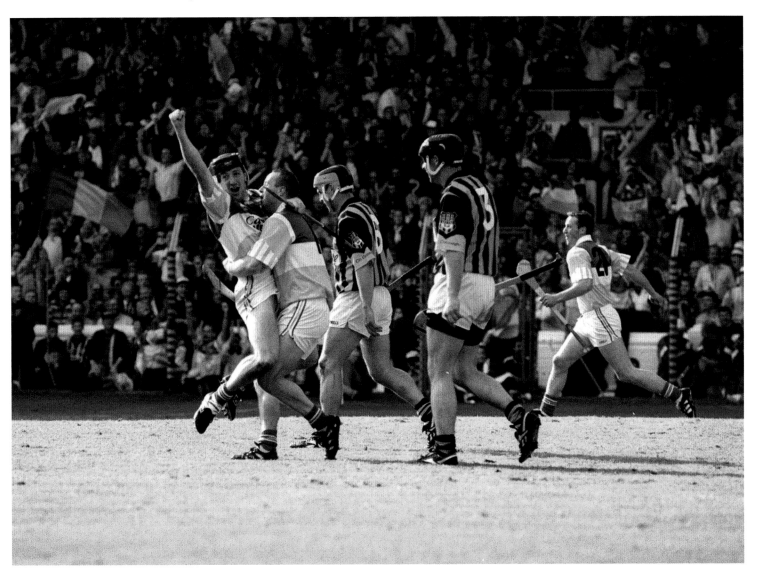

I have vivid memories of the build-up to this game; like every year, I remember the rush and scramble to get All-Ireland tickets. I attended with my parents, uncle, aunt and two cousins, Mick and Stephen. Mick, who passed away in September 2008 of a severe heart ailment, was a mammoth Offaly supporter and well known in GAA circles nationwide. My biggest memory of 98 was after the presentation of trophy when the team where brought to a room under the old Hogan Stand for interviews and for crowds to disperse. Kevin Martin, who played wing back, insisted on bringing Mick to the room with him, so Stephen and I were allowed follow. I remember the celebrations in the room, shaking hands with the millennium man Brian Whelahan, who because of illness played at full forward and scored 1-6. Offaly had a special team in 90's and hopefully there are more days like this are not so far away.

Aidan Kidney, Offaly supporter

13 September 1998
Young Offaly supporters, Stephen & Aidan Kidney, from Tullamore celebrate the Leinster outfit's 2-16 to 1-16 win over Kilkenny. All-Ireland Hurling Final, Croke Park, Dublin.

David Maher / SPORTSFILE

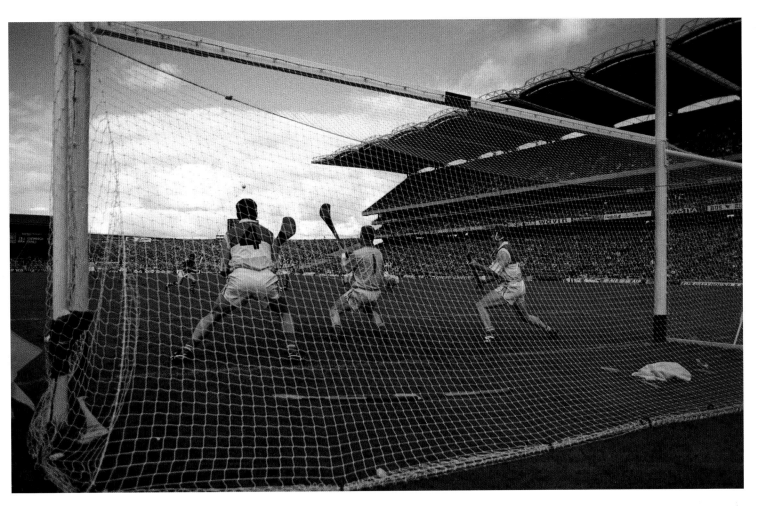

13 September 1998

Offaly goalkeeper Stephen Byrne, along with Brian Whelehan and Martin Hanamy, 4, are powerless to stop DJ Carey of Kilkenny's penalty sailing over the bar. All-Ireland Hurling Final, Croke Park.

Brendan Moran / SPORTSFILE

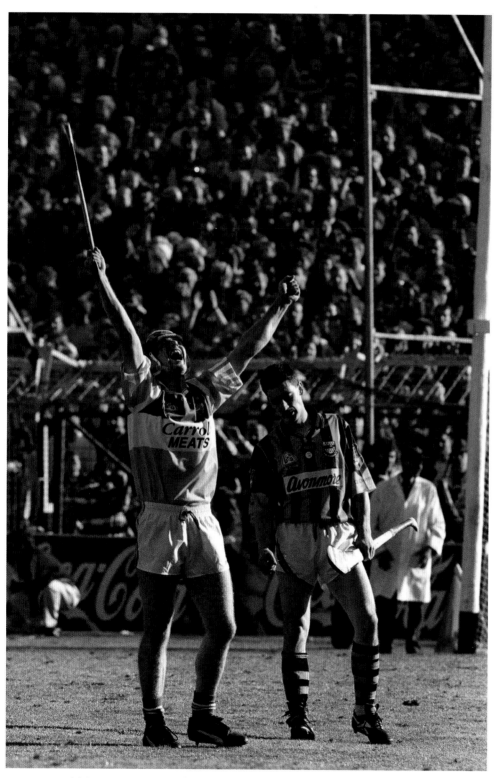

13 September 1998
Offaly captain Hubert Rigney demonstrates the stark contrast between winning and losing as he stands next to Kilkenny's Sean Ryan after Offaly's 1998 All-Ireland win. All-Ireland Hurling Final, Croke Park, Dublin.

David Maher / SPORTSFILE

13 March 1999

Nickie Quaid, son of Limerick's
Tommy Quaid, keeps goal for the Irish
Under-12 team in challenge match
between the shinty-playing boys of
Scotland and the hurling-playing boys
of Ireland, Bught Park, Inverness.

Ray McManus / SPORTSFILE

2 May 1999

Frank Hogan in attendance at the National Hurling League Semi-final between Galway and Kilkenny in Limerick. Frank has been displaying this sign at various Gaelic Games stadiums across the country for decades now. John 3:7 is a verse from the Gospel of John which says, 'Do not marvel that I said to you, you must be born again'. Frank has become a cult hero in the GAA over the last number of years and he, and his sign, are present at many a GAA game.

Damien Eagers / SPORTSFILE

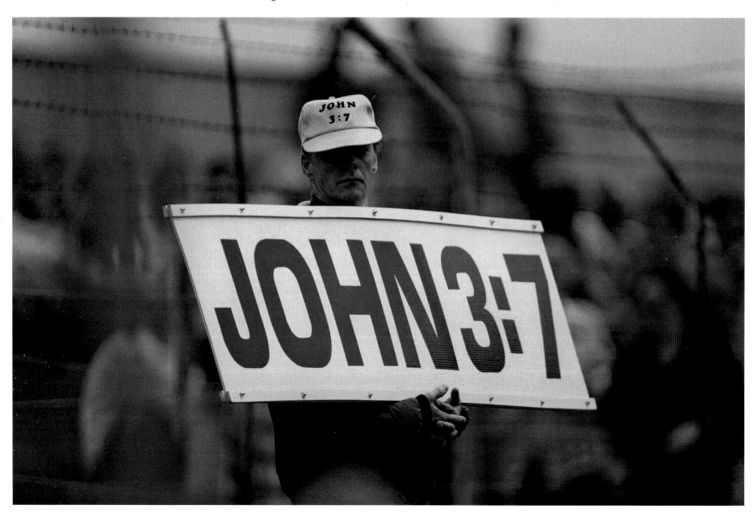

4 July 1999

Three-time All-Star Seán Óg Ó hAilpín battles against Enda Flannery of Clare in a heated Munster Hurling Final in 1999. Cork v Clare, Munster Senior Hurling Final, Semple Stadium, Thurles.

Damien Eagers / SPORTSFILE

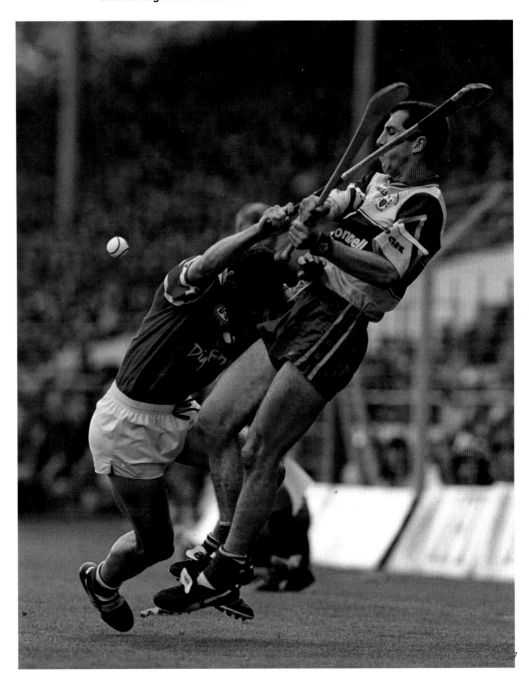

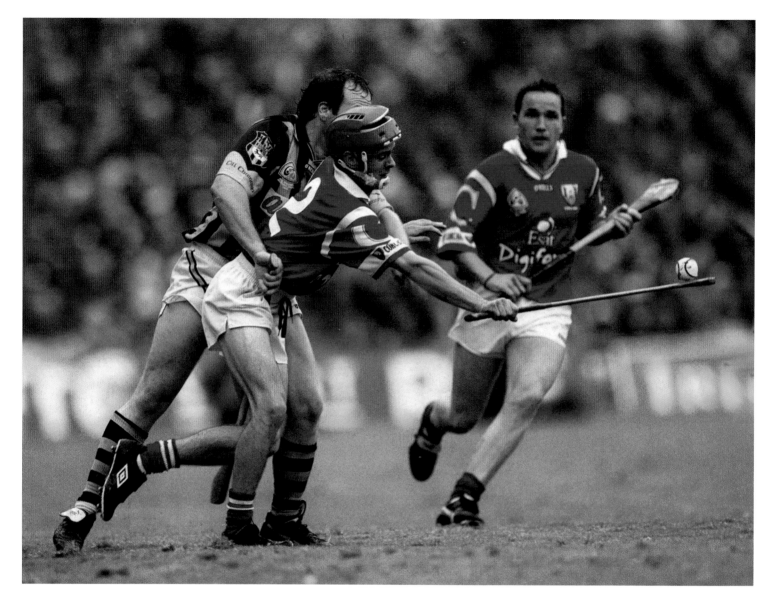

12 September 1999

Cork's Sean McGrath attempts to maintain possession despite the strength and persistence of Willie O'Connor of Kilkenny in the 1999 All-Ireland Final. After a decade which saw Offaly, Clare and Wexford arrive at the top table of hurling elite, the final final of the 1990s reverted to the traditional powers of Cork and Kilkenny. Cork would gain the upper hand over their fierce rivals on a wet day, on a scoreline of 0-13 to 0-12. All-Ireland Hurling Final, Croke Park, Dublin.

Ray McManus / SPORTSFILE

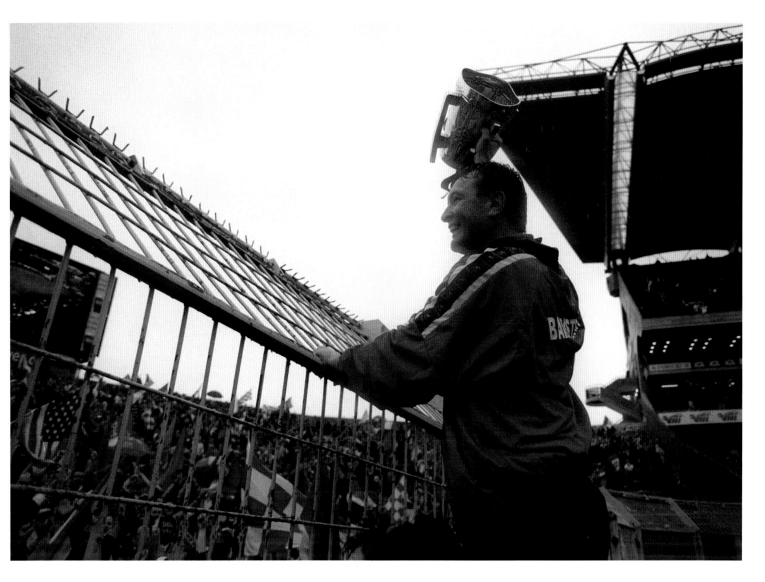

12 September 1999

Cork manager Jimmy Barry Murphy holds the Liam
MacCarthy Cup aloft in front of the Cork faithful after
their All-Ireland Final victory over Kilkenny, Croke Park,
Dublin.

David Maher / SPORTSFILE

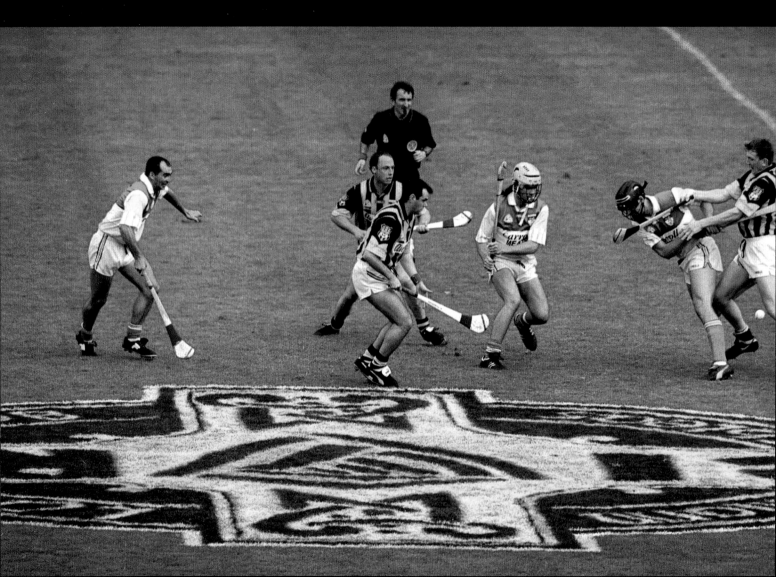

1 September 2000

From left, Johnny Dooley, Offaly, Brian McEvoy and Andy
Comerford, Kilkenny, Ger Oakley (yellow helmet), Offaly, Gary
Hanniffy, Offaly and Eamon Kennedy battle it out in the middle of
the park during Kilkenny's eventual 5-15 – 1-14 trouncing of Offaly
in the 2000 All-Ireland Final, Croke Park, Dublin.

Damien Eagers / SPORTSFILE

2000s

6 August 2000

Offaly's Brian and Simon Whelahan combine to pressurise Ben O'Connor of Cork into losing possession in this All-Ireland Semi-Final. A game which Offaly would go on to win 0-19 – 0-15 in Croke Park, Dublin.

Ray McManus / SPORTSFILE

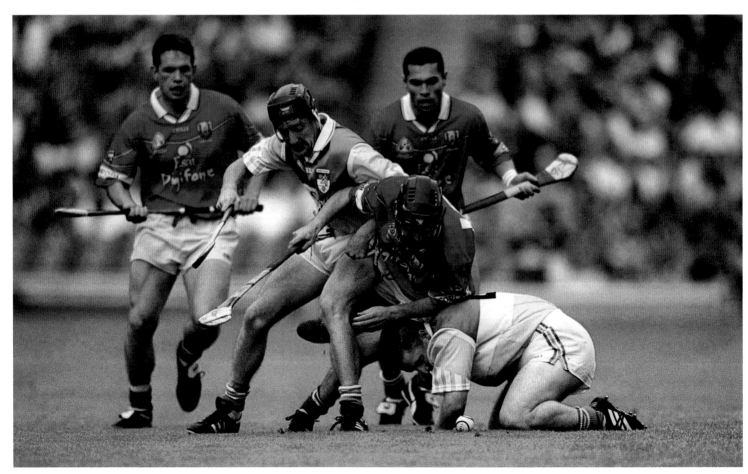

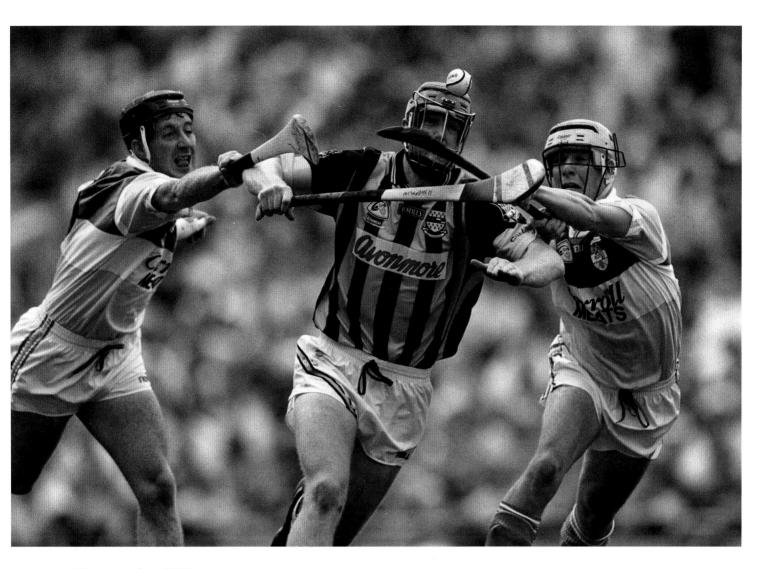

10 September 2000

Henry Shefflin evades the tackles of Brian Whelahan, left, and Niall Claffey in a game which saw the Kilkenny legend score an impressive 2-2. This final was the first of Shefflin's record-breaking 11 titles won with the black and amber. Kilkenny v Offaly, All-Ireland Hurling Final, Croke Park, Dublin.

Ray McManus / SPORTSFILE

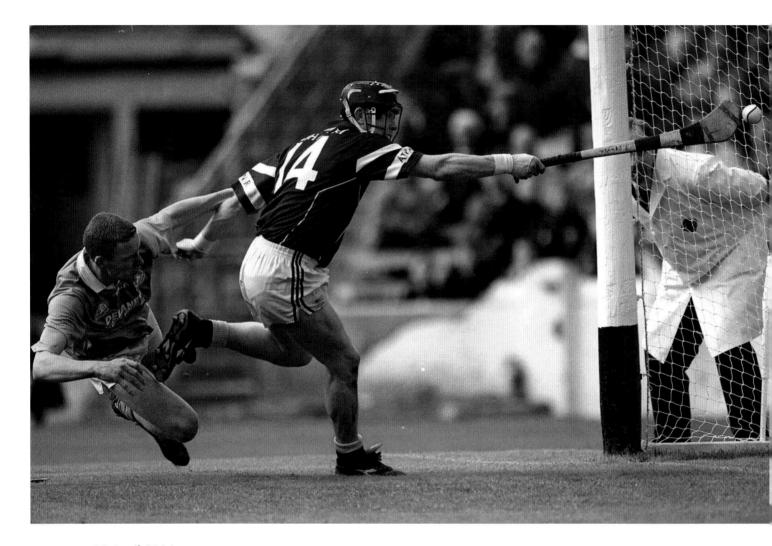

16 April 2001

The ultimate insult – Eugene Cloonan of Athenry scores a last-gasp goal in the All-Ireland Club Hurling Final using the hurl of the man who was marking him. This goal sent the game into extra-time. Athenry went on to win the game 3-24 – 2-19. St Mary's Athenry v Graigue Ballycallan, Croke Park, Dublin.

Ray McManus / SPORTSFILE

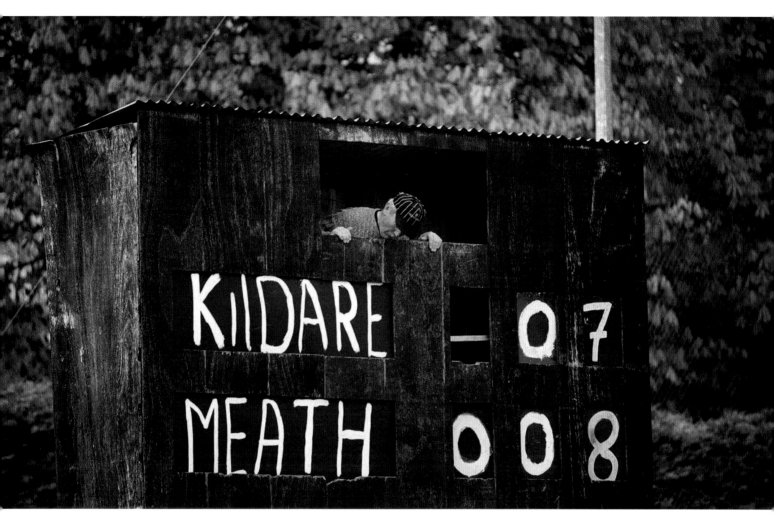

29 April 2001

The scorekeeper adjusts the scoreboard before the Kildare v Meath, Leinster Hurling Championship, Preliminary Round in Clane. A game that would keep him busy as the final score was 2-24 – 2-25 to Meath after extra time. Meath's Leinster Championship dreams would end in the next round at the hands of Laois.

Aoife Rice / SPORTSFILE

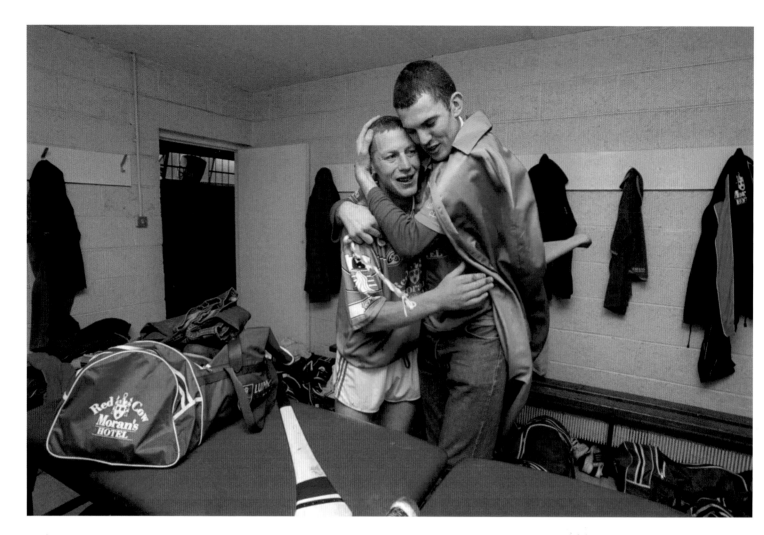

27 May 2001

Limerick centre back Ciarán Carey is embraced by
supporter Eoghan Murphy in the changing rooms after a
1-16 - 1-15 win over Cork at Páirc Uí Chaoimh. Munster
Hurling Championship.

Ray McManus / SPORTSFILE

Opposite: 3 June 2001

Tipperary manager Nicky English
celebrates at the final whistle after his
side's victory over Clare. Munster Hurling
Championship, Páirc Uí Chaoimh, Cork.

Brendan Moran / SPORTSFILE

It might just be that the shadow was a burden jumping off my shoulder! This was at the end of a huge game against Clare in the Munster semi-final 2001. We went through the league unbeaten, but I knew the season-defining game would be against Clare in Páirc Uí Chaoimh. No back door in 2001 either, so it was all or nothing.

The Tipp team had developed and been through a lot over the previous two years, but didn't have the experience or indeed success of the Clare players who had been the dominant hurling team of the mid to late 90s.

It was a huge game played in a full house with as passionate an atmosphere as I remember at a Tipp game. We had two new exciting players making their championship debuts that day: Eoin Kelly and Lar Corbett. I vividly remember Eoin Kelly's welcome to the Munster championship, when a challenge from Seanie McMahon and Ollie Baker nearly blew him out over the stand. It was a great testament to his future potential that he nailed a difficult free very shortly afterwards.

Our fortunes swung up and down through the game. Bringing on John Leahy midway through the second half was playing my trump card at the vital time, but bringing him off badly injured after his first challenge two minutes later felt as though this might not be our day after all .

At the end of a seriously intense and exciting battle we held on grimly to win by a point. It was easy to jump and lose that shadow as the summer lay ahead!

Nicky English

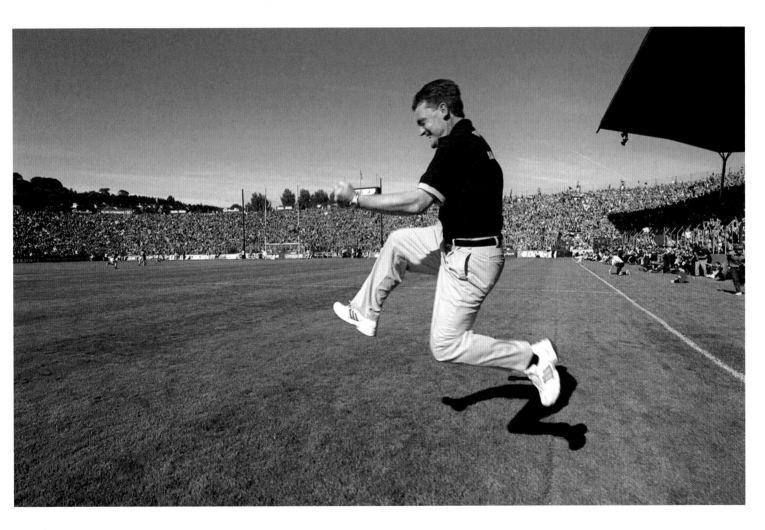

15 July 2001

Odhran McKeever plays hurling
before his dad, Kieran, lined
out for Derry in the Ulster
Final against Down. Kieran and
his Derry team mates went
on to win by a single point,
but were knocked out of the
Championship at the quarter
final stage. Ulster Hurling Final,
Casement Park, Belfast.

Aoife Rice / SPORTSFILE

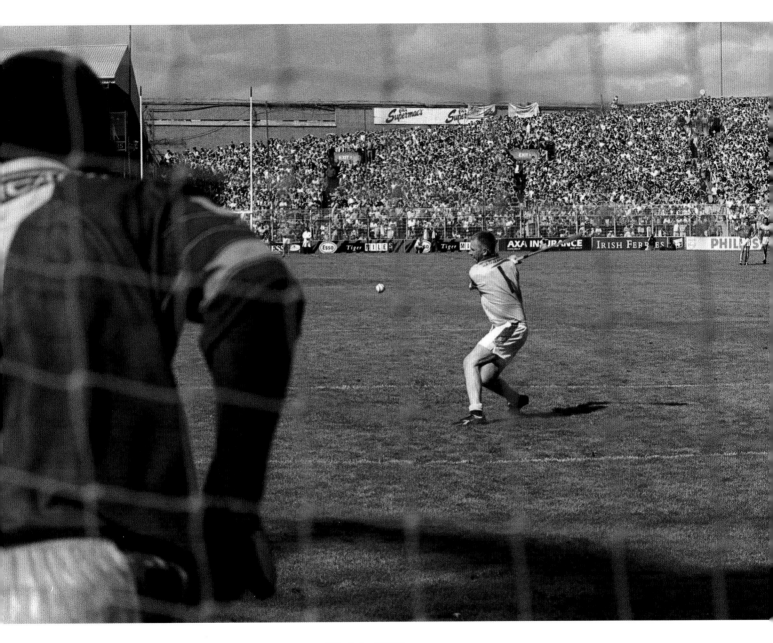

29 July 2001

Wexford goalkeeper Damien Fitzhenry scores his first goal from a penalty with Limerick's Mark Foley bravely standing in the line of fire on the goal-line in this All-Ireland Hurling Quarter Final in Croke Park,

Aoife Rice / SPORTSFILE

12 August 2001

David O'Connor of Wexford shows that he's willing to sacrifice his hurl if it means winning the ball off Tipperary's Declan Ryan in an All-Ireland Semi-Final that forced a replay which Tipperary eventually saw out as victors. Tipperary v Wexford, All-Ireland Hurling Semi-Final, Croke Park, Dublin.

Damien Eagers / SPORTSFILE

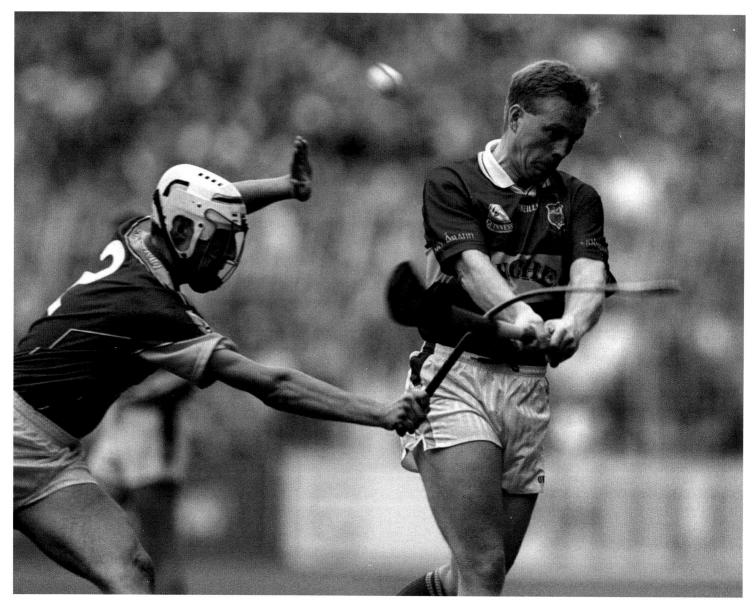

19 August 2001

Three-time All-Ireland winning player, Noel Lane, celebrates successfully guiding his Galway team to an All-Ireland Final in his first full season of management. This came after a shock Semi-final victory over reigning champions Kilkenny. All-Ireland Hurling Semi-final, Croke Park, Dublin.

Brendan Moran / SPORTSFILE

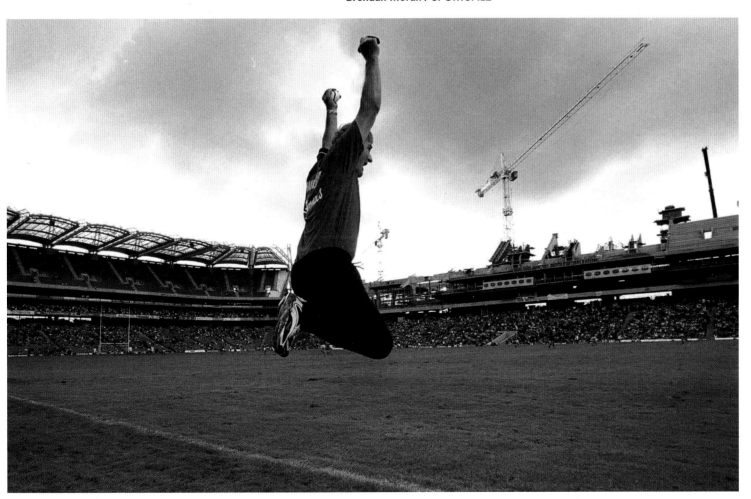

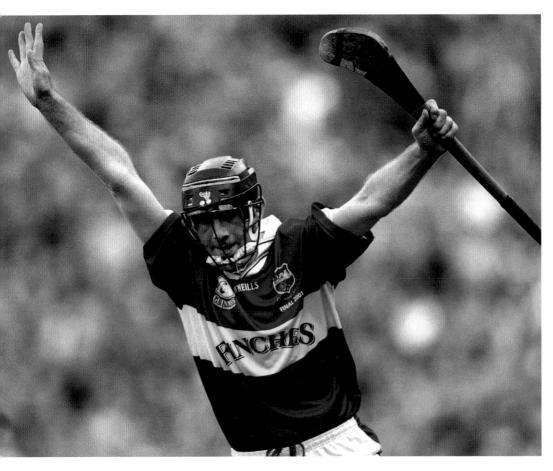

9 September 2001

Top: Wing-forward Mark O'Leary celebrates scoring a goal for Tipperary in the All-Ireland Final against Galway, one of two goals he'd score that day.

Brendan Moran / SPORTSFILE

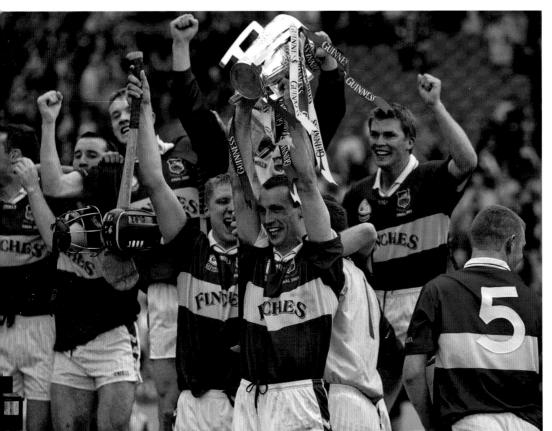

Bottom: Thomas Dunne holds the Liam MacCarthy aloft after Tipperary's three point victory over Galway. Tipperary v Galway, All Ireland Senior Hurling Final, Croke Park, Dublin.

Ray McManus / SPORTSFILE

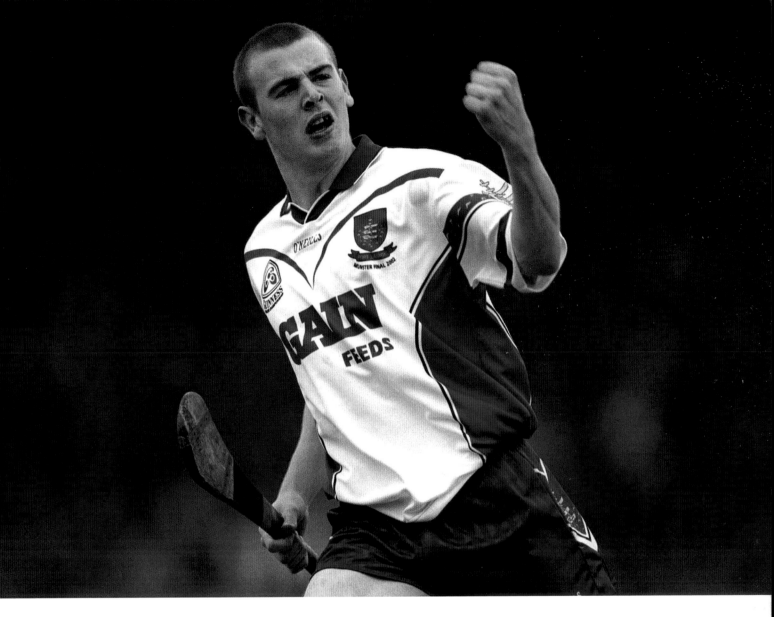

30 June 2002

Eoin Kelly of Waterford celebrates scoring an early point
to send Waterford on their way to Munster Final victory.
Waterford v Tipperary, Páirc Uí Chaoimh, Cork.

Ray McManus / SPORTSFILE

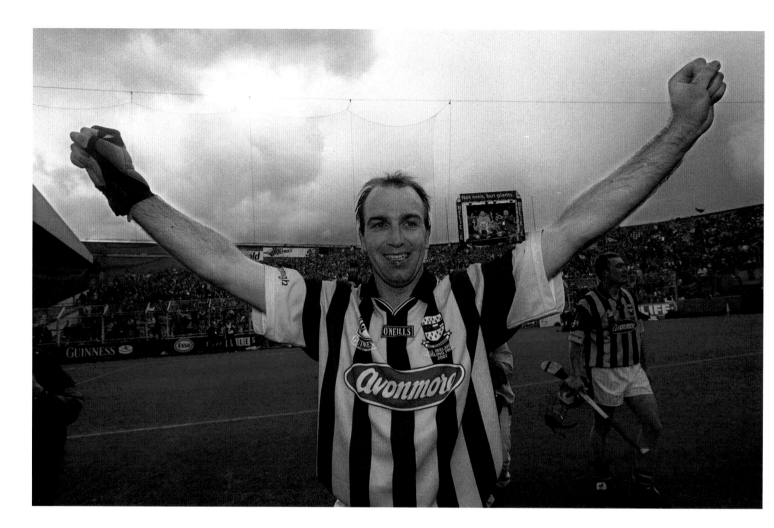

8 September 2002

Kilkenny's DJ Carey celebrates at the end of the Kilkenny v Clare All-Ireland Hurling Final, Croke Park. With nine All-Star Awards and 5 All-Ireland medals, the Gowran sharpshooter is regarded as one of the greatest forwards to have ever played the game. A tally of 1-6 in this final contributed to The Cats beating Clare on a scoreline of 2-20 to 0-19.

Ray McManus / SPORTSFILE

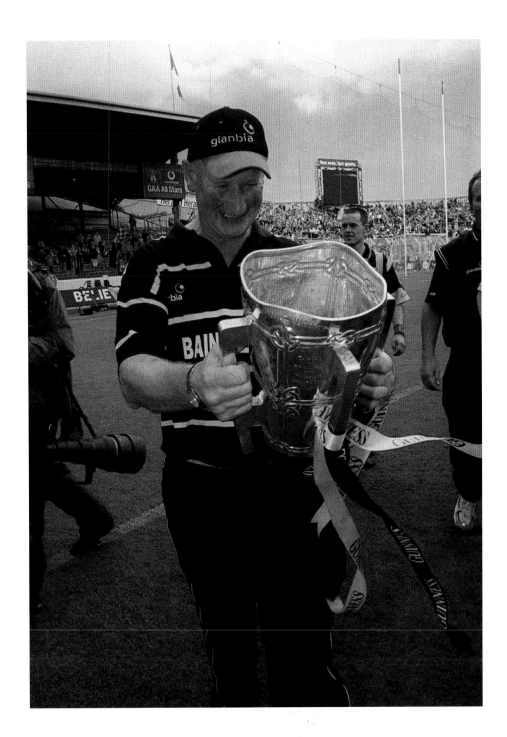

8 September 2002

Brian Cody holds the Liam MacCarthy cup for the second time in his managerial career after a 2-20 - 0-19 points win over Clare in Croke Park. Clare v Kilkenny, All-Ireland Hurling Final, Croke Park, Dublin.

Brendan Moran / SPORTSFILE

5 May 2003

Tipperary's Martin Maher closes down Eddie Brennan of Kilkenny in this National Hurling League game. This proved to be one of the more entertaining games that year with a final score of 5-14 - 5-15 in favour of The Cats. National Hurling League Division 1 Final, Kilkenny v Tipperary, Croke Park, Dublin.

Ray McManus / SPORTSFILE

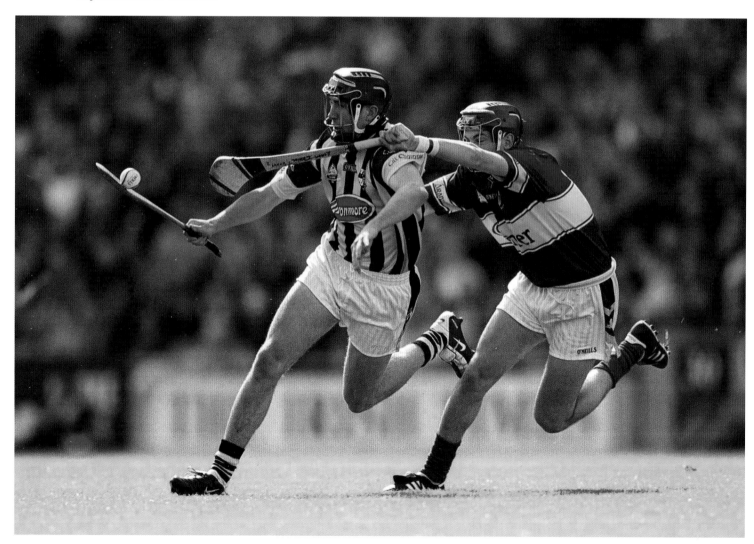

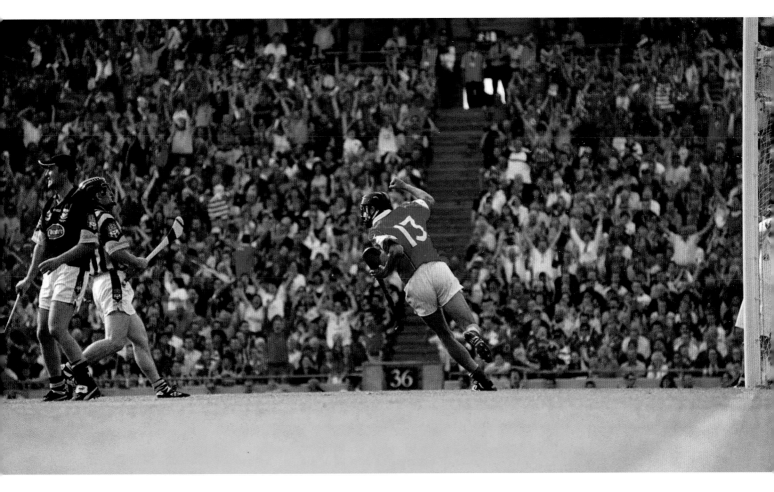

14 September 2003

Cork player Setanta Ó hAilpín, celebrates scoring a goal, which ultimately, wasn't enough for Cork. Ó hAilpín's performances throughout the season earned him the Young Hurler of the Year award and an All Star. After the 2003 season came to a close, Setanta Ó hAilpín announced he was leaving the GAA to play Australian Rules for the Carlton Football Club in Melbourne. All-Ireland Hurling Final, Kilkenny v Cork, Croke Park, Dublin.

Damien Eagers / SPORTSFILE

GREAT MOMENTS IN HURLING

14 September 2003

Cork's Joe Gardiner, kneels, crestfallen, on the turf of Croke Park after their three point loss to Kilkenny.

Ray McManus / SPORTSFILE

Kilkenny's DJ Carey celebrates in front of Hill 16. Carey captained his county to what would be his final All-Ireland title. All-Ireland Hurling Final, Kilkenny v Cork, Croke Park, Dublin.

Damien Eagers / SPORTSFILE

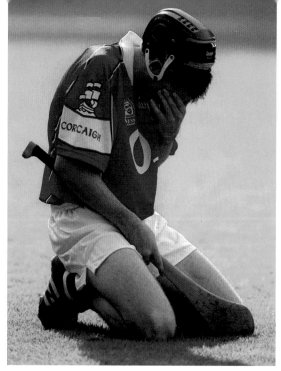

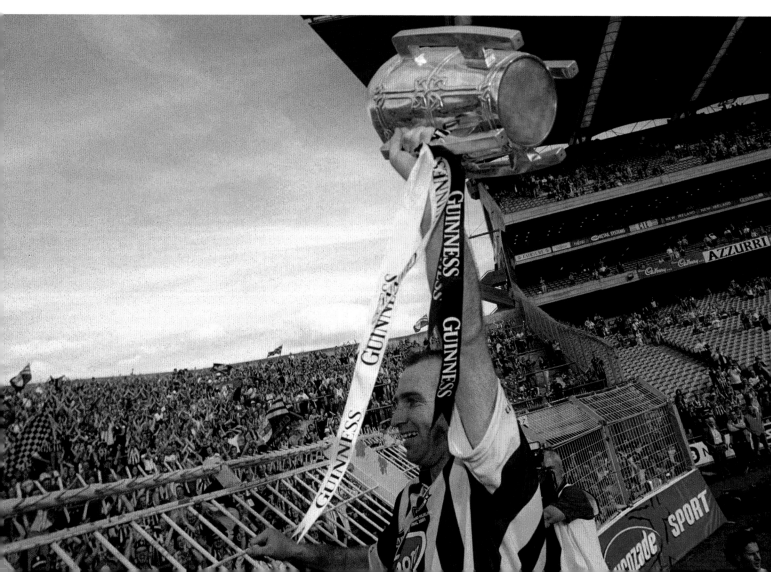

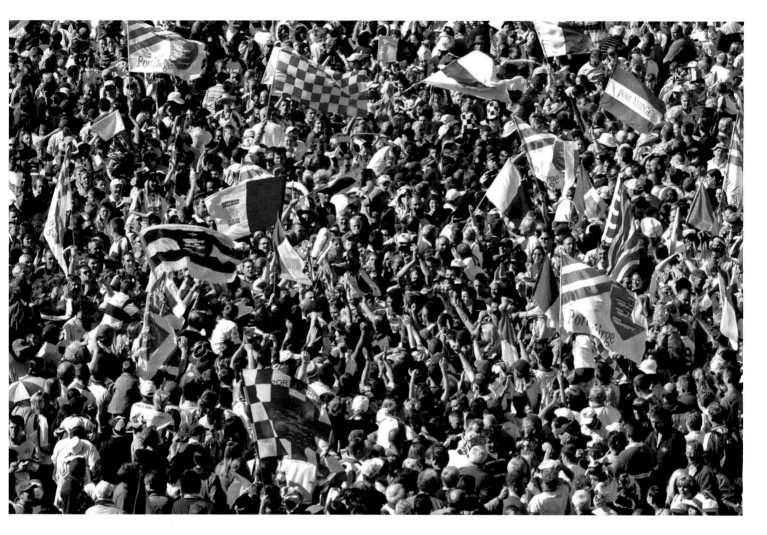

27 June 2004

A barely visible Ken McGrath lifts the Munster
Hurling Championship trophy in a sea of Waterford
supporters in Semple Stadium, Thurles. Munster
Hurling Final, Cork v Waterford.

Ray McManus / SPORTSFILE

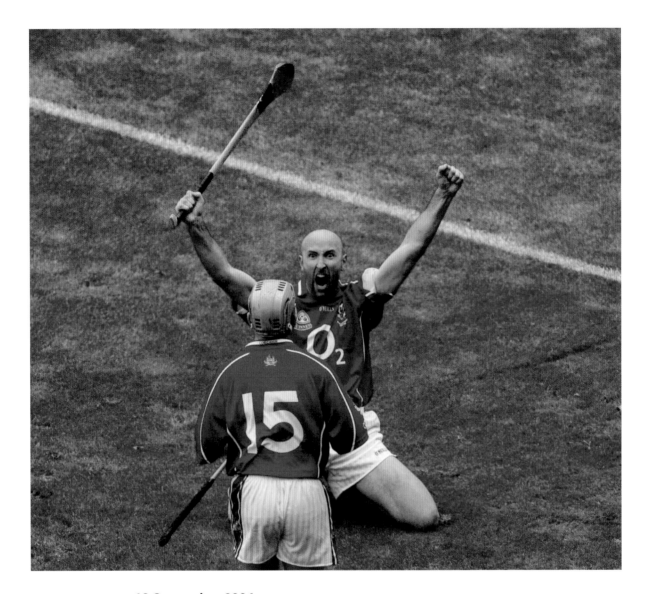

12 September 2004

Cork's Brian Corcoran enthusiastically celebrates squeezing a fine point over the bar from a tight angle towards the end of the 2004 All-Ireland Hurling Final. This was the last score of the game and proved to be the final nail in Kilkenny's coffin as Cork ran out 0-17 - 0-9 victors.

Pat Murphy / SPORTSFILE

26 March 2005

Clare captain Sean McMahon leads his side out of the dressingrooms before the game. National Hurling League, Division 1A, Waterford v Clare, Fraher Field, Dungarvan, Co. Waterford.

Brendan Moran / SPORTSFILE

1 May 2005

Far from the crowds of Semple Stadium or Croke Park, the hurlers of Mayo and Donegal serve up a close encounter in their Division 3 Final. Connacht Council President Tommy Moran presents the National Hurling League Division 3 shield to Mayo captain Derek Walsh. Markievicz Park, Sligo.

Damien Eagers / SPORTSFILE

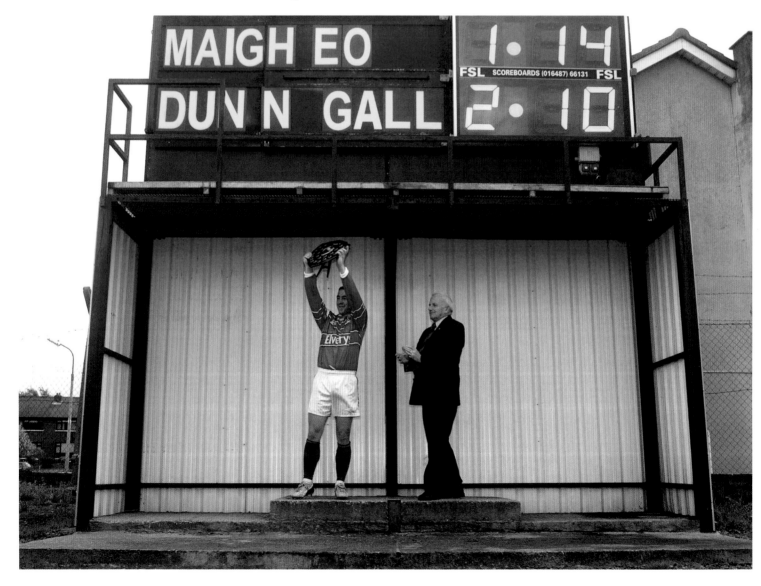

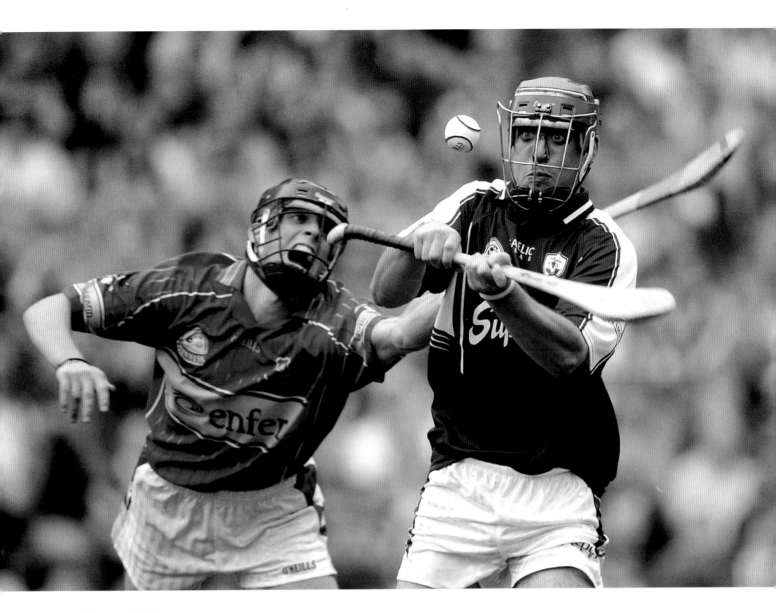

31 July 2005

Alan Kerins, Galway, keeps his eyes on the sliotar despite the challenge of Hugh Moloney, Tipperary. Galway won with a scoreline of 2-20 to 2-18 in a thrilling game. Guinness All-Ireland Hurling Quarter-Final, Croke Park, Dublin.

Brendan Moran / SPORTSFILE

'Is fada an turas é ó Fiji go Corcaigh agus ó
Corcaigh go Pairc an Chrocaigh.'
From Séan Óg's 2005 acceptance speech

11 September 2005

Cork captain Séan Óg Ó hAilpín lifts the Liam
MacCarthy cup. All-Ireland Hurling Final, Galway v Cork,
Croke Park, Dublin.

David Maher / SPORTSFILE

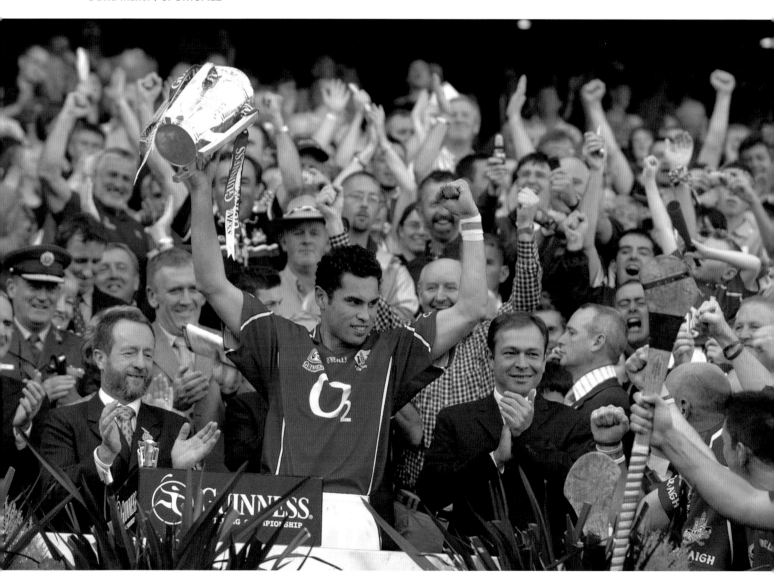

21 May 2006

Dublin's Kevin Flynn attempts to remove some of the surface water on the pitch before the start of the second half. Leinster Hurling Quarter-final, Dublin v Westmeath, O'Moore Park, Portlaoise, Co. Laois.

Brendan Moran / SPORTSFILE

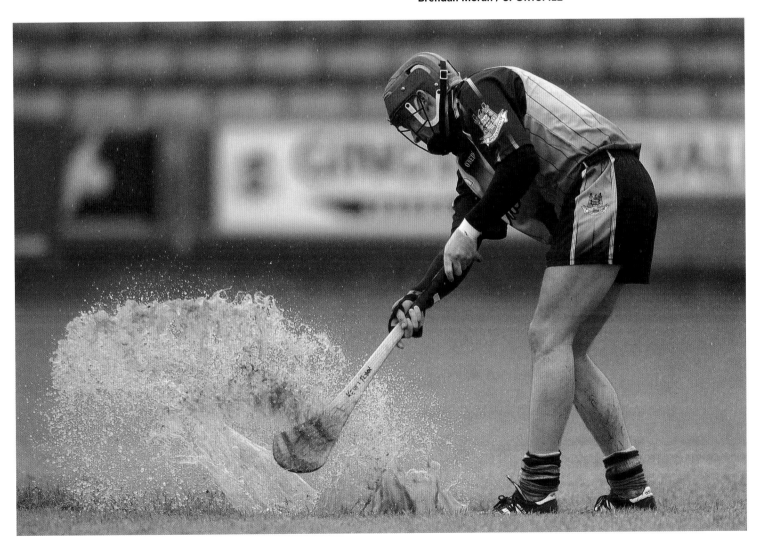

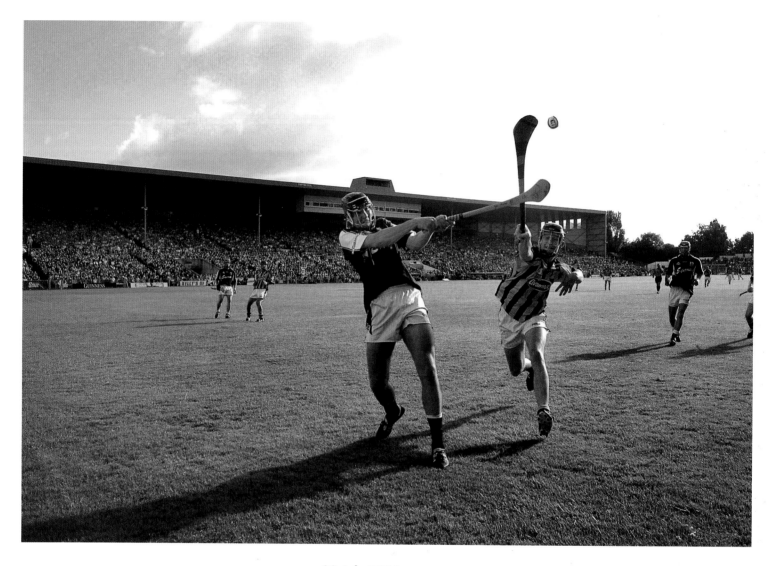

22 July 2006

Ger Mahon, Galway, has his clearance blocked by Martin Comerford, Kilkenny. Kilkenny went on to win the match, 2-22–3-14, and progressed to play Clare in the semi-final. All-Ireland Hurling Quarter-Final, Semple Stadium, Thurles, Co. Tipperary.

Brendan Moran / SPORTSFILE

6 August 2006

A dejected John Mullane, Waterford, at the end of the All-Ireland

Hurling Semi-Final, Cork v Waterford, Croke Park, Dublin.

Ray McManus / SPORTSFILE

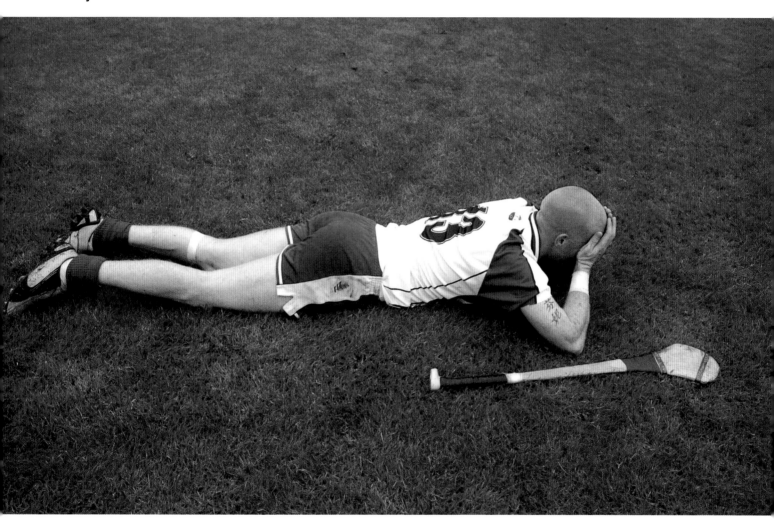

12 August 2006

Donegal's Ciaran Dowds after defeat to Derry in the Nicky Rackard Cup Final, Croke Park, Dublin. The Nicky Rackard cup was initiated in 2005 as a championship for so-called 'third tier' teams; the winning team progresses to the Christy Ring Cup championship.

Brian Lawless / SPORTSFILE

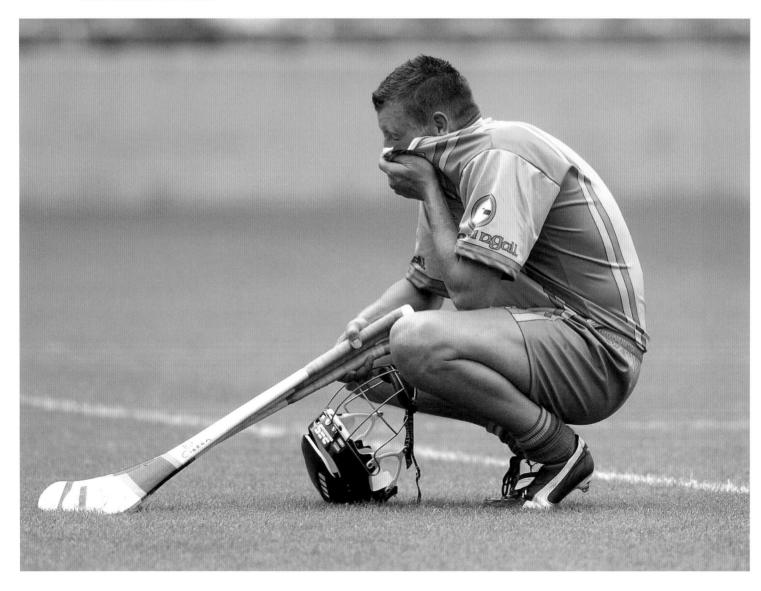

3 September 2006

Cork's Cian O'Connor, left, and Diarmuid O'Sullivan show their dissapointment after being beaten by Kilkenny 1–16 to 1–13. The two sides had met in the 2004 final, when Cork were victorious. In 2006 Cork were trying for three in a row, but Kilkenny, under the leadership of Brian Cody, captured their first title since 2003. All-Ireland Hurling Final, Croke Park, Dublin.

Pat Murphy / SPORTSFILE

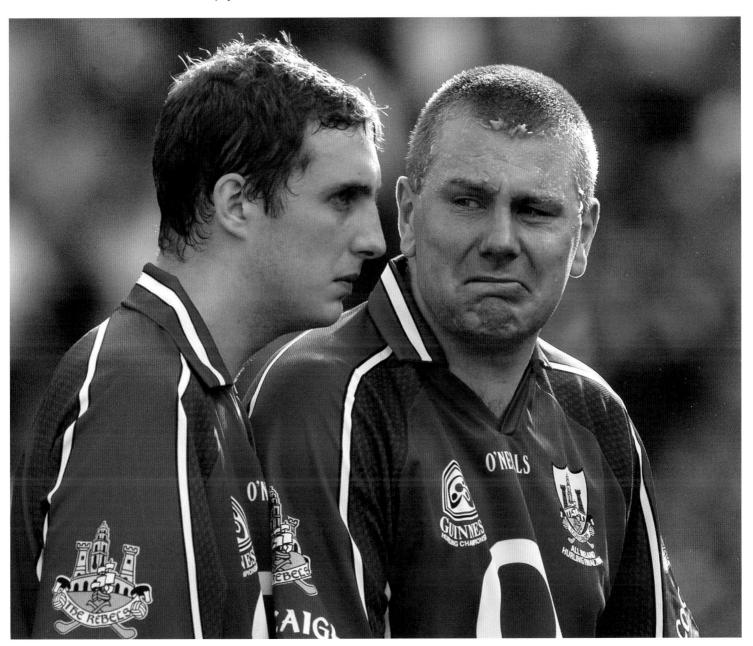

15 April 2007

Dan Shanahan, Waterford, has a word with Diarmuid O'Sullivan,
Cork, in the final minutes of the game. Considered one of the Déise's
all-time greats, Shanahan made 52 championship appearances for
Waterford, won three All-Star awards and in 2007 was named Texaco,
All-Star and GPA Hurler of the Year. Another great, O'Sullivan made
48 championship appearances for Cork and won won four All-Star
awards. On this occasion Shanahan's team were the victors, with a
1-19 to 1-16 scoreline.

National Hurling League Semi-Final, Division 1, Waterford v Cork,
Semple Stadium, Thurles, Co. Tipperary.

Brendan Moran / SPORTSFILE

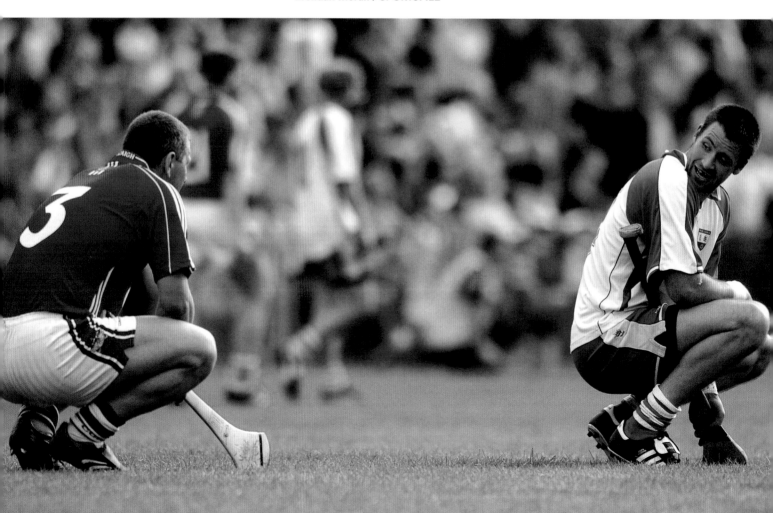

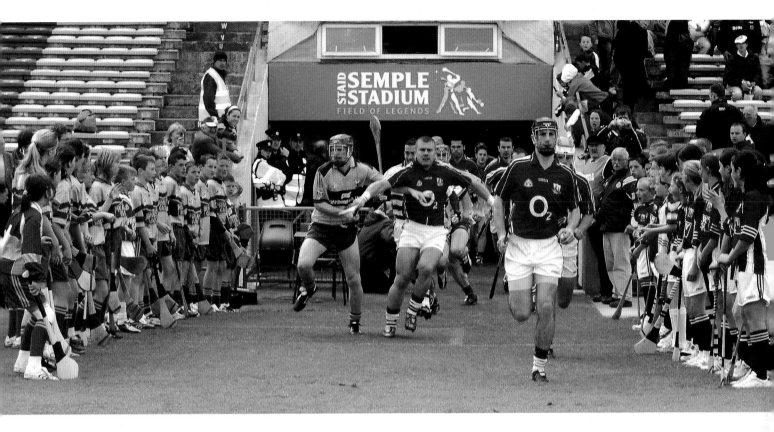

Just another Munster Hurling Championship game between Cork and Clare. I took my position for the team photos in front of the team bench. The Primary Game children lined up as usual to welcome the teams onto the pitch. Using a standard 24-70mm lens I watched the players' tunnel for the signal for the teams to enter the field of play, one team followed by the second team about 2 minutes later. As the first team started to run out, I instinctively started taking pictures. Initially I didn't notice both teams coming together, but as soon as I realised what was happening, I left my position amongst the other photographers to get closer to what was going on; photographers always run towards what's going on! Once the dust settled and the players separated, I knew I had pictures that would be widely used in the following day's newspapers. And so it proved. Clare came out that day all guns blazing, but I knew Cork would win the game; they weren't going to be bullied. Cork won in the end by 7 points. The pictures were easy enough to take, but instinct and experience taught me to react in an instant to get the best pictures I could and record a very unusual scenario and one I have not seen since.

Brendan Moran, photographer

27 May 2007

Clare's Frank Lohan and Cork's Diarmuid O'Sullivan clash as both teams come out of the dressing rooms at the same time. On the pitch, Cork came off best, winning Cork 1-18 Clare 1-11; Clare had four players suspended and Cork three after a bitter game. Munster Hurling Quarter-Final, Semple Stadium, Thurles, Co. Tipperary.

Brendan Moran / SPORTSFILE

141

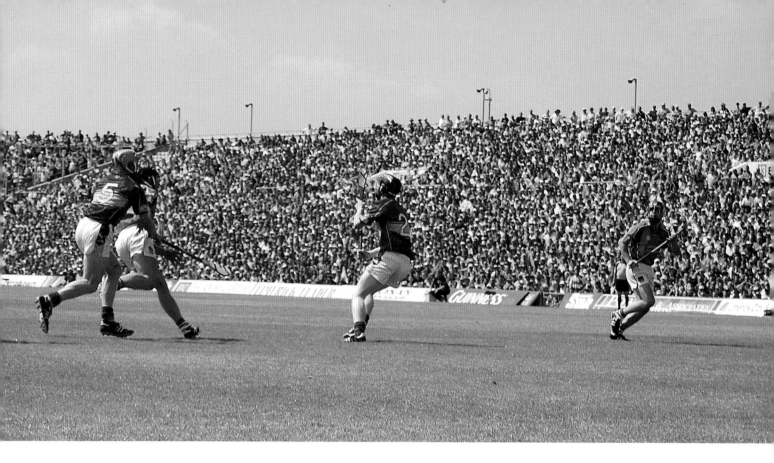

I had started working as a photographer on work experience from school this year, and with my interest in hurling, I was delighted to be at such a big game. I was sitting at the far end for the whole game, until with a few minutes to go and Tipperary 3 points ahead, Ray McManus rang me and said I should chance going down the opposite end in case Limerick scored a goal. I moved quickly, and Limerick thankfully scored the goal. I took the picture, sent it in, and was ecstatic the following morning when the picture was published seven columns wide in the Irish Times. This was my first major picture to be printed, and one I will always remember. 2007 would turn out to be a great year for the Limerick hurlers, who beat Tipperary after 3 games, before reaching the All-Ireland Final.

Dáire Brennan, photographer

10 June 2007

Limerick's Ollie Moran, under pressure from Tipperary's Eamonn Corcoran, passes to team-mate Pat Tobin who went on the score a goal in the last minute. On this occasion, the teams drew; after two replays, Limerick emerged the victors on 24 June. Munster Hurling Semi-Final, Gaelic Grounds, Limerick.

Dáire Brennan / SPORTSFILE

16 June 2007

Limerick manager Richie Bennis with Tipperary manager Michael 'Babs' Keating at the end of the game. Munster Hurling Semi-Final Replay, which ended in a draw. Semple Stadium, Thurles, Co. Tipperary.

Pat Murphy / SPORTSFILE

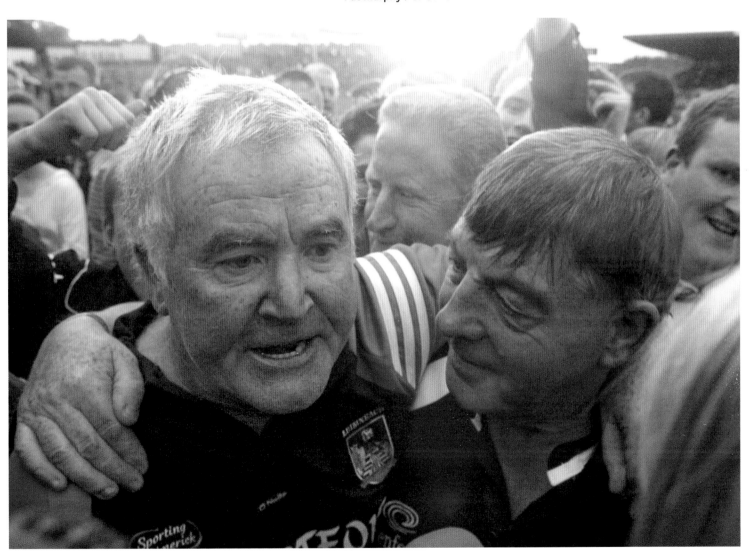

8 July 2007

Waterford's Dan Shanahan, left, is congratulated by team-mate Eoin McGrath after scoring his second and their side's third goal. Waterford claimed their third Munster Championship of the decade, beating Limerick on a scoreline of 3-17 to 1-14, a 9-point winning margin. Limerick would get their revenge on Waterford by beating them in the semi-final. Munster Hurling Final, Semple Stadium, Thurles, Co. Tipperary.

Dáire Brennan / SPORTSFILE

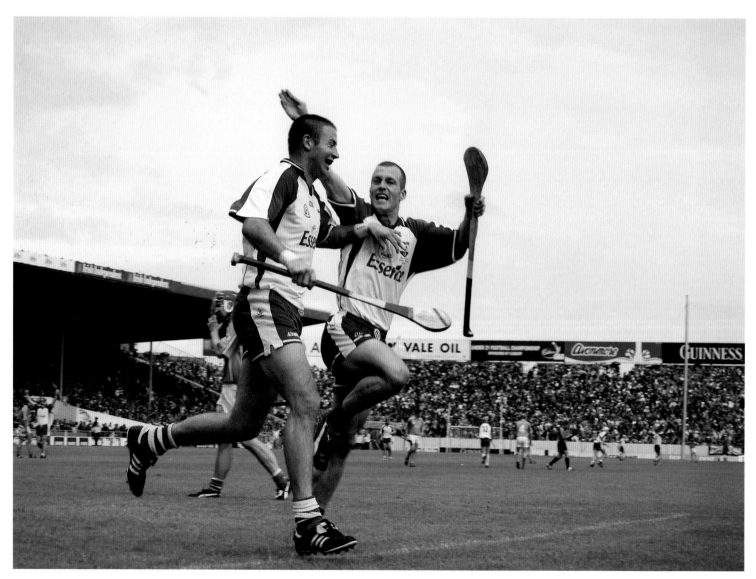

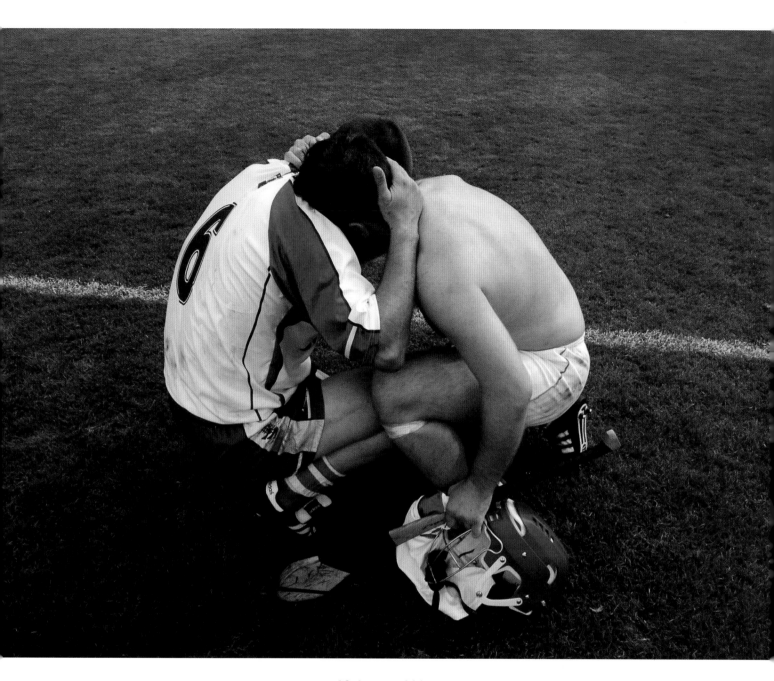

12 August 2007

Waterford's Ken McGrath is consoled by Limerick captain
Damien Reale. All-Ireland Hurling Semi-Final, Croke Park,
Dublin.

Ray McManus / SPORTSFILE

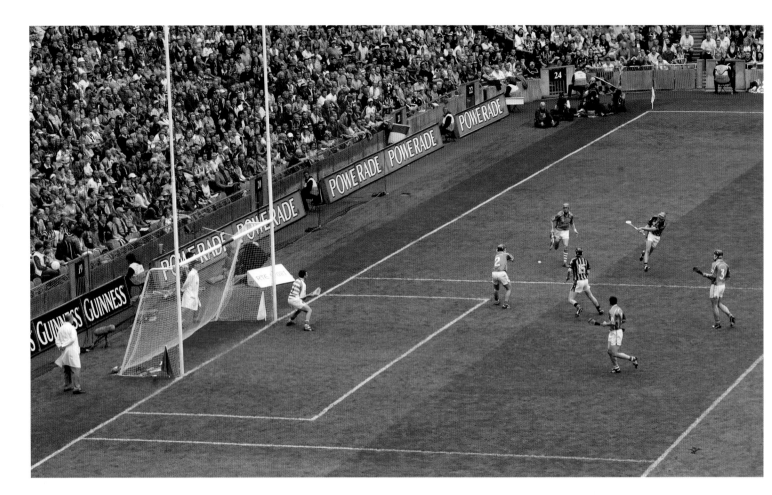

2 September 2007

Eddie Brennan beats the Limerick defence and goalkeeper, Brian Murray, to score the first goal for Kilkenny. Limerick and Kilkenny hadn't met in an All-Ireland final since 1974. Limerick were hoping to raise the Liam McCarthy Cup for the first time since 1973, but instead Kilkenny made it two in a row, with a scoreline of 2–19 to 1–15. All-Ireland Hurling Final, Croke Park, Dublin.

Liam Mulcahy / SPORTSFILE

2 September 2007

Opposite: Kilkenny's Henry Shefflin lifts the Liam MacCarthy cup with Darragh McGarry, son of Kilkenny goalkeeper, James McGarry, right. James McGarry's wife, Vanessa, died in a road accident in July 2007. All-Ireland Hurling Final, Croke Park, Dublin.

Pat Murphy / SPORTSFILE

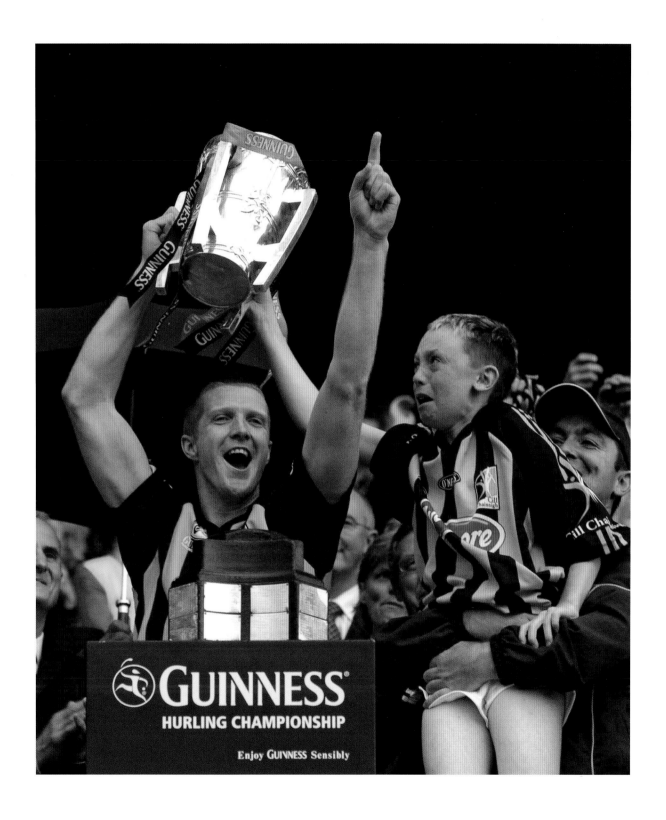

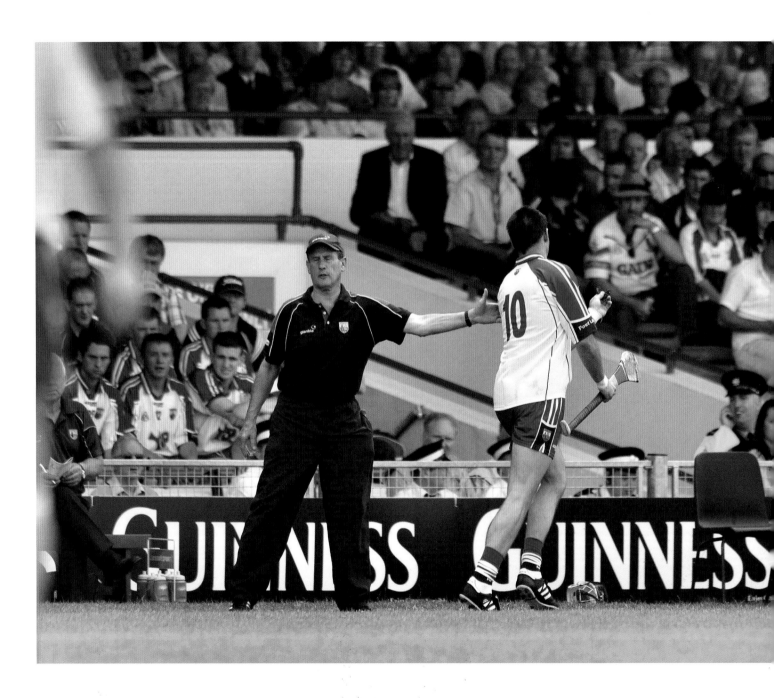

Waterford v Clare. Munster Hurling Championship: Huge history, great atmosphere Anything can happen. And usually when you least expect it. Waterford were the reigning Munster champions and Clare hadn't won a game in Munster since 2003. Clare put on an incredible performance and won by 2-26 to 0-23. Dan Shanahan was a player at the top of his game; when a player of that calibre is substituted you always end up taking a picture of them walking off. I followed his progress all the way off the pitch towards manager Justin McCarthy, but when McCarthy reached out his hand, Shanahan swerved to avoid him. I didn't really notice it until I reviewed them, but I knew that it was unusual so I sent the picture back after the game. The following morning I the picture was used in nearly every newspaper, along with the stories about unrest in the Waterford camp. Justin McCarthy resigned the following week and Davy Fitzgerald took over, guiding Waterford all the way to the All-Ireland Final.

Brendan Moran, photographer

1 June 2008

Waterford's Dan Shanahan appears to ignore Justin McCarthy's handshake after being substituted during the second half. Shanahan later claimed in hoganstand.com that it wasn't deliberate: 'People took it up the wrong way, but there's nothing I can do about that only to get out on the field and do my best. But I didn't deliberately do that. I wouldn't do that deliberately to any man.' Munster Senior Hurling Quarter-Final, Gaelic Grounds, Limerick.

Brendan Moran / SPORTSFILE

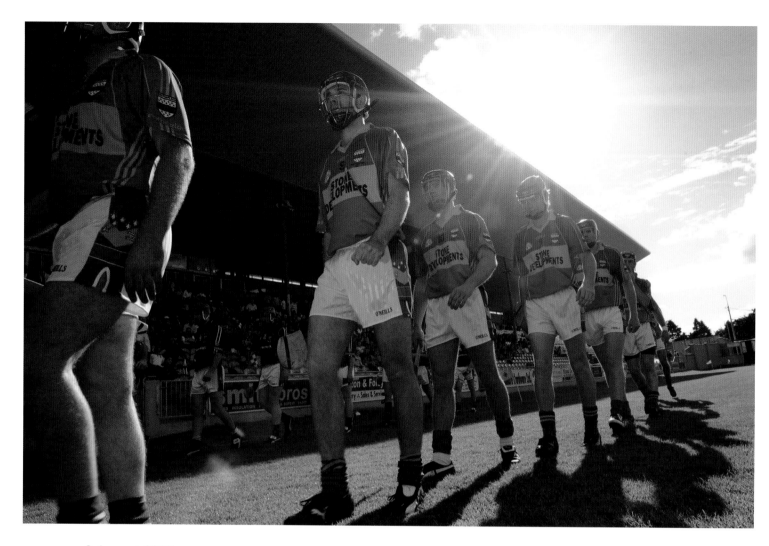

3 August 2008

The Carlow players make their way past the main stand during the parade. In an exciting match, Carlow scored score 2-4 in the first ten minutes of the second half, going on to win by 3-22 to 4-16. Christy Ring Cup Final, Westmeath v Carlow, O'Connor Park, Tullamore, Co. Offaly.

Matt Browne / SPORTSFILE

7 September 2008

Henry Shefflin, Kilkenny, in action against Eoin Kelly,
left, and Stephen Molumphy, Waterford. Kilkenny won
3–30 to 1–13, giving them their first three-in-a-row
since the 1911, '12 and '13 championships.
All-Ireland Hurling Final, Croke Park, Dublin.

Brendan Moran / SPORTSFILE

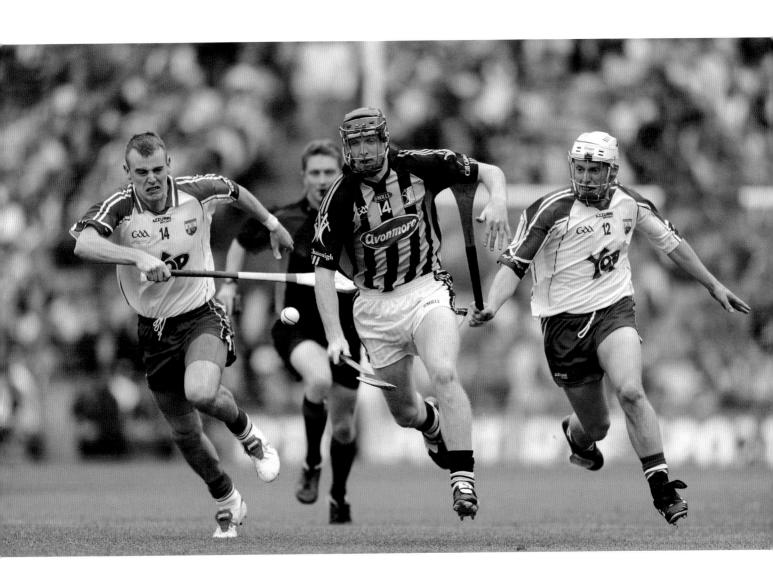

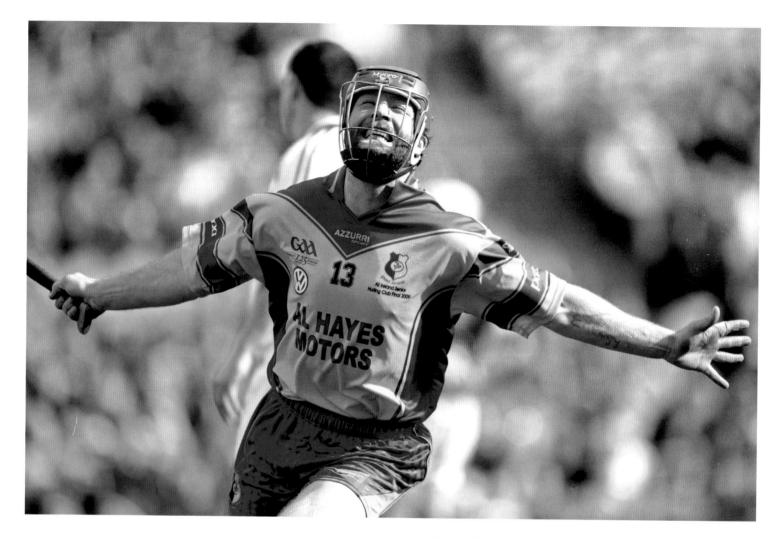

17 March 2009

Damien Hayes, Portumna, celebrates scoring his side's first goal. All-Ireland Club Hurling Final, Portumna, Co. Galway v De La Salle, Waterford, Croke Park, Dublin.

Dáire Brennan / SPORTSFILE

31 May 2009

All over including the shouting. Cork's Jerry O'Connor, whose twin Ben also played for Cork, is comforted by a supporter at the final whistle of the game against Tipperary, where they defeated Cork by 1-19 to 0-19 in a closely-fought match.

Ray McManus / SPORTSFILE

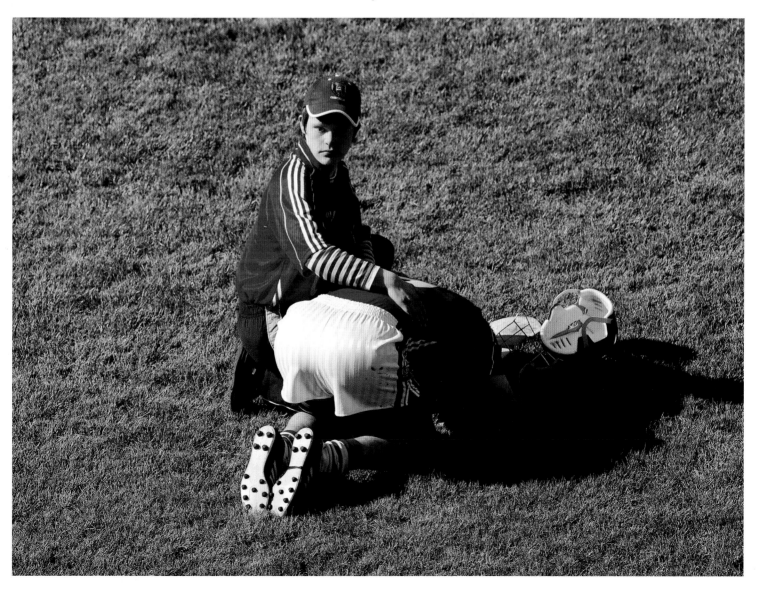

7 June 2009

David O'Callaghan, Dublin, in action against Kieran McGourty, Antrim. Leinster Hurling First Round, Croke Park, Dublin.

David Maher / SPORTSFILE

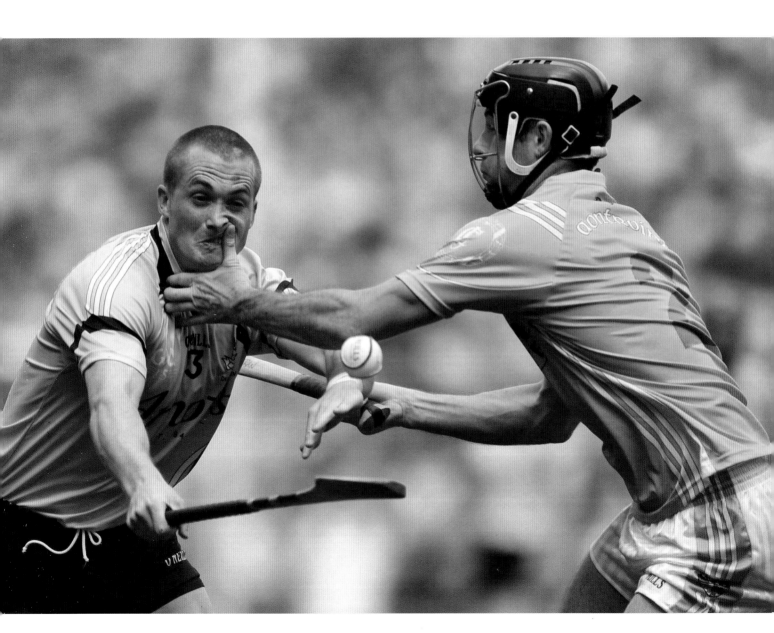

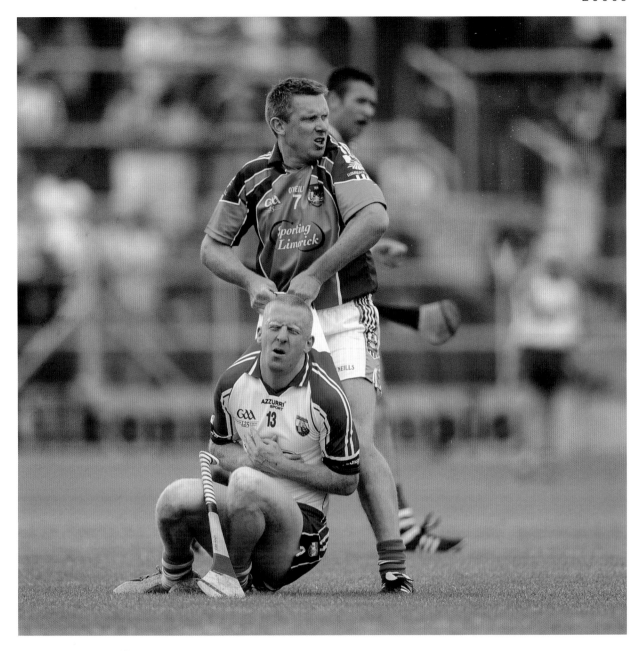

20 June 2009

Mark Foley, Limerick, assists Waterford's John Mullane – who turned in a 'man of the match' performance with six points from play – as he rises to his feet. Munster Hurling Semi-Final Replay, Semple Stadium, Thurles, Co. Tipperary.

Ray McManus / SPORTSFILE

11 July 2009

Down's Martin Óg Coulter with his daughter,
Rachel, after defeat to Carlow. Christy Ring
Cup Final, Croke Park, Dublin.

Brian Lawless / SPORTSFILE

12 July 2009

Not men but giants. Stephen Molumphy leads his Waterford team into
the light. On this occasion, Tipperary, 4-14, claimed their third Munster
Championship of the decade, beating Waterford by four points.

Brendan Moran / SPORTSFILE

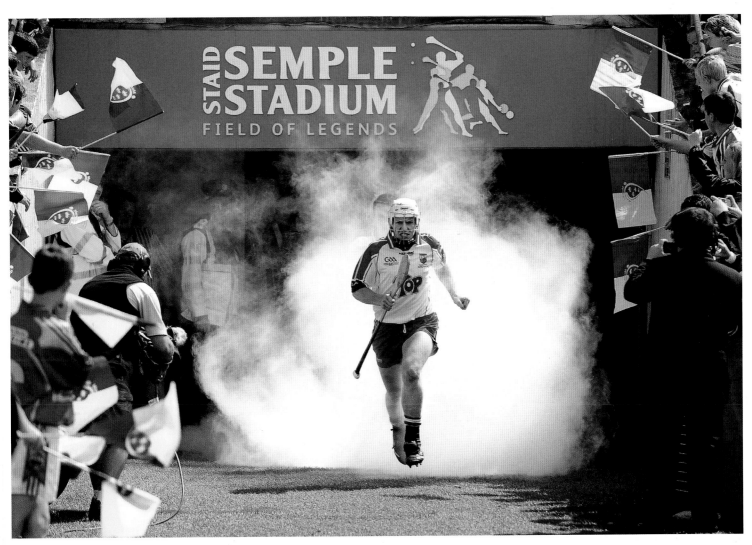

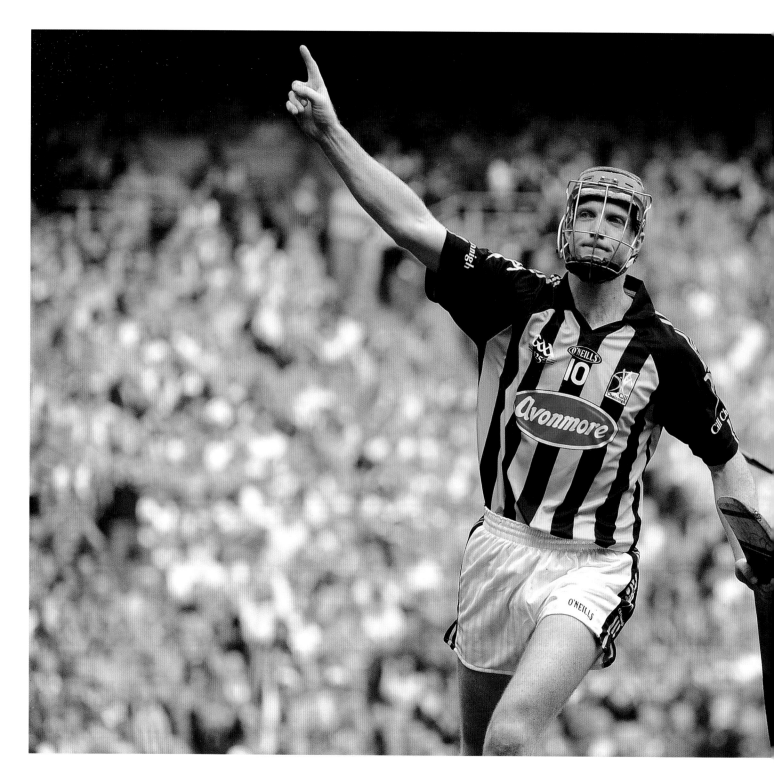

9 August 2009

Henry Shefflin celebrates after scoring Kilkenny's second goal against Waterford; Kilkenny won the match 2-23 to 3-15. All-Ireland Hurling Semi-Final, Croke Park, Dublin.

Dáire Brennan / SPORTSFILE

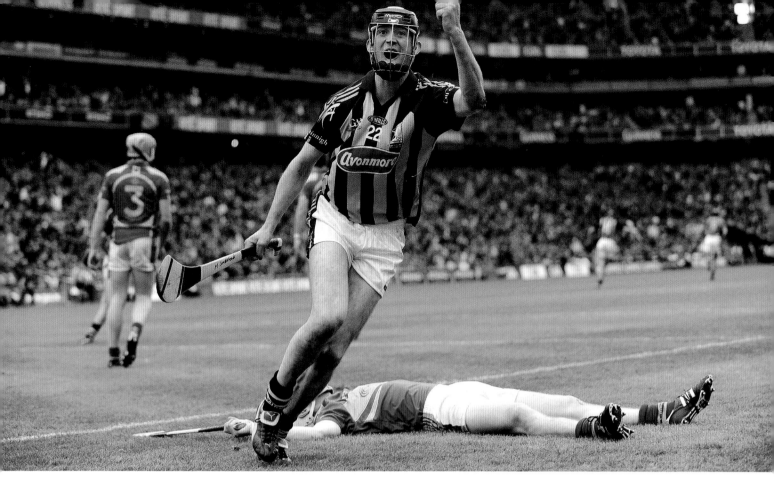

Hailed as 'the greatest side ever to play the game' the pressure was on Kilkenny in 2009 to secure their 7th title of the decade. In my position close to the posts in front of Hill 16 my main responsibility during the game was to get the goals! After a barren first half Kilkenny found the net twice in quick succession in front of me. Following on from Henry Shefflin's penalty moments earlier Martin Comerford rattled the net and celebrated towards the Kilkenny supporters on Hill 16 and towards my lens. The image captures the jubilation of Comerford while also showing the despair of Tipperary's Brendan Maher.

Stephen McCarthy, photographer

6 September 2009
Martin Comerford, Kilkenny, celebrates after scoring his side's second goal as Brendan Maher, Tipperary, falls dejected. Kilkenny's win in this match was their fourth in a row, an accomplishment last matched by Cork between 1941 and 1944. All-Ireland Hurling Final, Croke Park, Dublin.
Stephen McCarthy / SPORTSFILE

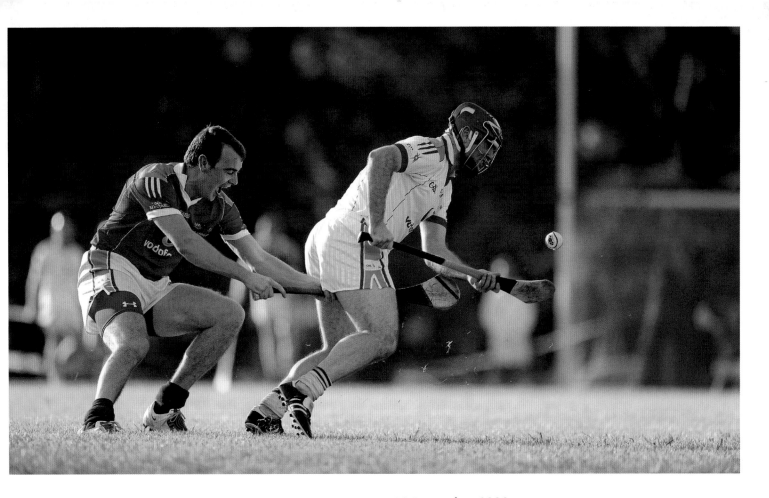

12 December 2009

Eoin Kelly, Tipperary, 2008 All-Stars, is tackled unconventionally by his Waterford namesake Eoin Kelly, 2009 All-Stars. Hurling All-Stars Tour 2009, sponsored by Vodafone, 2008 All-Stars (red) v 2009 All-Stars (white), Hurlingham Hurling Club, Hurlingham, Buenos Aires, Argentina.

Ray McManus / SPORTSFILE

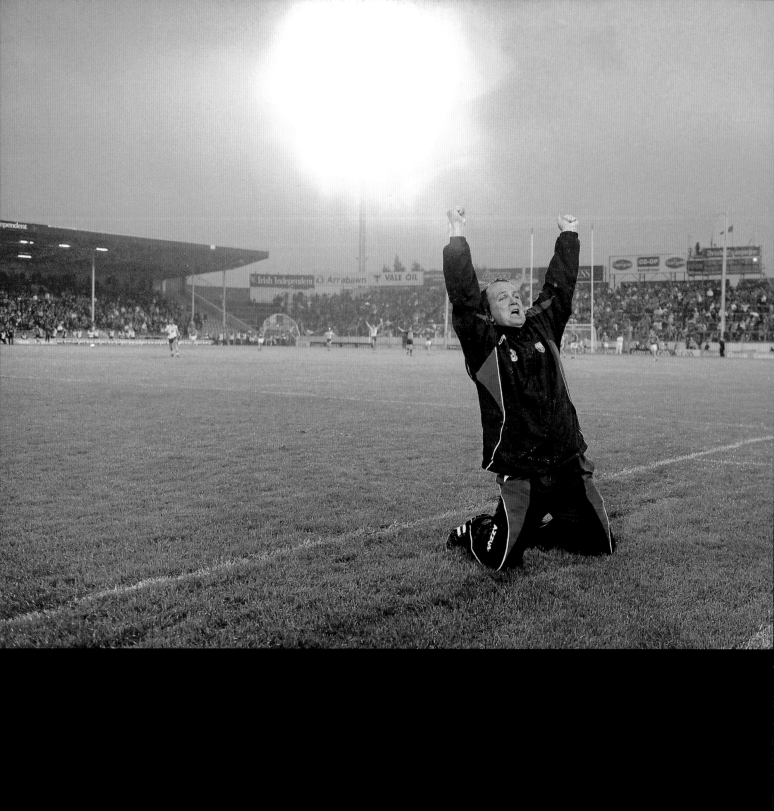

17 July 2010

Waterford manager Davy Fitzgerald celebrates at the final whistle. Munster Hurling Final Replay, Cork v Waterford, Semple Stadium, Thurles, Co. Tipperary.

Brendan Moran / SPORTSFILE

2010s

30 May 2010

Patrick Horgan, Cork, celebrates after scoring his side's second goal. Munster Hurling Quarter-Final, Cork v Tipperary, Páirc Uí Chaoimh, Cork.

David Maher / SPORTSFILE

5 September 2010

Lar Corbett, Tipperary, celebrates after scoring his side's second goal. Corbett scored a hat-trick in this final, as the Premier county put a halt to Kilkenny's bid for a historic 5-in-a-row of All-Ireland titles. All-Ireland Hurling Final, Croke Park, Dublin.

Dáire Brennan / SPORTSFILE

17 April 2011

The Wicklow bench celebrate the last point for their team. Hurling Division 3A Final, Wicklow v Derry, Pearse Park, Longford.

Ray McManus / SPORTSFILE

The return to hurling of Conal Keaney, and the recruitment of Ryan O'Dwyer, were crucial contributions to the campaign which produced Dublin's win over Kilkenny in the 2011 National League Final. Ryan brought a warrior spirit and a willingness, to quote Dalo, 'to put his head in on Sunday where no sane man would put his hand on Monday'. When he transferred to my own club, Kilmacud Crokes, he ate breakfast at my house every Sunday after training for months. Before the game, very few people outside of the panel had rated our chances of winning the National League final. Quotes from the Cats fans' website were very dismissive – and very motivational!

We hammered them on the day, with an exuberant display of hurling which changed the expectations of Dublin fans, and heralded our arrival as genuine All-Ireland contenders. At the final whistle, as we celebrated in front of the Hill, I hugged my son, Conor, who was maor uisce, and was engulfed by Ryan O'Dwyer. The picture shows our joy, relief and elation, emotions shared by the whole Dublin hurling community. As the photograph was taken, I think I was yelling 'it was my wife's rashers and eggs that got us here!

Dr Chris Thompson, Dublin team doctor

1 May 2011

Blood, sweat and tears! Dublin team doctor Chris Thompson celebrates with Ryan O'Dwyer after Dublin won the Division 1 Final following a 0-22 to 1-7 victory over Kilkenny, Croke Park, Dublin.

Dáire Brennan / SPORTSFILE

12 June 2011

The Limerick goalkeeper Nickie Quaid is comforted by umpire
Michael Coyle after the game. Munster Hurling Semi-Final,
Limerick v Waterford, Semple Stadium, Thurles, Co. Tipperary.

Ray McManus / SPORTSFILE

9 July 2011

Joe Canning, Galway, signs autographs for
supporters after the game. All-Ireland Senior
Hurling Championship Phase 3, Cork v Galway,
Gaelic Grounds, Limerick.

Diarmuid Greene / SPORTSFILE

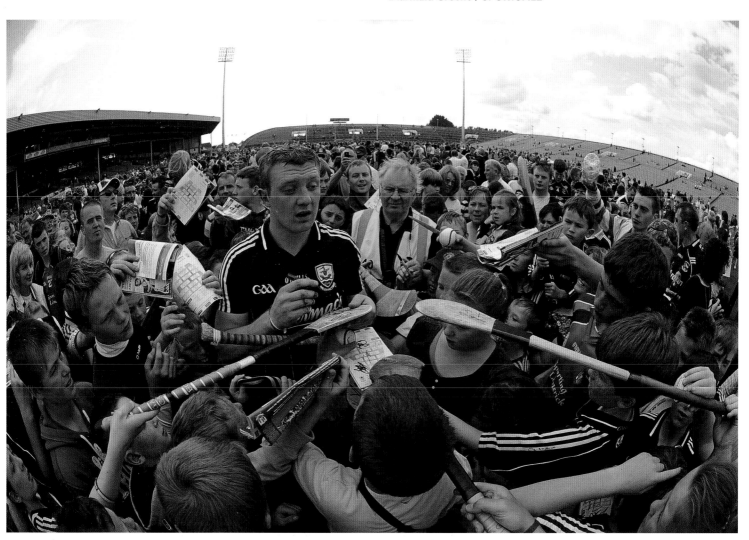

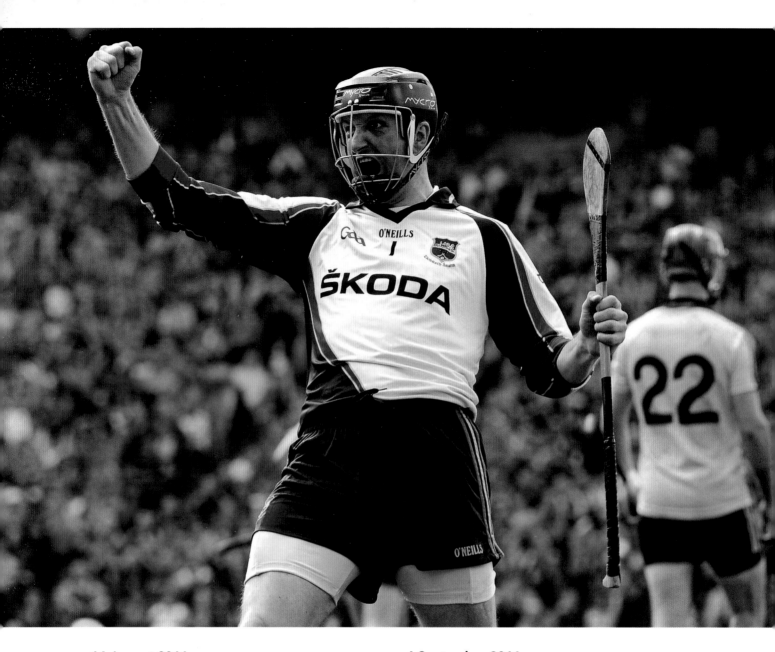

14 August 2011

Tipperary goalkeeper Brendan Cummins celebrates his side's 1-19 to 0-18 victory over Dublin, their second in four years; in 2007 Tipperary beat Dublin by 1-20 to 1-11 in Parnell Park. All-Ireland Hurling Semi-Final, Croke Park, Dublin.

Peter O'Leary / SPORTSFILE

4 September 2011

Tommy Walsh, Kilkenny, with support from team-mate Michael Rice, wins a puck out against Noel McGrath, Tipperary. This was the first ever time that the same two teams had played in the All-Ireland Hurling Final for three years in a row. On this occasion, Kilkenny won by a four-point margin. Croke Park, Dublin.

Barry Cregg / SPORTSFILE

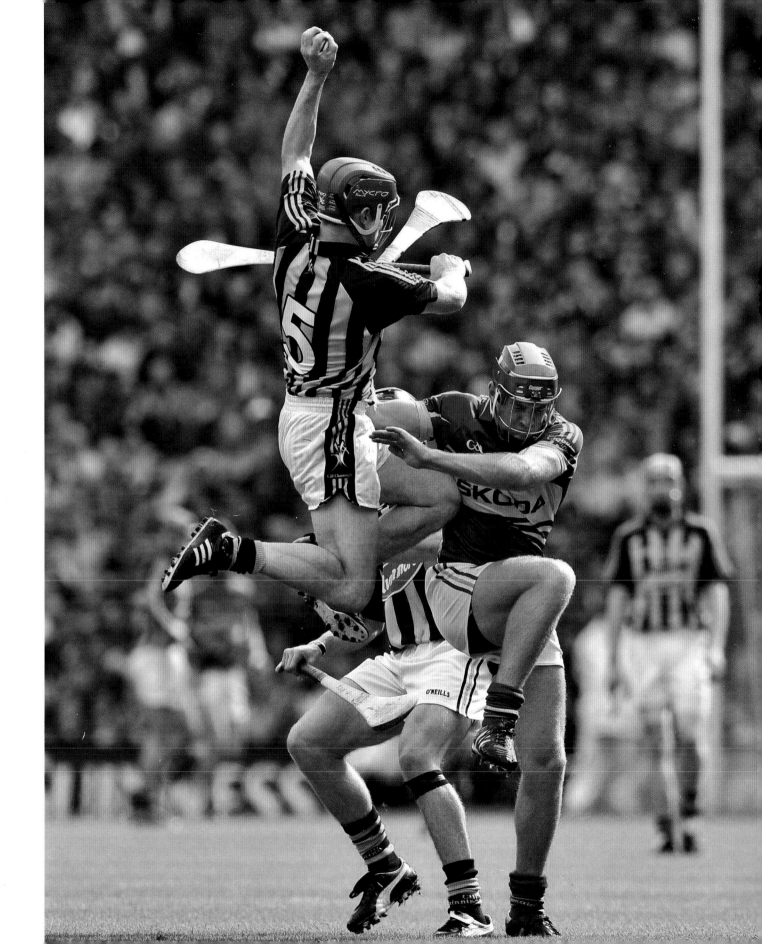

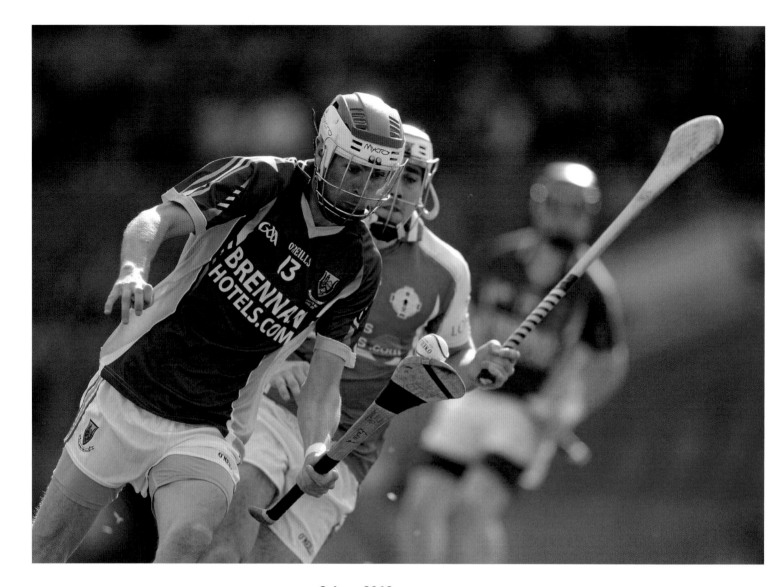

9 June 2012

Enan Glynn, Wicklow, in action against Ger Fennelly, London.
Christy Ring Cup Final, Croke Park, Dublin. London, who had
been promoted from the Nicky Rackard cup, were eventual
winners 1-17 to 4-18.

Oliver McVeigh / SPORTSFILE

24 June 2012

Supporters react after a line-ball decision was given against Tipperary. Munster Hurling Semi-Final, Cork v Tipperary, Páirc Uí Chaoimh, Cork.

Ray McManus / SPORTSFILE

12 August 2012

Galway's Joe Canning watches the flight of the sliotar
after taking a line ball. All-Ireland Hurling Semi-Final,
Cork v Galway, Croke Park, Dublin.

Ray McManus / SPORTSFILE

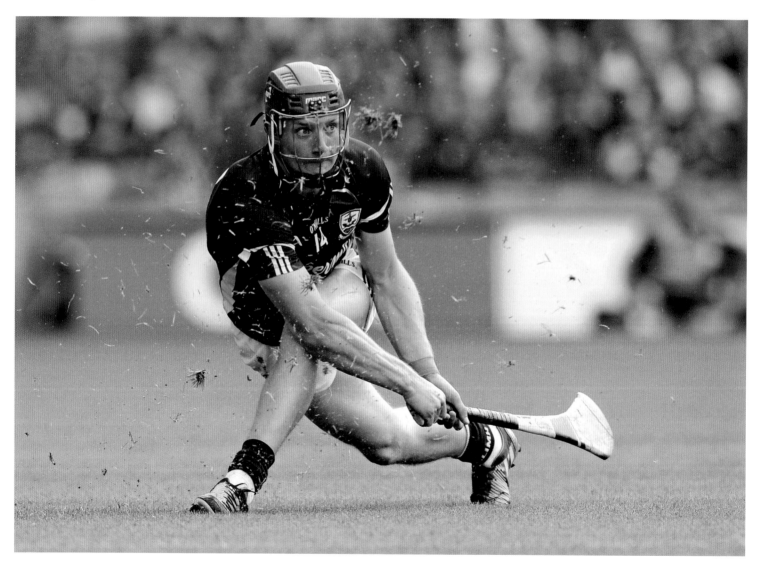

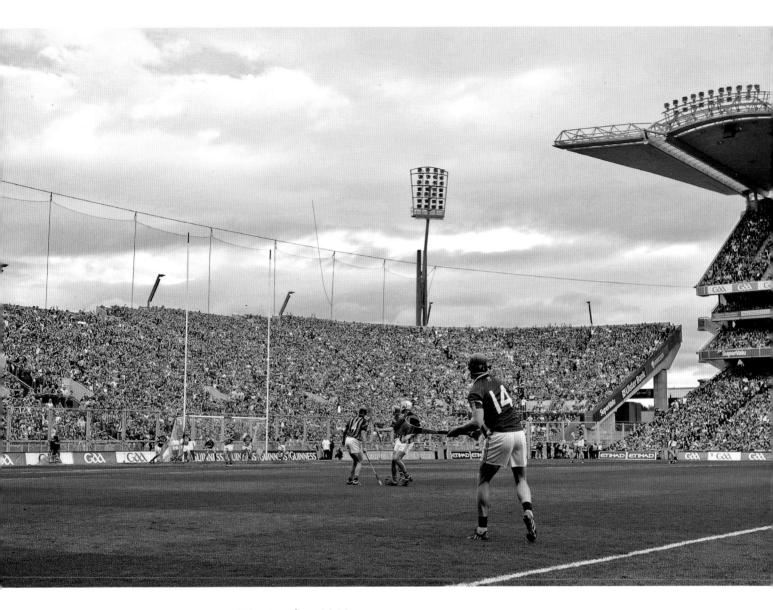

9 September 2012

Joe Canning, Galway, equalises against Kilkenny. All-Ireland Hurling Final, Croke Park, Dublin.

Matt Browne / SPORTSFILE

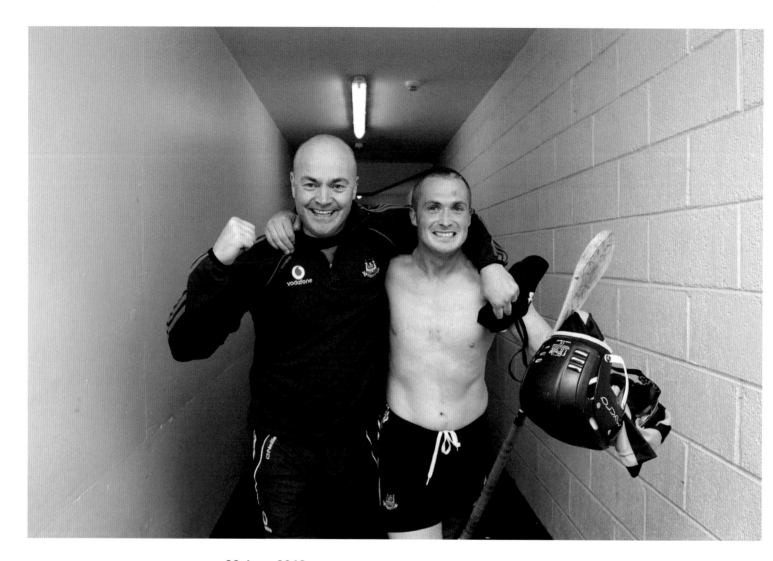

29 June 2013

Dublin manager Anthony Daly and David O'Callaghan celebrate as they make their way to the dressing room. This victory was Dublin's first over Kilkenny in the Leinster Championship since 1942, and was especially sweet, as the Skyblues had suffered an 18-point hammering at the hands of Kilkenny the previous Summer. Leinster Hurling Semi-Final Replay, O'Moore Park, Portlaoise, Co. Laois.

Ray McManus / SPORTSFILE

14 July 2013

Limerick supporters on the pitch during the cup presentation; this was Limerick's first Munster Championship win since 1996, and their first on home soil since 1955. Munster Hurling Final, Limerick v Cork, Gaelic Grounds, Limerick.

Ray McManus / SPORTSFILE

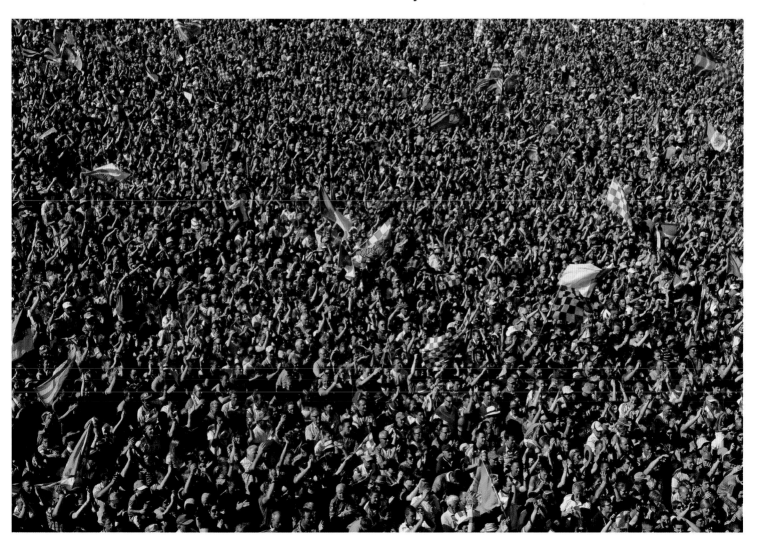

11 August 2013

Cork County Board Secretary Frank Murphy, right, celebrates with Cork manager Jimmy Barry Murphy at the end of the game. All-Ireland Hurling Semi-Final, Dublin v Cork, Croke Park, Dublin.

Paul Mohan / SPORTSFILE

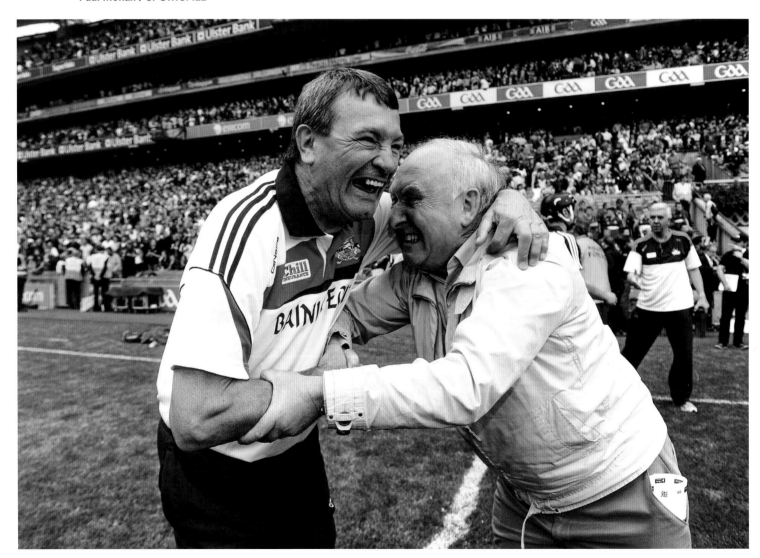

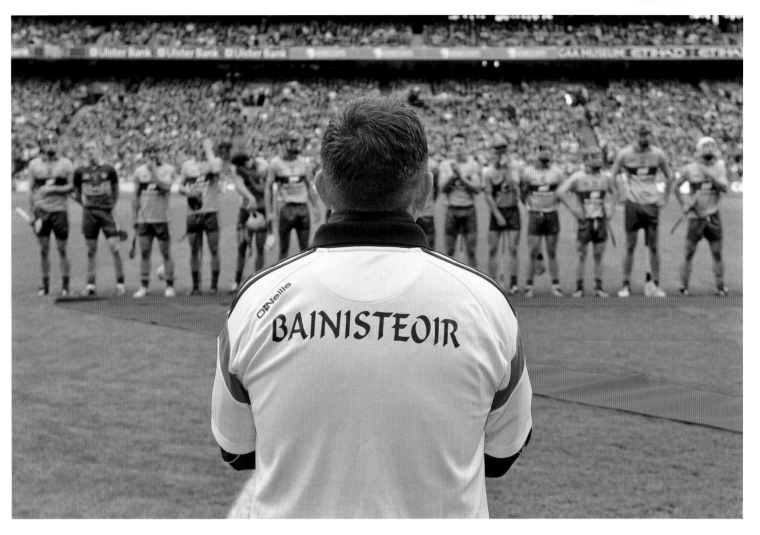

8 September 2013

Clare manager Davy Fitzgerald watches
his players before the start of the game.
All-Ireland Hurling Final, Cork v Clare,
Croke Park, Dublin.

Matt Browne / SPORTSFILE

I had just asked the lads before they went out
to enjoy the day and enjoy the occasion ...
While I stood there I was calling out their names
and smiling at them to help them relax. Big
occasions like these are few and far between. It's
so important to make the most of them ... These
lads were very young and I didn't want them to
get caught up with the sideshow I just wanted
them to express themselves, like every other
match they played.

Davy Fitzgerald, manager

8 September 2013

Captain Kevin Daly celebrates Waterford's first minor title since 1948 with the *Irish Press* Cup. All-Ireland Minor Hurling Final, Galway v Waterford, Croke Park, Dublin.

Barry Cregg / SPORTSFILE

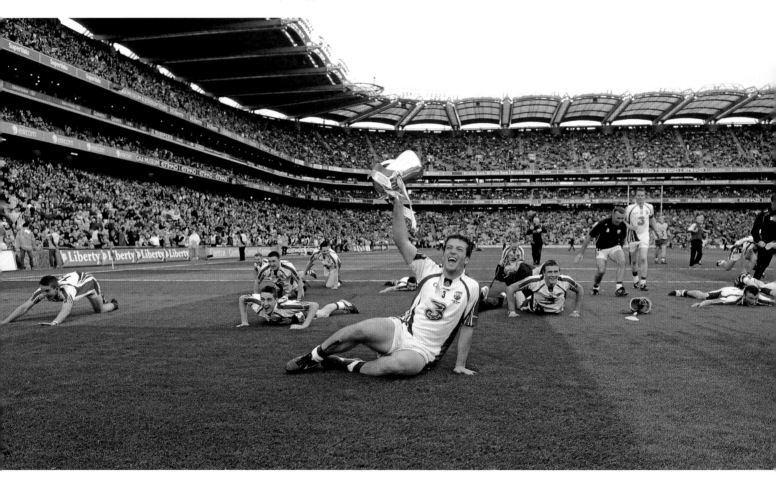

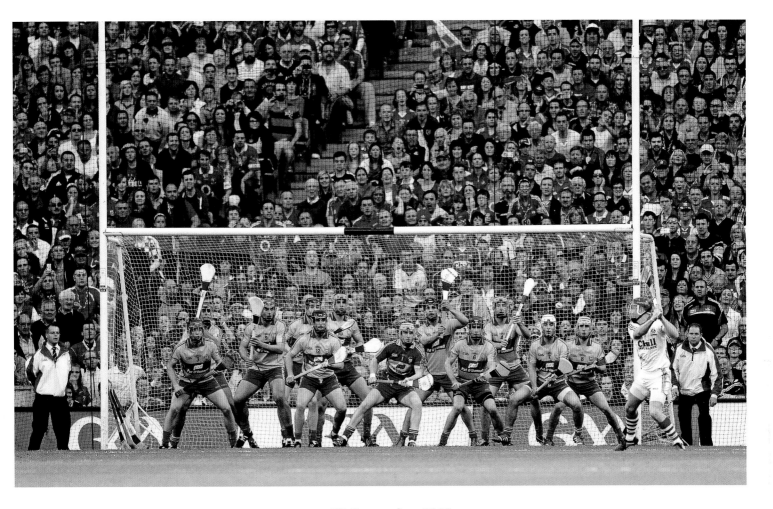

28 September 2013

Clare players prepare to defend an Anthony Nash free which resulted in a Cork goal. All-Ireland Hurling Final Replay, Cork v Clare, Dublin.

Stephen McCarthy / SPORTSFILE

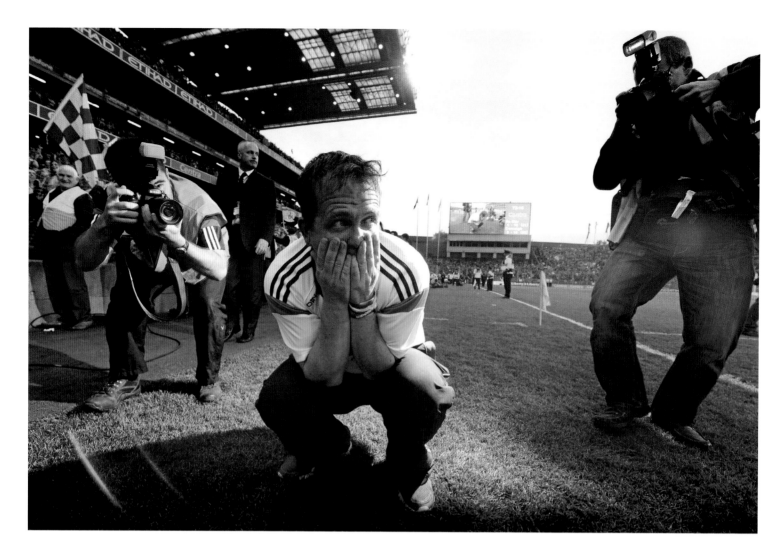

28 September 2013

Clare manager Davy Fitzgerald falls to the ground at the final whistle. This was the Banner county's fourth ever All-Ireland title, with Fitzgerald being involved as a player for two of them and now again as manager. All-Ireland Hurling Final Replay, Cork v Clare, Croke Park, Dublin.

Paul Mohan / SPORTSFILE

28 September 2013

Clare goalscorer Shane O'Donnell is lifted by his team-mates as they celebrate with the Liam MacCarthy cup after the game. Relatively unknown O'Donnell was only informed that he would be starting two hours before the game. His performance would go down in history; the Ennis forward scored 3-3 in the game, which saw Clare win on a scoreline of 5-16 to 3-16. All-Ireland Hurling Final Replay, Cork v Clare, Croke Park, Dublin.

Brendan Moran / SPORTSFILE

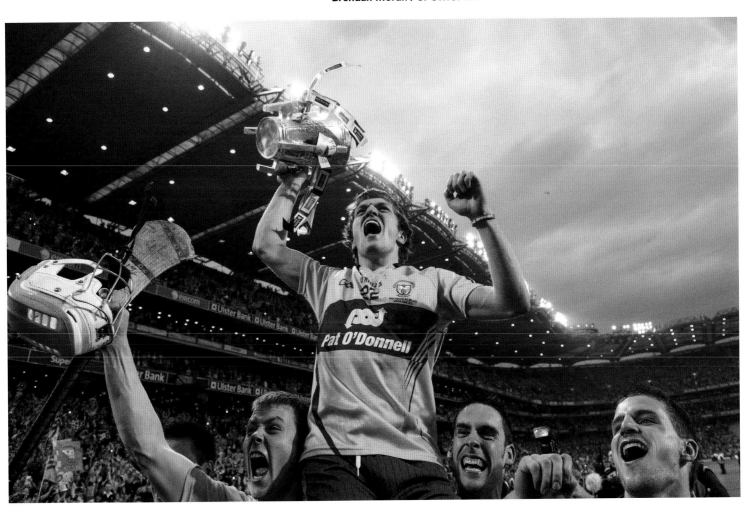

7 June 2014

Longford's Conor Egan celebrates with his eight-month old daughter Elayna and the Lory Meagher Cup. Lory Meagher Cup Final, Longford v Fermanagh, Croke Park, Dublin.

Piaras Ó Mídheach / SPORTSFILE

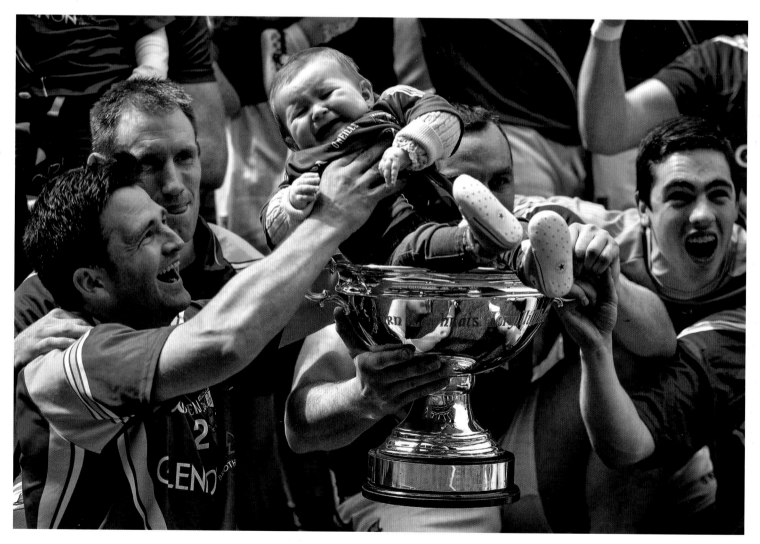

12 July 2014

Clare manager Davy Fitzgerald reacts to a decision against Clare late in normal time; the Bannermen surrendered their All-Ireland crown to Wexford after extra-time. All-Ireland Hurling Round 1 Replay, Clare v Wexford, Wexford Park, Wexford.

Ray McManus / SPORTSFILE

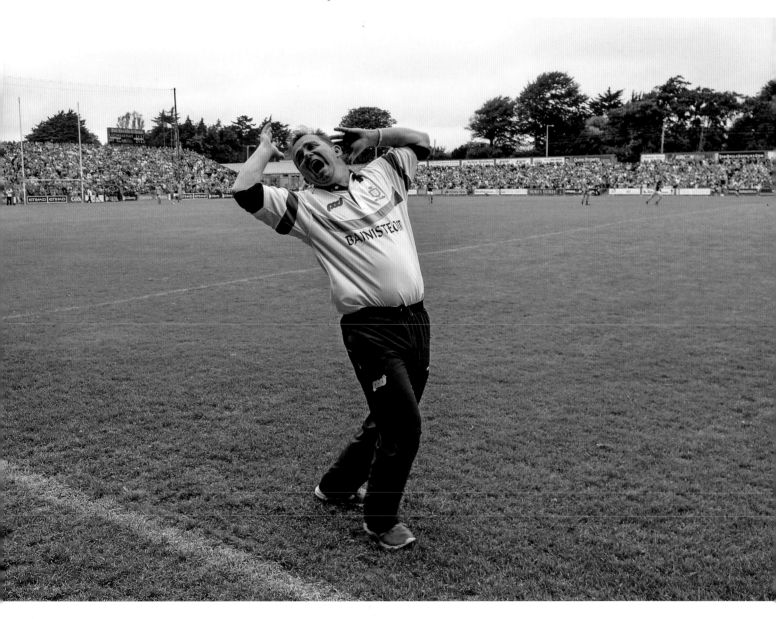

13 July 2014

It was the 2014 Munster hurling final. Limerick v Cork, and it was extra special as it was set to be the last full-house at Páirc Uí Chaoimh before it's major redevelopment.

When Ray asked me if I would be interested in taking pictures of the game from a helicopter I thought he was joking It is the easily the most incredible way I have witnessed a sporting occasion. The most striking thing was the silence in the air; At 1500ft up you couldn't hear anything from the 36,075 spectators so to see the game from this distance, as the players worked their way around the field like little ants, was extraordinary. I made it down to pitchside for the second half to join colleagues Brendan Moran and Ray McManus as Cork went on to win 2-24 - 0-24.

Diarmuid Greene, photographer

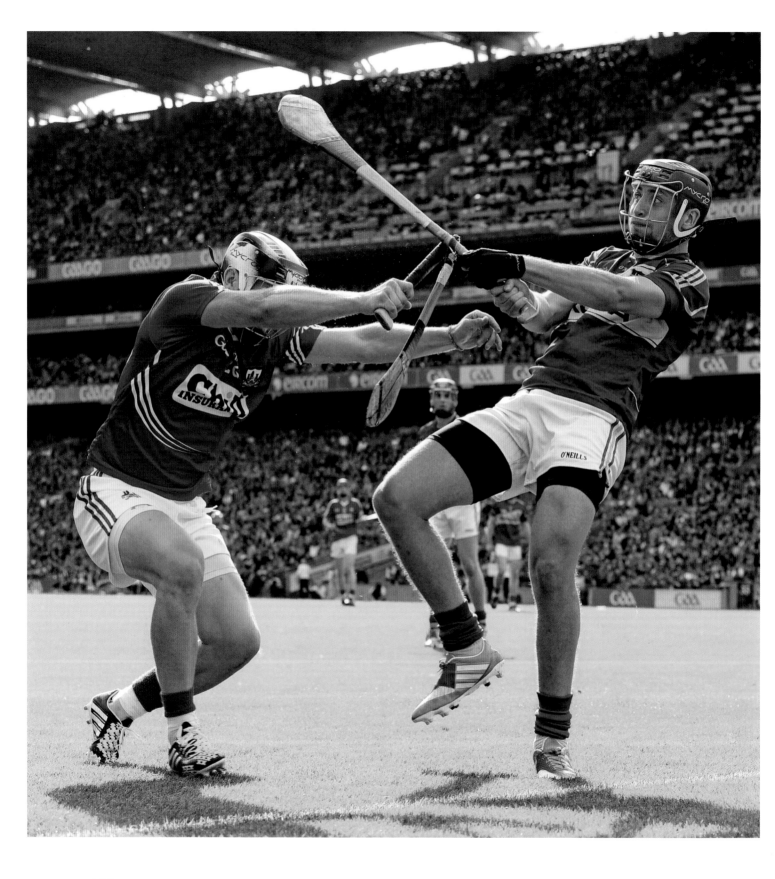

17 August 2014

Clash of the ash! James Barry,
Tipperary, reacts as Paudie
O'Sullivan, Cork, cracks his hurl in
two. All-Ireland Hurling Semi-Final,
Croke Park, Dublin.

Tomás Greally / SPORTSFILE

7 September 2014

Alan Murphy, Kilkenny, in action against Paddy
O'Loughlin, Limerick. All-Ireland Minor Hurling Final,
Croke Park, Dublin.

Ramsey Cardy / SPORTSFILE

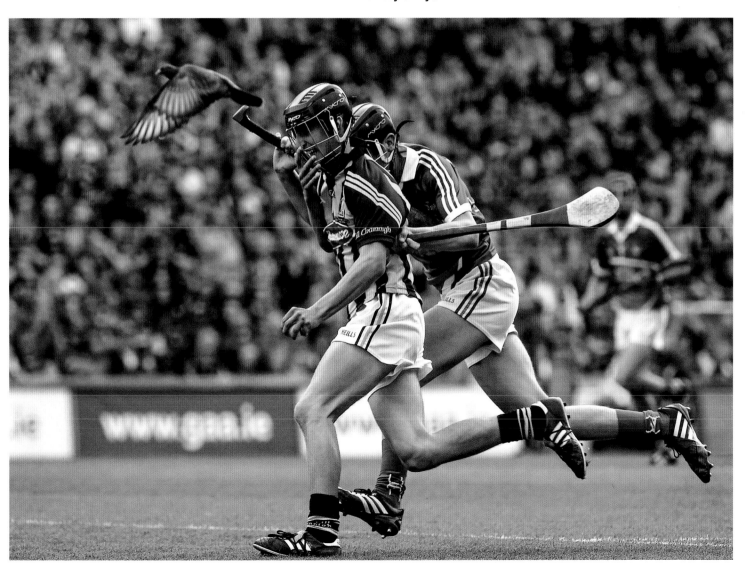

7 September 2014

John O'Dwyer, Tipperary, reacts to the 'hawkeye' decision that his late free was wide in the dying moments of the game. The sides were level in the dying moments of the game, Tipperary were awarded a free from long-range. Up stepped John 'Bubbles' O'Dwyer to strike the most important free of his career. He struck the sliotar high into the Dublin sky before it came down over the post. The referee signalled that hawkeye would be used to see if Tipperary would be crowned All-Ireland Champions. 82,000 people including John O'Dwyer waited anxiously before the shot was deemed to have gone wide. The Cats lived to fight another day, and would subsequently go on to win the replay. All-Ireland Hurling Final, Croke Park, Dublin.

Dáire Brennan / SPORTSFILE

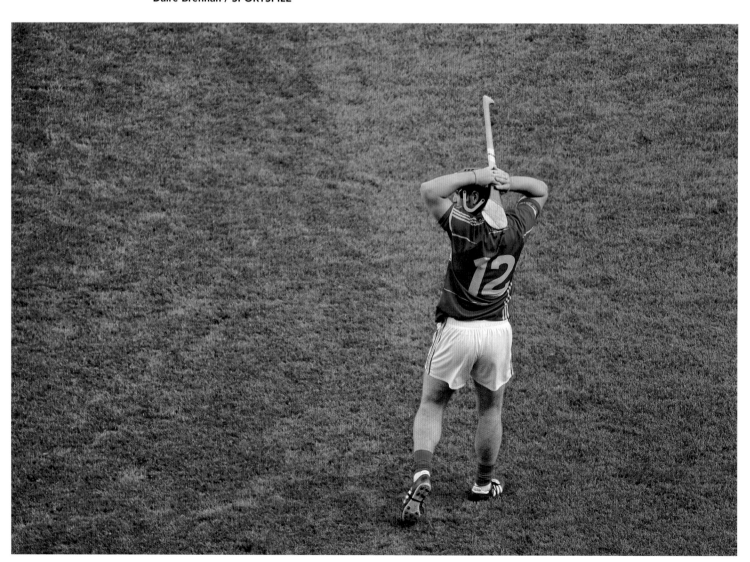

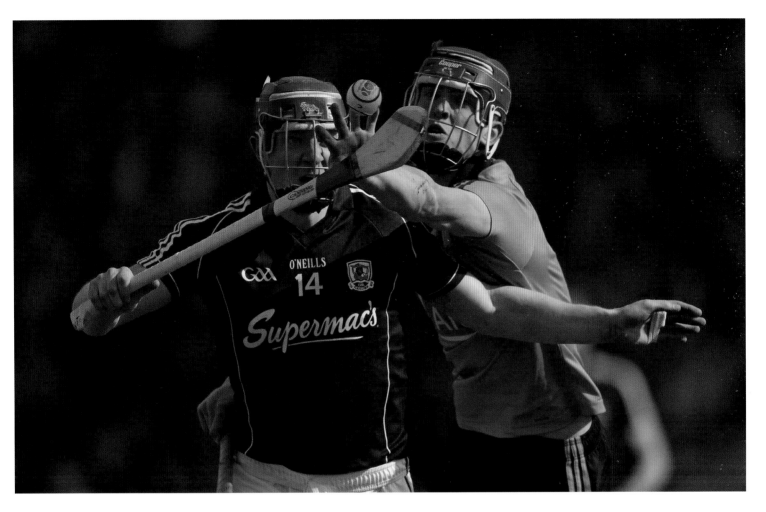

6 June 2015

Joe Canning, Galway, in action against Chris Crummy, Dublin. Leinster GAA Hurling Senior Championship Quarter-Final Replay, Dublin v Galway. O'Connor Park, Tullamore, Co. Offaly.

Stephen McCarthy / SPORTSFILE

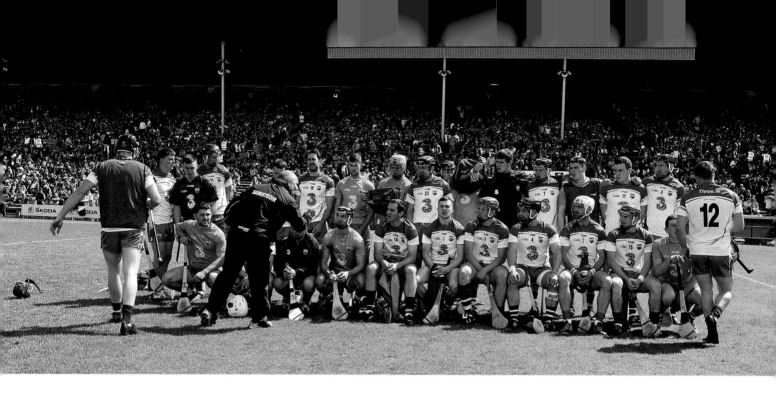

7 June 2015

The Waterford manager Derek McGrath issues final instructions as the team line up for the pre match photograph. Munster Hurling Semi-Final, Waterford v Cork. Semple Stadium, Thurles, Co. Tipperary.

Ray McManus / SPORTSFILE

21 June 2015

Seamus Callanan, Tipperary, clashes with Limerick goalkeeper Barry Hennessy – Callanan lost three teeth and left the pitch for a blood injury before returning late in the game. Munster Hurling Semi-Final, Gaelic Grounds, Limerick.

Brendan Moran / SPORTSFILE

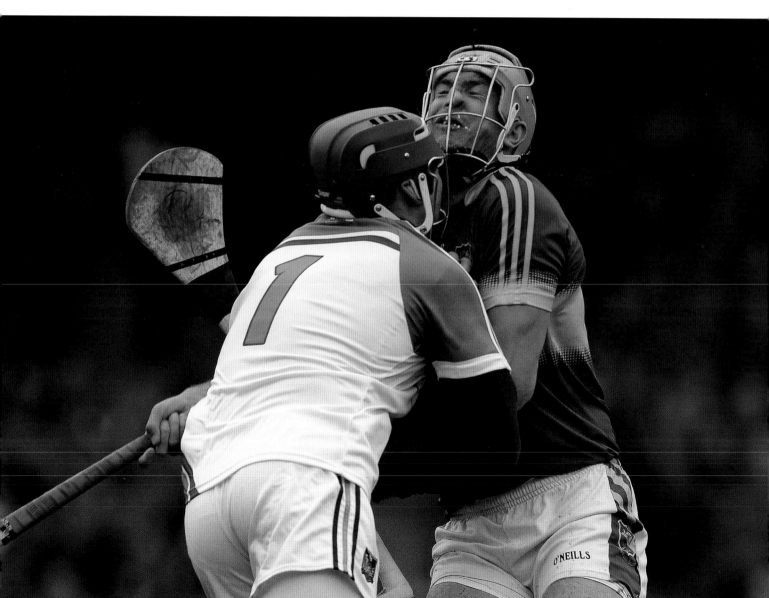

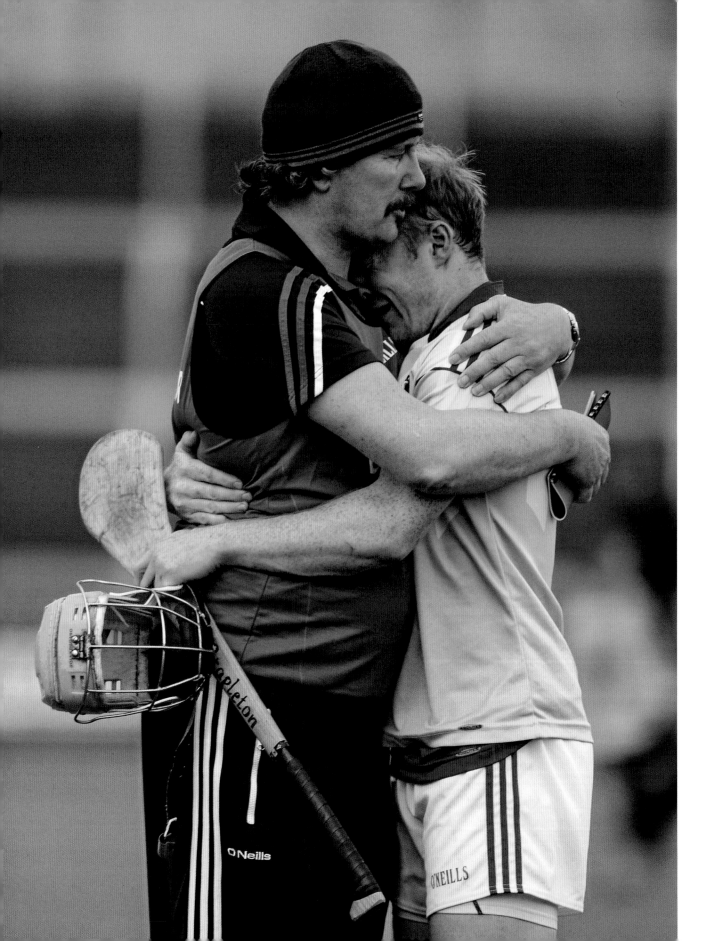

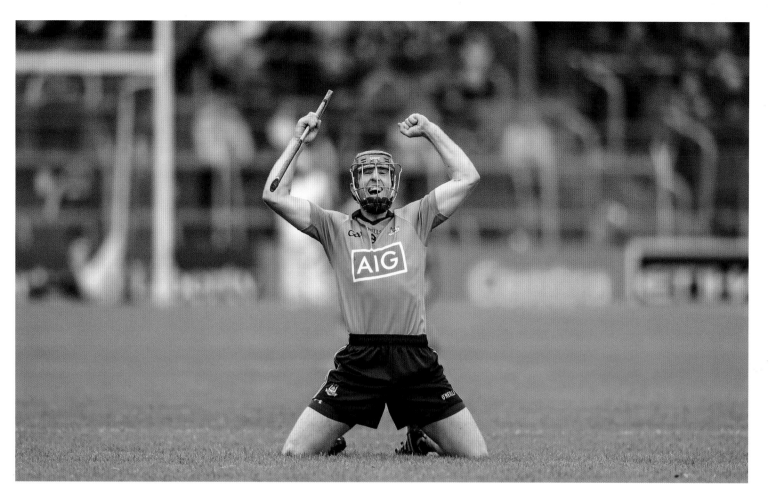

11 July 2015

Dublin's Johnny McCaffrey celebrates his side's victory at the final whistle. GAA Hurling All-Ireland Senior Championship, Round 2, Dublin v Limerick. Semple Stadium, Thurles, Co. Tipperary.

Stephen McCarthy / SPORTSFILE

4 July 2015

Laois manager Séamus Plunkett consoles corner-back Brian Stapleton, after the game. A goal by Conal Keaney in the 32nd minute set Dublin on the path to their 10-point victory. GAA Hurling All-Ireland Senior Championship, Round 1, Laois v Dublin. O'Moore Park, Portlaoise, Co. Laois.

Dáire Brennan / SPORTSFILE

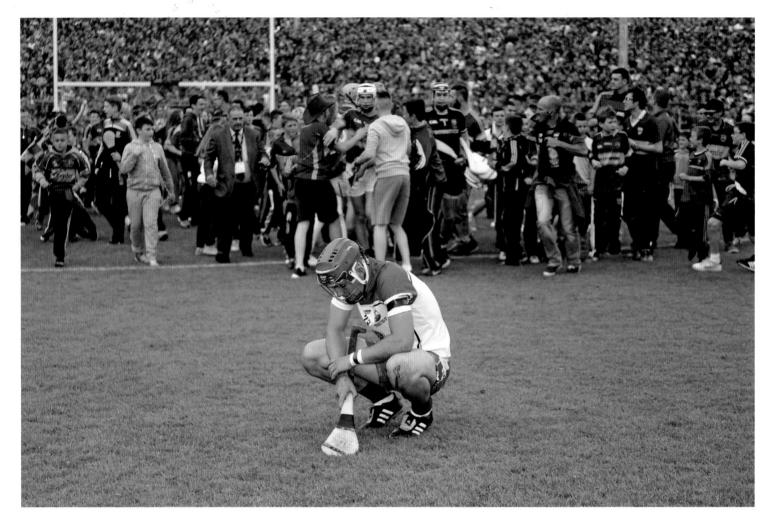

12 July 2015

The loneliest place to be. Waterford's Patrick Curran dejected after the game; Waterford started strong, but Tipperary powered ahead and won on a final score of 0-21 to 0-16. Munster Hurling Final, Semple Stadium, Thurles, Co. Tipperary.

Piaras Ó Mídheach/ SPORTSFILE

This is one of my favourite pictures from after the 2015 Munster Senior Hurling Championship final in Thurles. After the final whistle confirmed Tipperary's first senior provincial win since 2012, Waterford's Patrick Curran was stunned in defeat, while in the background Tipperary supporters celebrated their win. Yet Tipperary captain Brendan Maher and goalkeeper Darren Gleeson head through the crowd to their fellow hurler to commiserate before savouring in the well-earned victory. A sporting moment among some of hurling's best.

Piaras Ó Mídheach, photographer

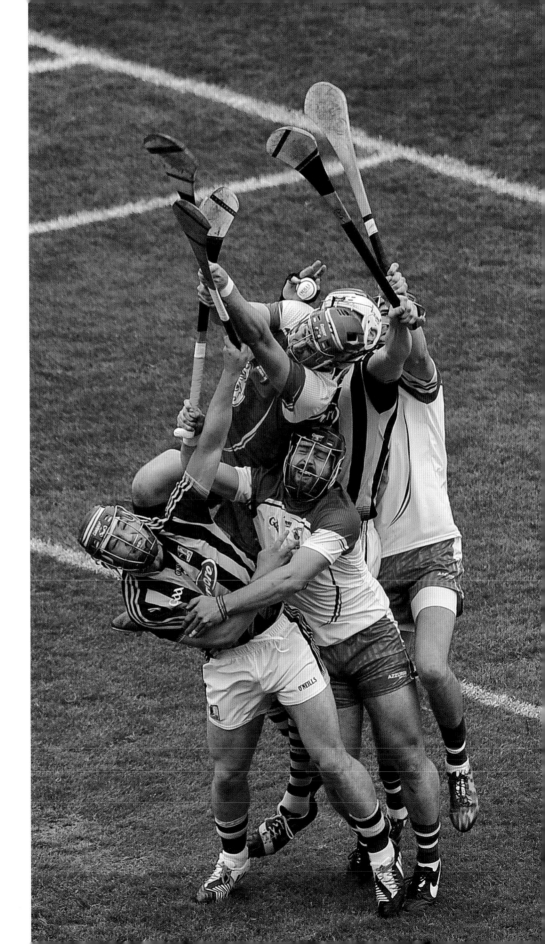

9 August 2015

Waterford players, left to right, Stephen O'Keeffe, Noel Connors, and Barry Coughlan, in action against Ger Aylward, left, and TJ Reid, Kilkenny. All-Ireland Hurling Semi-Final, Croke Park, Dublin.

Dáire Brennan / SPORTSFILE

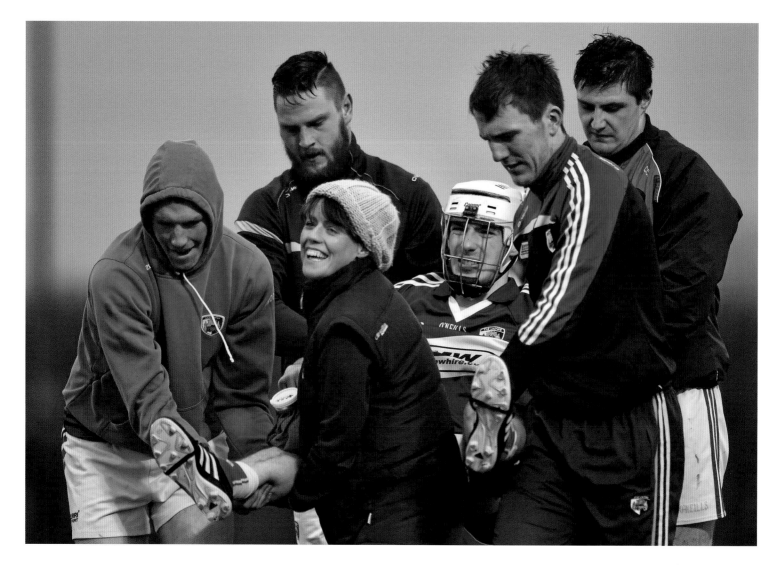

2 January 2016

Ben Conroy, Laois, is helped off the field by team-mates, from left, Padraig Lalor, Neil Foyle, Ciaran Collier, Ryan Mullaney, and team Doctor Sharon McDonnell after a knee injury during the game. Bord na Mona Walsh Cup, Group 2, Laois v Antrim. Kelly Heywood Community School, Ballinakill, Portlaoise, Co. Laois.

Matt Browne / SPORTSFILE

14 February 2016

Local children from Galway, Robert Noone, brothers Conor and Cian Geoghegan, and Danny Morrissey practise their hurling skills before the start of the game between Galway and Cork. Hurling League, Division 1A, Round 1, Pearse Stadium, Galway.

David Maher / Sportsfile

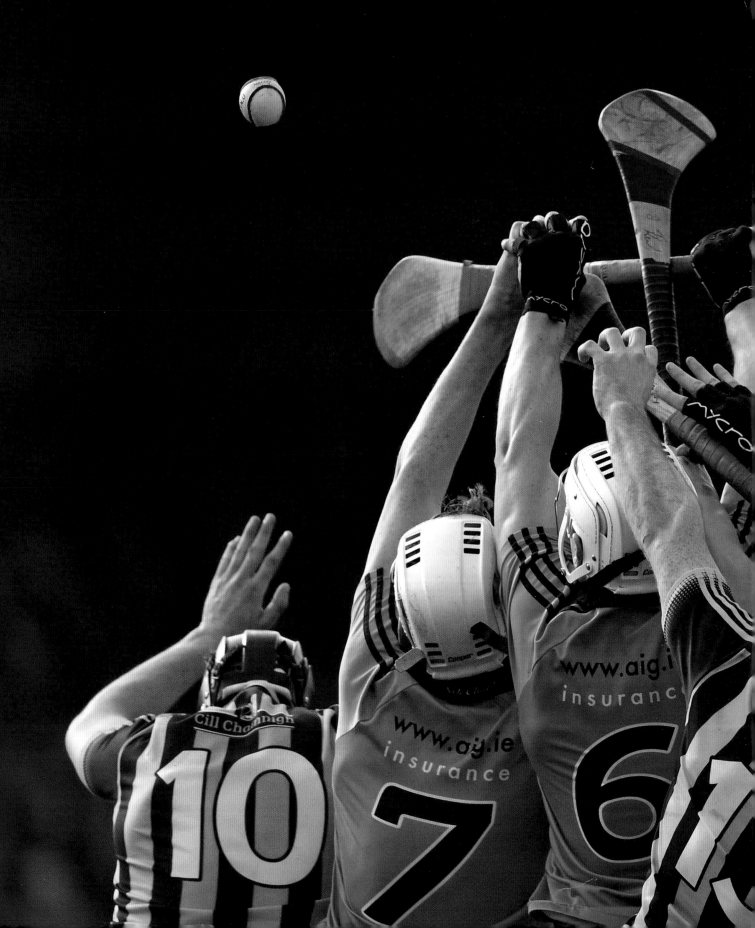

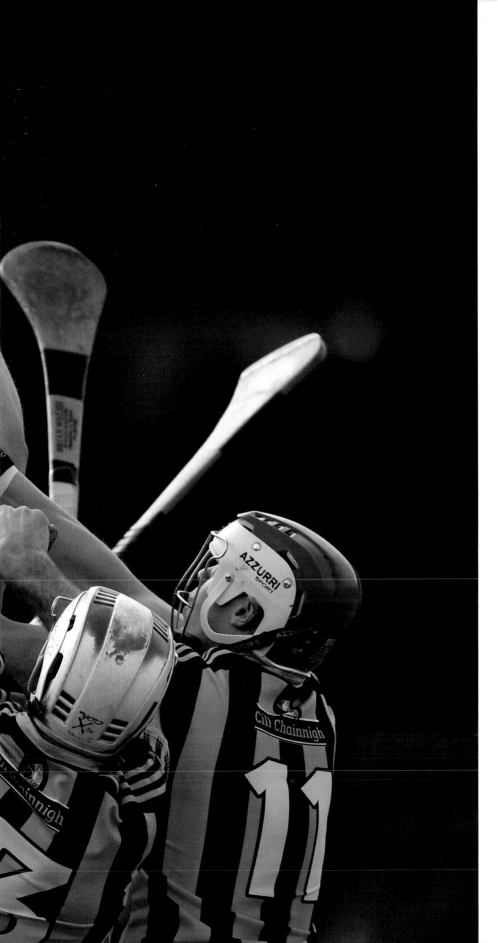

20 March 2016

Kilkenny players, from left, Walter Walsh, Jonjo Farrell and TJ Reid compete against Dublin's Shane Barrett, 7, and Liam Rushe. Hurling League, Division 1A, Round 5, Nowlan Park, Kilkenny.

Stephen McCarthy / SPORTSFILE

19 June 2016

Joe Canning of Galway clashes with Chris McDonald of Offaly during the Leinster Hurling Semi-Final match at O'Moore Park in Portlaoise, Co Laois.

Cody Glenn/Sportsfile

Late in the first half on a rain-soaked pitch the familiar maroon jersey and red helmet looked destined to score. Galway's stalwart Joe Canning had built up a head of steam as he tore through the centre of enemy territory when, in a flash, Chris McDonald of Offaly dug in his spikes stopping Canning in his tracks. Condensation flung off their helmets as the adversaries clashed during the 2016 Leinster Senior Hurling Championship Semi-Final.

It was the type of collision between two fearless players that supporters could feel from the stands, or in my case wincing through a 500mm lens from the corner of the pitch. We at O'Moore Park on that afternoon witnessed an unstoppable force meet an immovable object

As a sports photographer, capturing peak action is the aim. This image is special to me because it captured the moment of jaw-rattling impact. In fairness, if it hadn't been raining hard that afternoon, the photo wouldn't have been nearly as dynamic because the force of the clash can be measured in a way by their helmet spray similar to a sweaty boxer who had a right hook landed to his jaw.

The courageous stand didn't really alter the outcome of the match all that much – the heavily-favoured Galway would go on to win the match and later fall in the Leinster final against Kilkenny two weeks later. But rather it was a great example of the toughness and pride that the sport of hurling embodies.

Cody Glenn, photographer

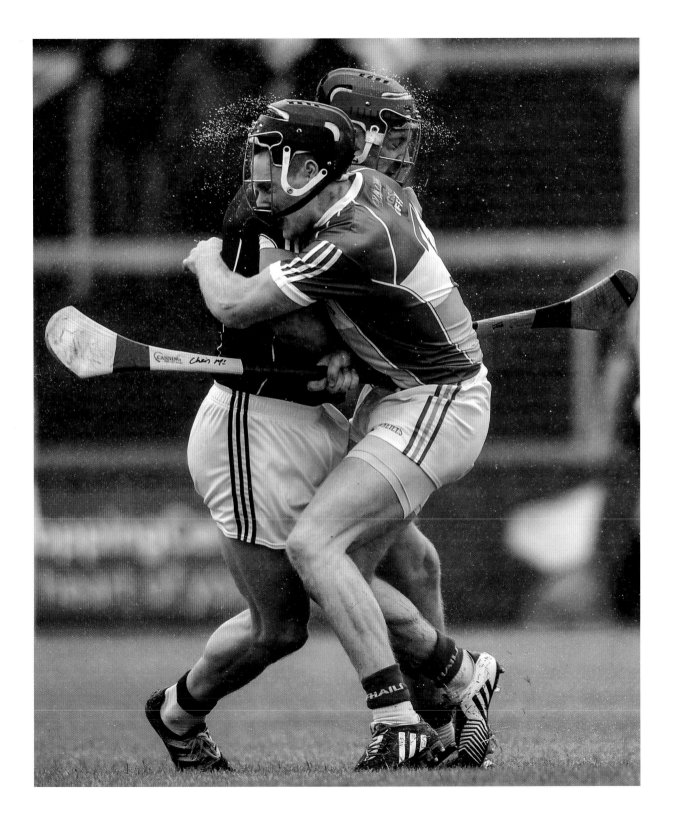

25 June 2016

Meath players, left to right, Stephen Morris, Damian Healy and Seán Quigley celebrate after the Christy Ring Cup Final Replay between Antrim and Meath at Croke Park in Dublin.

Piaras Ó Mídheach / Sportsfile

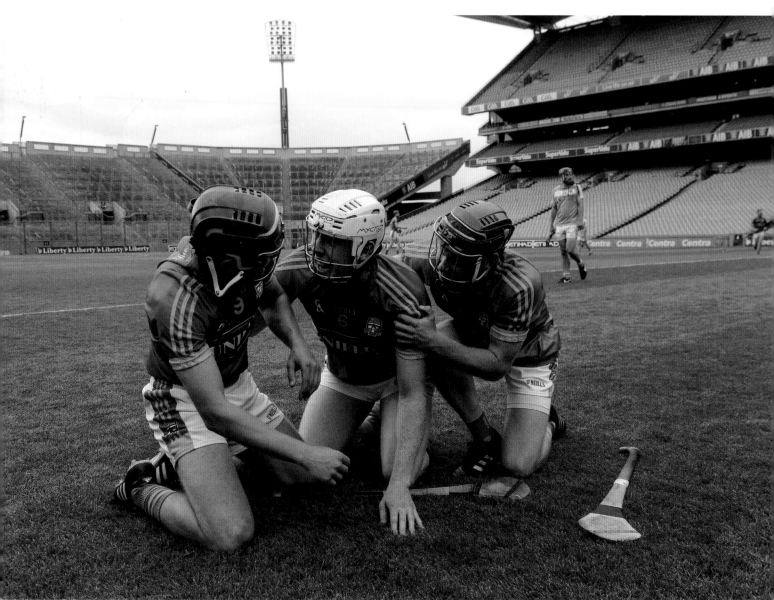

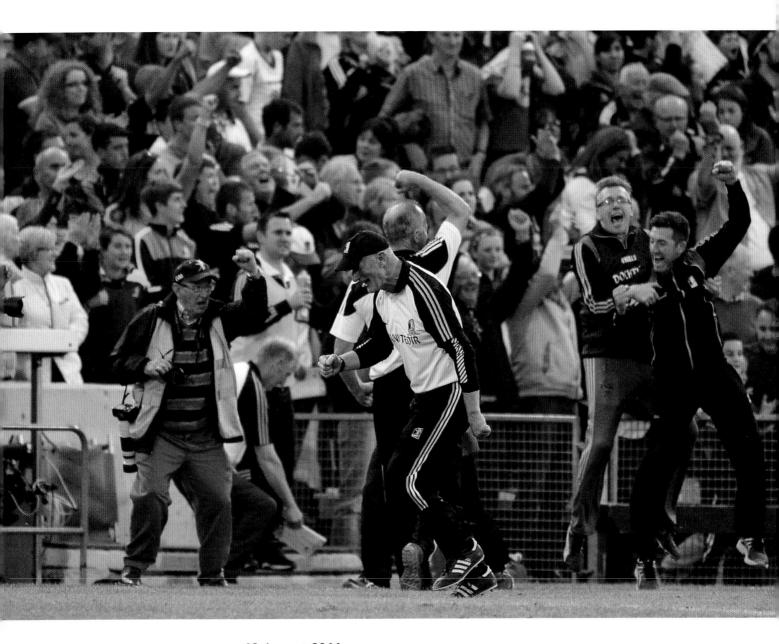

13 August 2016

Kilkenny manager Brian Cody celebrates at the end of the All-Ireland
Hurling Semi-Final Replay game between Kilkenny and Waterford at Semple
Stadium in Thurles, Co Tipperary. A two-point win for Kilkenny put the All-
Ireland champions through to their third final in a row.

Dáire Brennan / Sportsfile

4 September 2016

Liam Blanchfield of Kilkenny is tackled by Pádraic Maher of Tipperary during the All-Ireland Hurling Final match between Kilkenny and Tipperary at Croke Park in Dublin. Tipperary blew the Cats away and took the title, 2-29 to 2-20.

Stephen McCarthy / Sportsfile

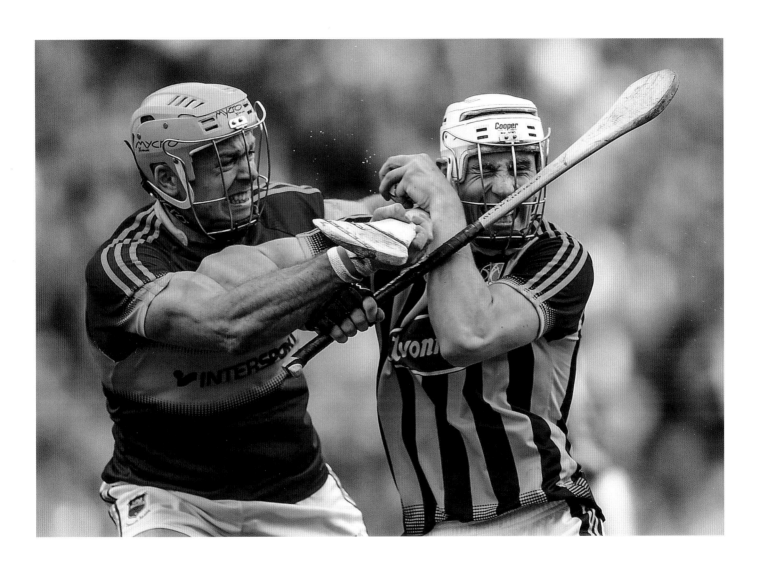